Essential, DALÍ

Works illustrated are copyright © Salvador Dalí/Foundation Gala-Salvador Dalí/DACS 1999

This is a Parragon Publishing book
This edition published in 2001

Parragon Publishing
Queen Street House
4 Queen Street
Bath BA1 1HE, UK

Copyright © Parragon 2000

Created and produced for Parragon by
FOUNDRY DESIGN AND PRODUCTION,
a part of The Foundry Creative Media Co. Ltd,
Crabtree Hall, Crabtree Lane
Fulham, London, SW6 6TY

ISBN: 0-75255-516-2

A copy of the CIP data for this book is available from
the British Library, upon request

The right of Kirsten Bradbury to be identified as the author of
this work has been asserted in accordance with Section 77 of the
Copyright, Designs, and Patents Act of 1988.

The right of Dr Jonathan Wood to be identified as the
author of the introduction to this book has been asserted in
accordance with Section 77 of the Copyright, Designs, and
Patents Act of 1988.

Printed in China

Essential
DALÍ

KIRSTEN BRADBURY

Introduction by Dr. Jonathan Wood

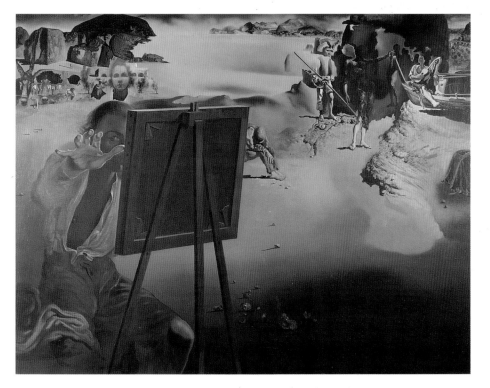

p

CONTENTS

CONTENTS

INTRODUCTION

AS the twentieth century draws to a close, the Spanish-born artist Salvador Dalí has gradually come to be seen, alongside the likes of Picasso and Matisse, as a prodigious figure whose life and work occupies a central and unique position in the history of modern art. Indeed, following his temporary allegiance to André Breton's Surrealism—perhaps the most dominant and influential movement of this century—Dalí has come to be regarded not only as its most well-known exponent but also, to many people, as an individual artist synonymous with Surrealism itself. In addition to this, the broad and multifarious nature of his oeuvre has contributed significantly to the scope and extent of his reputation: not only was Dalí a painter (and, of course, draftsman, illustrator, and printmaker)

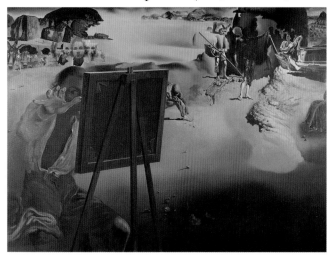

but he was also a sculptor, a maker of objects, of ceramics, of furniture and of jewelry; he was also a film maker, theorist, novelist, autobiographer and perhaps most crucially of all, a master of self-publicity. For without this last ingredient, through which both his famous moustachioed persona was presented and his identity as an artist, for whom art and life had become one, was staged, Salvador Dalí would not have acquired the international fame and status that he has. Indeed only now, a decade after his death, is the complexity of his "exhibitionism," as a central, motivating force for his art and lifestyle, being fully appreciated.

Christened Salvador Dalí Domènech, he was born on May 11 1904 in Figueres, a town in Catalonia, northern Spain to Salvador Dalí Cusí and his wife Felipa Domènech Cusí. The premature death of his older brother, also called Salvador, had occurred less than a year earlier, in August 1903, and was later recalled, in his autobiography *The Secret Life of Salvador Dalí*, as a decisive and formative event: "my brother and I resembled each other like two drops of water, but we had different reflections. Like myself, he had the unmistakable facial morphology of genius ... My brother was probably a first version of myself, but conceived too much in the absolute.' Dalí's idiosyncratic meditation was

art theory. Although Dalí may not have satisfied the academy's rules and regulations, he did, however, both produce good work and, most significantly, made some new friends, among them, film director Luis Buñuel, playwright and poet Frederico García Lorca, and Pedro Garfias, individuals who were to play important roles in Dalí's life. Madrid also provided exposure to a wealth of artistic material, both ancient and modern, and opportunities hitherto unexperienced by Dalí. He

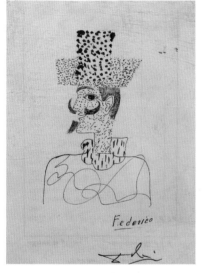

became a regular visitor to Madrid's museum the Prado and its collections of works by masters such as Raphael, Titian, Bosch, Velásquez, Rubens, Rembrandt, and Goya. Dalí also, as evidenced in paintings such as *Portrait (Frederico García Lorca)* (c.1923) and *Still Life (Syphon and Bottle of Rum)* (1924), had developed a keen interest in both Cubism (particularly that of Juan Gris) and in the Italian "metaphysical' painters Giorgio de Chirico and Carlo Carrà and in the still lives of Giorgio Morandi.

Perhaps, significantly, it was early 1920s Neo-Classicism which at this stage characterized Dalí's canvases of 1924-25, demonstrated in masterpieces such as *Girl Standing at a Window* (1925) and *Seated Girl Seen from the Rear* (1925), both paintings of Dalí's sister Ana María. These were shown at his first one-man exhibition at the Galeries Dalmau in Barcelona in November of that year. Having shown fifteen canvases in 1925, it was after his second exhibition at the gallery in December 1926–January 1927 (when he displayed 21 works), that Dalí began to attract attention from Paris. He had visited Paris with Buñuel in 1926, but the trip had been a fleeting one before traveling on to Brussels. Now, however, following the Barcelona show and its press coverage, Paris was coming to him.

Having returned to Figueres in 1926, and spending summers in nearby Cadaqués, Dalí was to be visited in 1927 by Spanish Surrealist painter Joan Miró who would help and advise him over the next few years, and also by Miró's dealer Pierre Loeb. Although no purchases were made (indeed it was only later in 1930, after his temporary arrangement with Camille Goemans, that Dalí signed a proper contract, with the dealer Pierre Colle), it would have provided confirmation, especially in the light of his increasingly poor relations with his father, that Paris was where, in the short term, his artistic future lay. With his

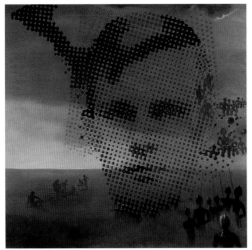

typical of the way he set about constructing the origins of his artistic identity and such self-mystifying commentary, obsessed as it was with the declaration of his genius, was highly characteristic of his autobiographical narratives, especially after 1940.

In some ways, the young Dalí was given an unusual start in life. His father, a public notary in Figueres, was a freethinker and sent Dalí in 1908 (also the year of the birth of his sister, Ana María), to the local municipal school, Escuela Pública de Parvulos de Figueres, rather than to a religious school. In 1910, Dalí began attending primary school, the Colegio Hispano-Francés de la Immaculada Concepción, where he was educated (and also learned French) until he was twelve. Indeed, 1916 was an important year; not only did Dalí begin his secondary education at the Figueres Instituto and at the Marist Brothers' College, but he also experienced his first extended contact with painters: Ramon Pichot and Juan Núñez. In the summer, Dalí spent the holidays with the Pichot family and, in the midst of such an artistic family, discovered French Impressionism and Spanish Symbolism through the paintings of Ramon, an artist in his mid-thirties who was friendly with Picasso and very much in contact with artistic developments in Paris. Núñez was an academic painter who, having arrived in Figueres in 1906 to undertake professorship of the institute's drawing department, held classes which Dalí attended from that fall .

The talent and enthusiasm for art displayed by Dalí during these years, 1916–22, was not lost on his friends, teachers or family. He wrote and made illustrations which were published in Catalan magazines such as *Patufet* and *Studium* and sold his work both from home and in student exhibitions in Barcelona. As his secondary schooling ended and on the advice of his father, who was keen for his son to acquire a formal qualification in his chosen field, Dalí left Figueres and moved to Madrid to take up a place at the Residencia de Estudiantes and the School of Painting, Sculpture and Engraving (the Academia de San Fernando).

Dalí's time at the academy in Madrid, from which he was suspended for a year in 1923 for disobedience and disruption, was prematurely terminated in 1926 following his refusal to be examined in

close friend and admirer García Lorca away in New York, it was with his old Madrid companion Luis Buñuel that Dalí collaborated to take Paris by storm, which they did in 1929 with their film *Un Chien Andalou (An Andalusian Dog)*.

First shown in June and then in October, where it ran for eight months at Studio 28, the script for *Un Chien Andalou* began: "once upon a time ... a balcony. Night. A man is sharpening a razor by the balcony. The man looks through a window at the sky and sees ... A light cloud passing across the face of the full moon. Then the head of a young woman with wide-open eyes. The blade of the razor moves toward one of her eyes. The light cloud now moves across the face of the moon. The razor blade slices the eye of the young woman, dividing it.' Dalí had been following the concerns and activities of the Surrealists in magazines, and was now signed up and very much in their midst—as he later recalled in his *Secret Life*: "the film produced the effect that I had wanted, and it plunged like a dagger into the heart of Paris as I had foretold.' The young artist again reaffirmed his presence through his first one-man show in Paris, at the Goemans Gallery in November that year. With a catalogue introduction by French Surrealist writer André Breton, 11 paintings were displayed including *Portrait of Paul Eluard, Illuminated Pleasures, The Enigma of Desire,* and *Apparatus and Hand*.

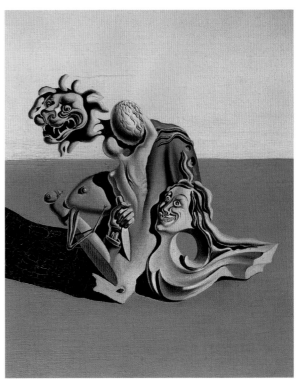

Dalí's early Surrealist years, spanning 1929 to the disagreements of 1934–35, represented a period both of intense activity (on canvas and on paper) and of collaboration, and have been seen justifiably as his finest hour. If, with Dalí in his mid-twenties, it was a time that he was coming into his own as an artist, it was also a time of rupture and scandal. By 1930, his relations with his father had effectively collapsed, aggravated by the artist's public pronouncements in the press and his antics in Paris, and also by his ostentatious relationship with Gala Eluard

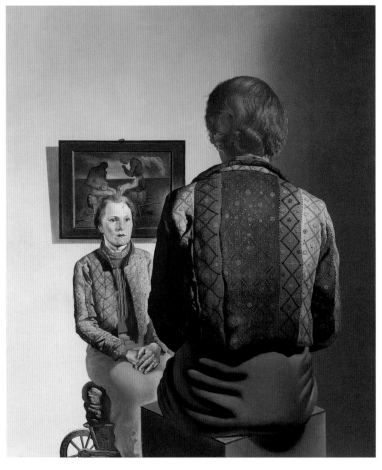

(the French Surrealist poet's wife and a woman considerably older than him), who became his companion and muse for life. Indeed, when Dalí and Gala returned to Spain to reside, following their travels in France, it was at Port Lligat, not neighbouring Figueres, that they settled in 1930, with the purchase of an old fisherman's cottage.

Paris for Dalí in 1930 was no less frantic. In December, his and Buñuel's second film *L'Age d'Or* (*The Golden Age*), sponsored once again by the collector Charles de Noailles, created an outrage in the press among right-wing Parisian groups. As a result, the film was banned and the exhibition, which was arranged to coincide with the screening, was vandalized. A valuable member of the Surrealist group, which was beginning to show signs of disunity under Breton's leadership, Dalí participated significantly in their activities. He exhibited recent work alongside Miró, Magritte, Ernst, Man Ray, Duchamp, Picabia, Arp, Picasso, and Tanguy in Paris and later in the US. He illustrated Breton and Eluard's Surrealist text, *L'Immaculée Conception* (*The Immaculate Conception*) which was published in 1931, and provided illustrations to the former's *Le Revolver à Cheveux Blancs* (*The White-haired Revolver*) and the frontispiece to his *Second Surrealist Manifesto*. It was also, importantly and in keeping with his earlier articles for Spanish periodicals, a new time and a new forum for the articulation of his own theories on art and creativity in the light of Surrealism. Not only did he do so through *La Révolution Surréaliste* and through several contributions to *Le Surréalisme au Service de la Révolution*, which included the famous 1931 essay *Objets Surréalistes*

(*The Object as Revealed in Surrealist Experiment*), but also through books such as *La Femme Visible* (1930) and the later *La Conquête de l'Irrationnel* (1935).

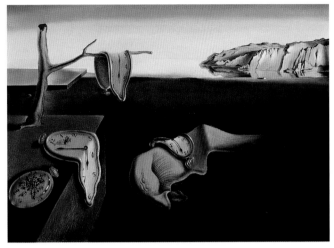

In accordance with Surrealist writing as a whole, the thinker at the heart of Dalí's intellectual concerns was Sigmund Freud. Free association occupied a central position within the Surrealist program. As Breton stated in his definition of Surrealism in his 1924 manifesto: "Surrealism, n.m. Pure psychic automatism by which it is proposed to express, either verbally, in writing or in any other way, the real function of thought. Thought's dictation in the absence of all control exercized by reason and outside all aesthetic or moral preoccupations.'

Dalí's absorption of the Surrealists' preoccupation with automatism was detectable earlier, under Miró's influence, in paintings such as *Honey is Sweeter than Blood* (1927), *Apparatus and Hand* (1927) and *Little Cinders* (1927–28). The route he was to take, however, in and beyond these canvases over the forthcoming years, was more idiosyncratic and less strictly in keeping with Bretonian Surrealist doctrine. For, on the one hand and in relation to Breton's definition, the opening up of subject matter to concerns beyond the traditional, and within the realms of dream and the unconscious, was an invitation and prospect relished by the artist. In conjunction with his reading of Freud's texts, it afforded endless opportunities both to explore his own anxieties and taboo issues—such as masturbation, castration, impotence and a number of sexual perversions—and to evoke these concerns through a mixture of a constructed private iconography and Freudian figures and motifs.

The approach thus adopted by Dalí was set out in the early Thirties as his "paranoia-critical method," as he stated "a spontaneous method of irrational knowledge based upon the critical and systematic objectification of delirious associations and interpretations.' What, however, this method required was control, critique and, importantly, technique—a factor which Dalí was not to abandon and which placed his work among painters such as Magritte and Tanguy, who practised a

meticulous, ambiguous illusionistic realism, figurative and biomorphic respectively, a so-called "veristic surrealism'.

In the Thirties Dalí's "paranoia-critical method' produced some of the most memorable paintings of his career, and some of its richest and most seminal visual imagery. The crutches and limp clocks which became his trademark signatures date from these years and were seen in work such as *The Persistence of Memory* (1931), *The Triangular Hour* (1933), *The Architectonic Angelus of Millet* (c. 1929), and *Sleep* (1937). Set in phantasmagoric landscapes, which echoed Tanguy's horizonless domains and the geological formations of his native Catalonia, Dalí's

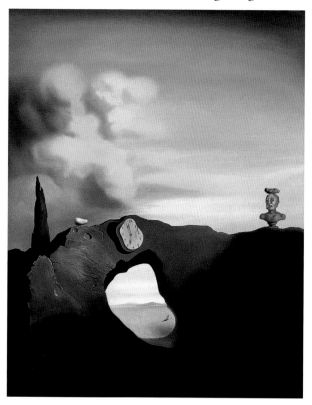

biomorphic repertoire included a diverse range of curiosities (animal, vegetable, and man-made) set within powerful and evocative juxtapositions: eggs, cups, baguettes, cutlery, and ink wells; chairs, tables, chests of drawers and pianos; ants, grasshoppers, lobsters, swans, giraffes, and elephants feature enigmatically in his paintings at this time and would recur emblematically throughout his career.

On some occasions, the associations within the imagery used by Dalí were constructed through the clever use of the double image, as in *Paranoiac Face* (1935), *Swans Reflecting Elephants* (1937), and *The Metamorphosis of Narcissus* (1936–37). At other times, Dalí turned back toward pre-existing myths, legends, and old master paintings; using them as a starting point, he was able to reinterpret their objects, characters, and narratives through the subversive and revelatory process of his "paranoia-critical method." This can be seen in his reappropriations of the myths and legends of Gradiva and William Tell and of the paintings of Goya, Jan Vermeer and Millet, such as the latter's *Angelus*.

After Dalí's acrimonious break with Breton and the Surrealists in the mid-1930s, as a result of his reactionary politics, his support of Franco and his scurrilous bare-buttocked image of Lenin in *The*

Enigma of William Tell (1934), he did nevertheless participate in the International Surrealist Exhibition in London in 1936. Finally, with the outbreak of the Spanish Civil War, he left Paris for Spain with Gala, before going to the US, where he stayed until 1948.

Despite his break with Surrealism, the 1940s was the decade which witnessed both the spread of Dalí's reputation as a modern artist and his increased financial security. It also saw the consolidation of his self-publicizing enterprises, with the publication in 1942 of *The Secret Life of Salvador Dalí* and his first novel, *Hidden Faces* in 1944. Dalí's own face was far from hidden during these years: in 1941 the Julien Levy Gallery staged an exhibition of his paintings, which included *Soft Self-Portrait with Fried Bacon* (1941), and the huge retrospective which followed that year at the Museum of Modern Art in New York and (including over forty paintings and drawings, from juvenalia to recent work) traveled to eight other major cities.

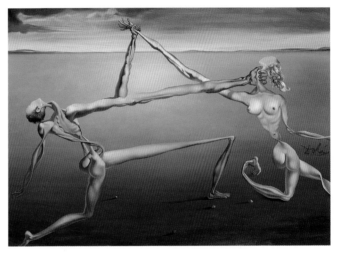

If Dalí's reputation was spreading throughout the US, he was also busily becoming a chic household name among the art-loving rich and famous. After the success in November 1939 of the *Bacchanale* ballet, for which he created the sets, he designed sets and costumes for other ballets such as *El Café de Chinitas*, *Colloque Sentimentale*, *Labyrinth* and *Tristan Insane*. He designed jewelry and furniture and, having produced advertisements for perfume and stockings, worked with fashion magazines such as *Vogue*, *Town and Country* and *Harper's Bazaar*. He also, in addition to a brief collaboration with Walt Disney on the animated film *Destino* (which was never completed), worked with Alfred Hitchcock producing the dream sequences for his film *Spellbound* in 1945. Furthermore, acting as a kind of modern-day court painter, Dalí executed portraits of prominent members of American high society from 1942 onwards, including Princess Helena Rubenstein (for whose apartment he also designed the decor), Ambassador Cardenas, Mrs. Harrison Williams, Mrs. Isabel Styler-Tas, and in 1951, Mrs. Jack Warner. Dalí's critics were far from silent before what they saw as an

undisguised quest for fame and fortune—and perhaps the most cutting was voiced by his former supporter and leader of the Surrealists, André Breton, who renamed him anagramatically "Avida Dollars'—greedy for dollars. Dalí, however, in part thrived on such hostility, as he was famously to state in his 1964 text, *Diary of a Genius*; "the jealousy of other painters has always been the barometer of my success."

After hectic years in New York and California, Dalí's return to Port Lligat in 1948, at the age of 44, was far from a retiring gesture. Indeed, his work and artistic preoccupations over the following two decades was characterized by an increased tendency, which started in the USA following the atomic explosion at Hiroshima, toward the grand, universal and absolute—in the form of an idiosyncratic mixture of Catholicism, mysticism, and the theories of nuclear physics. Although an important shift in concerns was evident in these later years, the "particle" paintings did nevertheless take their cue from his earlier work. The painterly technique employed represented an intensification, rather than a disavowal, of his lifelong interest in Classicism and his adoption of a so-called "nuclear mysticism," a spiritual and futuristic reinvention of his earlier "paranoia-critical" strategies. Indeed, on occasion, and as demonstrated in *The Disintegration of the Persistence of Memory* (1952–54), he returned to earlier canvases and reconstructed them in a cellular, atomized manner.

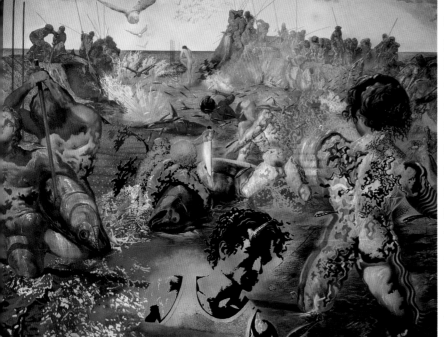

The motivation for these dematerializing procedures was set out in his *Mystical Manifesto* of 1951, and he lectured upon the same theories in the 1950s. Many of the paintings dating from these years were remarkable for their scale (anticipating large works such as *Tuna Fishing* (1966–67) and *The Hallucinogenic Toreador* (1968–70)) as well as their perspectival

feats, among them paintings such as *The Madonna of Port Lligat* (1950), *Christ of St. John of the Cross* (1950), *Lapis-lazuli Corpuscular Assumption* (1952), *The Last Supper* (1955), and *Corpus Hypercubus* (*Crucifixion*) (1954). The role that many of these paintings also performed was the apotheosis of Gala, who Dalí finally married in 1958. She died in 1982 in the castle at Púbol given to her by Dalí, where he had lived until his death.

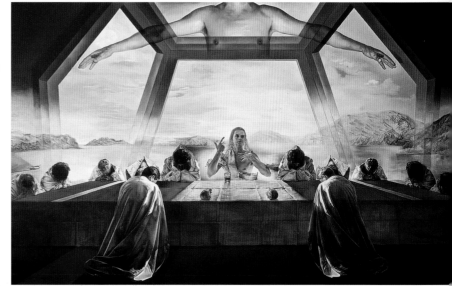

An obsession with eternity and the projected immortality of both his and Gala's fame and status became the overriding concern of his last years. In typical "Dalían" fashion (to use his terminology), such self-mystifying was accompanied by an equally characteristic tendency to self-scandalize, and the later years witnessed the publication of his *Diary of a Genius* (with its appendix on "The Art of Farting') and *The Unspeakable Confessions of Salvador Dalí* (1976). His major undertaking, however, of the last years of his career was the design for and installation of his works in what would become the Teatro Museo Dalí in Figueres. For an artist who had lived out his art and his life upon a public stage, it was indeed fitting that his final memorial should have as its venue a "theater-museum." Moreover, until his death in 1989 (after which Dalí was buried in the building's crypt), and indeed beyond, this site was, and is, one of his most fantastic creations, and continues to perpetuate the project Dalí himself first began in the 1920s, namely the myth of his own artistic identity.

DR. JONATHAN WOOD

PORTRAIT OF THE CELLIST, RICARDO PITCHOT (1920)
Courtesy of AiSA

*P*ORTRAIT *of the Cellist, Ricardo Pitchot* was painted in 1920 using oil on canvas. The Pitchot family were friends of the Dalís who, like them, spent their summers in Cadaqués. The family had a strong influence over Dalí as a child, being very creative and cosmopolitan in contrast with his conventional father.

Ricardo, as the portrait shows, was a cellist. He was given to playing outside to an audience of wild turkeys; the family often gave open-air concerts, going to the extent of hauling a grand piano to a cliff top on one occasion. In later paintings, Dalí was to use the form of the cellos and violins often twisted out of shape, as an evocatively sexual image, as can be seen in *The Masochistic Instrument* (1933).

Dalí is clearly influenced by the paintings of Ricardo's brother, Ramon. His father owned several of Ramon's paintings, which the young Dalí greatly admired. His assimilation of Ramon's style is seen in the Neo-Impressionist brushwork of *Portrait of the Cellist*. The same style can also be seen in Dalí's use of color; there is a predominance of orange here, with the floor, Ricardo's face and the cello all sharing a burnt orange shade.

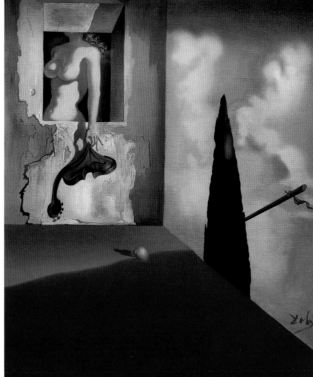

The Masochistic Instrument (1933)
Courtesy of AiSA (See p. 90)

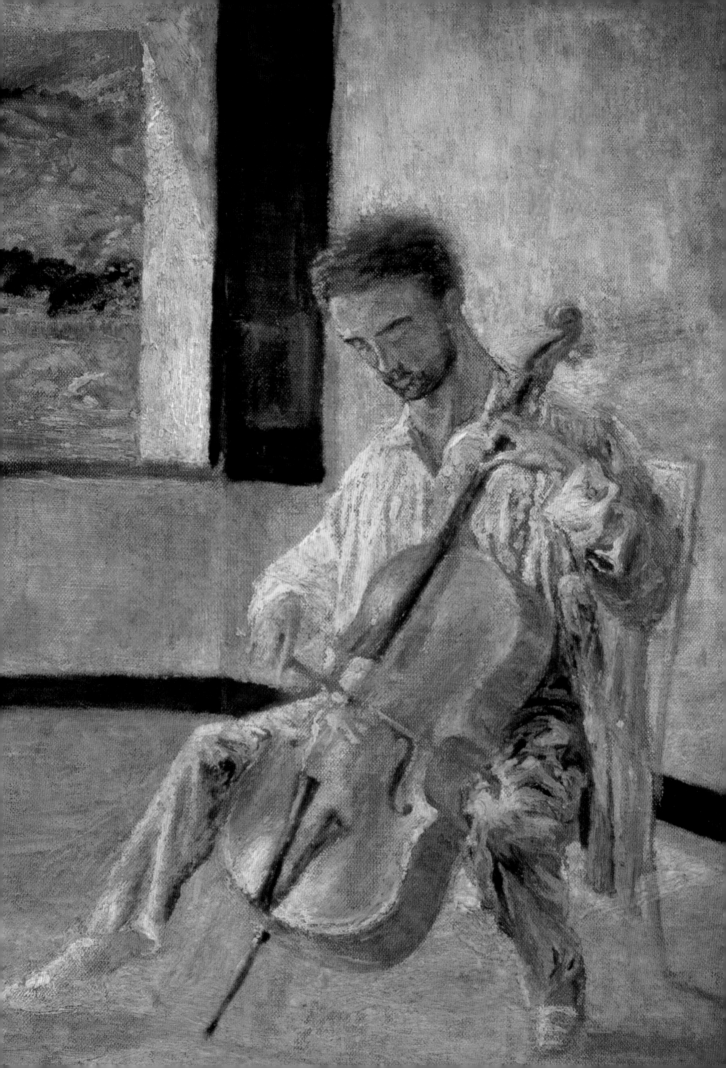

VIEW OF THE CHURCH AND THE ABBEY OF
VILLABERTRAN (c. 1920)

Courtesy of Christie's Images

*T*HIS painting is of the simple village church and the abbey at Villabertran. Villabertran is a small Spanish village that lies to the east of Figueras, the town where Dalí spent his childhood. The village is renowned for the Augustine monastery that was built there in the twelfth century. Although undated, the painting has been signed by Dalí in orange paint, in the bottom right corner. In 1920, Dalí painted another view of Villabertran, that of the lake; this painting shares a similar style with *View of the Church and Abbey of Villabertran*.

The oil in this painting has been intensely and liberally applied, the patterns and strokes of the brush are clearly visible. For the water, downward strokes have been used to insinuate the reflection of the trees that line the bank of the river. Within the trees, the energetic brushmarks give the effect of movement and of dense foliage. The concentrated use of the color orange, seen around the trees and the lake, is reminiscent of the Neo-Impressionist painting, *Portrait of the Cellist, Ricardo Pitchot.* As with *Portrait of the Cellist* (1920) the use of orange gives an illusion of balmy late-summer afternoon light.

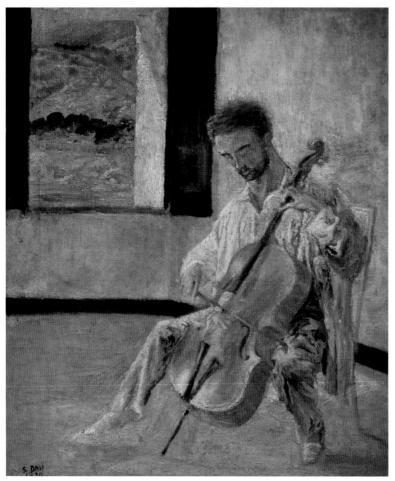

Portrait of the Cellist, Ricardo Pitchot (1920)
Courtesy of AiSA. (See p. 16)

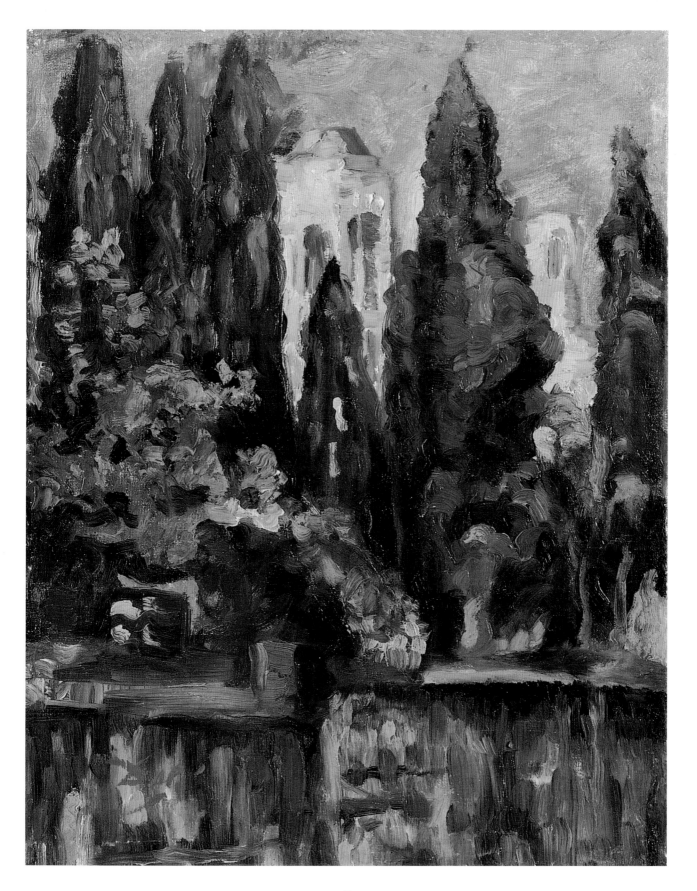

SELF-PORTRAIT WITH RAPHAELESQUE NECK (1921–22)

Courtesy of AiSA

SELF-PORTRAIT *with Raphaelesque Neck* was painted during 1921–22, using oil on canvas. Like the undated *View of the Church and Abbey of Villabertran*, the style of this painting is that of the Neo-Impressionist (or Pointillist) movement, which Dalí was exposed to through the works of Ramon Pitchot, a family friend who greatly encouraged his wish to be an artist. Dalí wrote of Pitchot's paintings that their use of a "systematic juxtaposition of orange and violet produced in me a kind of illusion and sentimental joy like that which I had always experienced in looking at objects through a prism.' In *Self-portrait with Raphaelesque Neck*, Dalí tries to recreate this effect by painting a violet sea to contrast with the orange hills.

Behind Dalí is the fishing village of Cadaqués on the Costa Brava coast where his family spent their summers. Dalí was only aged 17 when he painted this self-portrait. It was the year his mother died from cancer shortly before he was to leave Figueres. These factors could explain the artist's melancholy but defiant, almost angry, expression. He is pale, and his eyes are rimmed with red. The paleness was cultivated; Dalí had taken to wearing his mother's make up to create it.

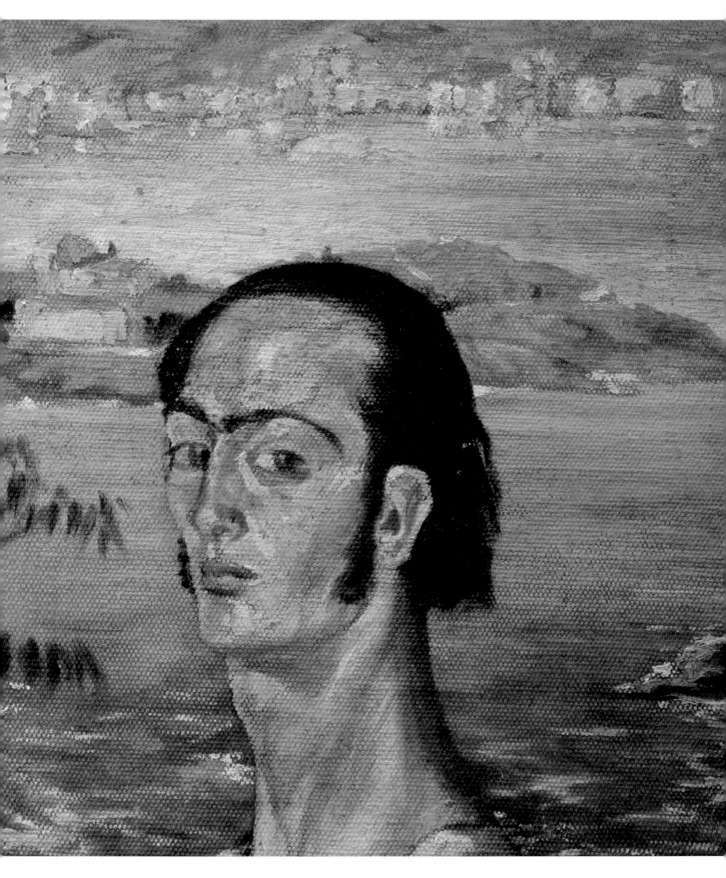

SELF-PORTRAIT WITH L'HUMANITIE (1923)
Courtesy of AiSA

SELF-PORTRAIT *with L'Humanitie* was painted in 1923 while Dalí was at the Madrid Academy of Arts. The title refers to a French Socialist journal *L'Humanitie* to which Dalí subscribed. In the background to the right of Dalí is part of the word "L'Humanitie'; Dalí cut out the title from the front page and pasted it on to the painting, giving a collage effect, to create contrasting textures and formats within the piece.

As with a lot of artists, Dalí did many self-portraits that were reflective of his life at the time of painting them. Here we see an almost featureless Dalí compared to the realistic portrait in the 1921–22 painting, *Self-portrait with Raphaelesque Neck*. Although this featureless depiction is reflective of the Cubist style of painting that Dalí was exploring, it may also be indicative of his feelings about himself, a young man trying to find his own identity. Dalí has included humanity here almost as a way of stating who he is through his reading materials, which were rather exclusive, rather than through his featureless self. Dalí has no mouth in this painting, an image that is repeated in many of his later paintings, personifying loss of control and subsequent fear.

View of the Church and the Abbey of Villabertran (c. 1920)
Courtesy of Christie's Images. (See p. 18)

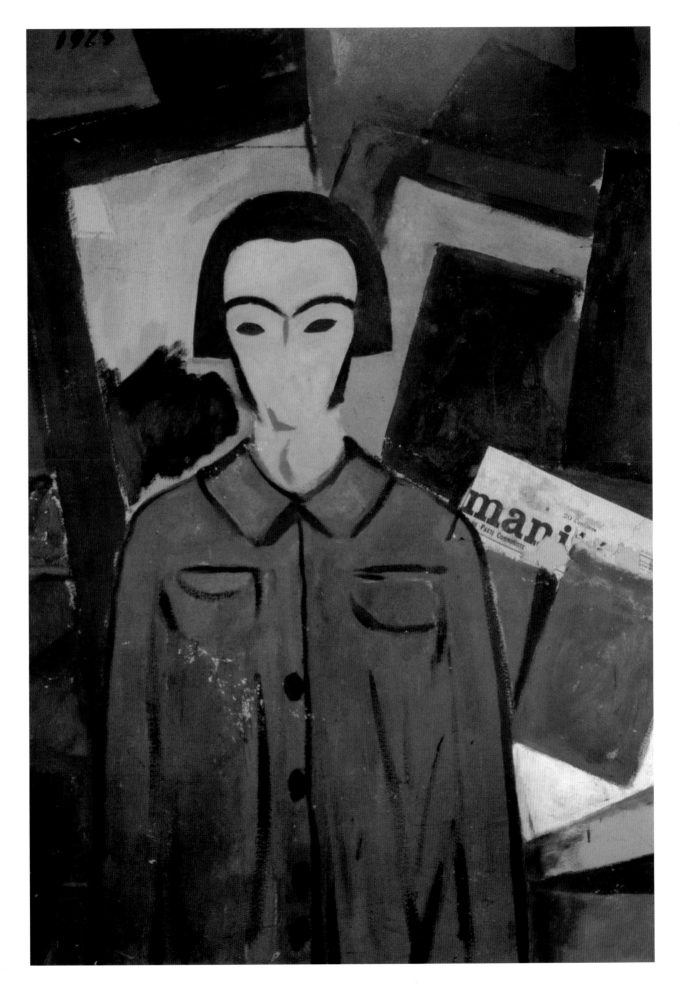

PORTRAIT OF LUIS BUÑUEL (1924)

Courtesy of Giraudon

DALÍ met Luis Buñuel at the Royal Academy of Arts in Madrid, where he studied from 1922 until 1926, when he was finally expelled. Buñuel was one of a circle of intellectual friends that greatly influenced Dalí; among them was Frederico Garcia Lorca, the Spanish poet and playwright to whom the self-portrait opposite was dedicated. Buñuel was to become a Surrealist film maker, completing two films with Dalí: *Un Chien Andalou* in 1929 and *L'Age d'or* in 1930.

Portrait of Luis Buñuel was painted when the sitter was 25 years old. It shows a very solemn and thoughtful-looking man who stares out beyond the painter and viewer to the distance. The palette of the portrait is quite restricted, making use of only a few somber colors—this use of color emphasizes the serious look on the subject's face, helping to give the portrait a grave atmosphere.

The portrait is in a similar

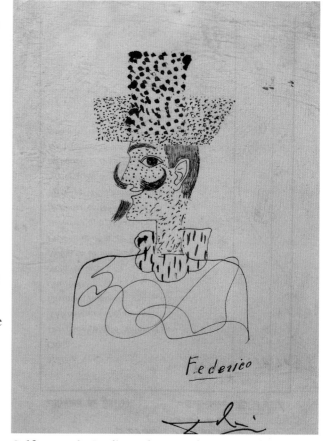

Self-portrait Dedicated to Frederico (undated)
Courtesy of Giraudon. (See p. 26)

style to that of other paintings, sculpture and architecture of this period. A Catalan movement called "Noucentisme," meaning a style of art that returned to the Classical while attempting to bring in something of the contemporary spirit of modern life, was evidently an influence on Dalí.

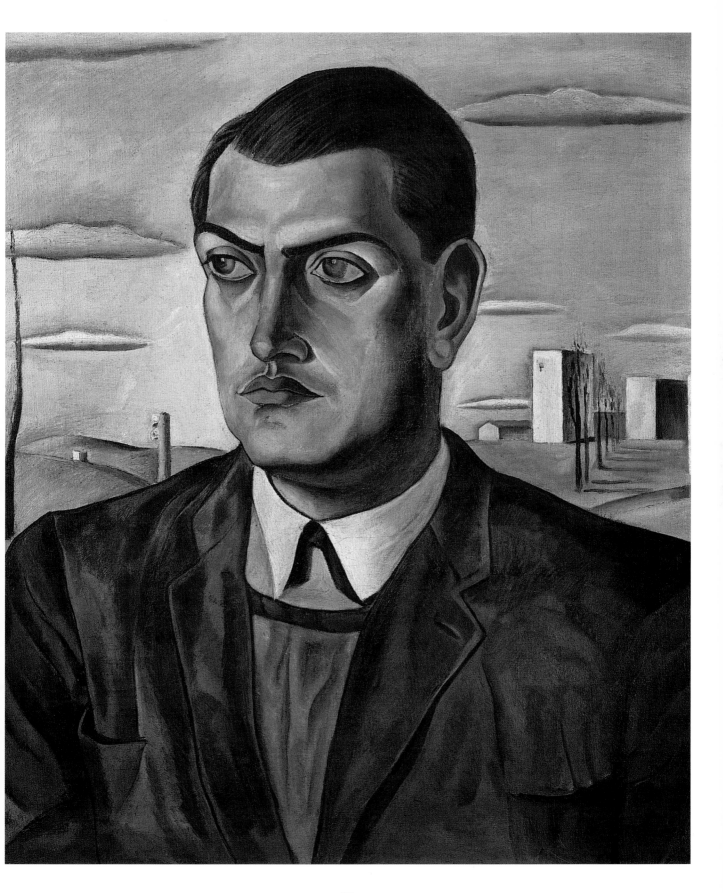

SELF-PORTRAIT DEDICATED TO FREDERICO (UNDATED)

Courtesy of Giraudon

This undated self-portrait in ink is dedicated to Frederico, being Frederico Garcia Lorca, a Spanish poet and playwright who Dalí met at the Madrid Academy of Arts. Dalí and Lorca became very close. Lorca was known to be homosexual but the extent of Dalí's relationship with him has never been entirely clear. There are some references in letters and writing to Lorca's attempts to sodomize Dalí; one incident on a beach near Cadaqués is thought to have contributed to the decline of their relationship as Dalí had an acute fear of sexual contact and was repelled by Lorca's advances.

The self-portrait, although just a sketch, shows a more confident Dalí than was seen in his 1923 painting *Self-portrait with L'Humanitie*. He has grown what would later be his trademark mustache, the ends emphatically turned up. The self-portrait also shows Dalí's new style of dress, he is wearing a fancy hat and a cravat. When he became part of a group of literary and artistic avant-garde students, among whom Lorca was the leader, he began to dress as they did, as a dandy. It was a style that he was to keep, exaggerating it greatly in his later years.

Self-portrait with L'Humanitie (1923)
Courtesy of AiSA. (See p. 22)

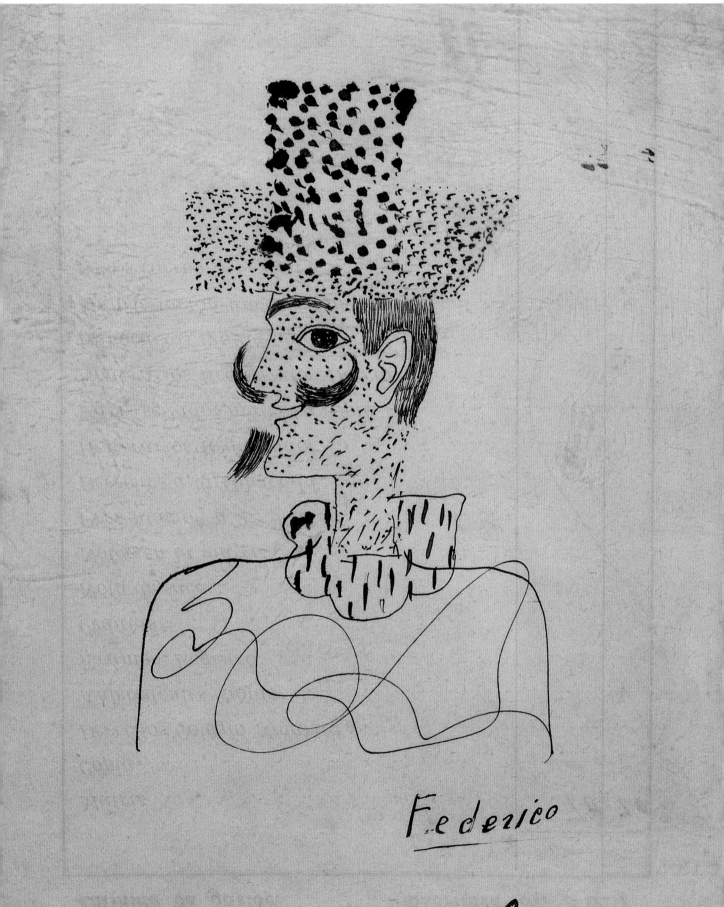

PIERROT PLAYING THE GUITAR (1925)
Courtesy of AiSA

*P*IERROT *Playing the Guitar*, also called *Harlequin with Small Bottle of Rum*, was painted in 1925, using oil on canvas. The painting shows that Dalí was still working in a Cubist style. The piece is an exploration of different, connecting and opposing forms. The palette is subdued, with limited color used, in typical Cubist style, with emphasis on form, not on color.

This work shows an early attempt at visual illusion and double images. At first glance, there appears to be one clown in the picture, but the image is actually two clowns standing one behind the other to create the appearance of just one figure. The pierrot can be seen only in outline, his shape delineated by one bold, jagged line, a technique that Dalí uses in *The Spectral Cow (*1928). Behind the pierrot is a harlequin, who is composed of shadowy blocks that stand out against the pastel background of the wall behind them. The two clowns appear to be a piece of collage; the rectangular shape of their legs has a shadow falling behind it, as if the clowns were made from paper stuck to the room.

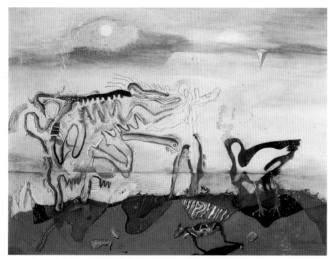

The Spectral Cow (1928)
Museum of Modern Art, Paris. Courtesy of Giraudon. (See p. 46)

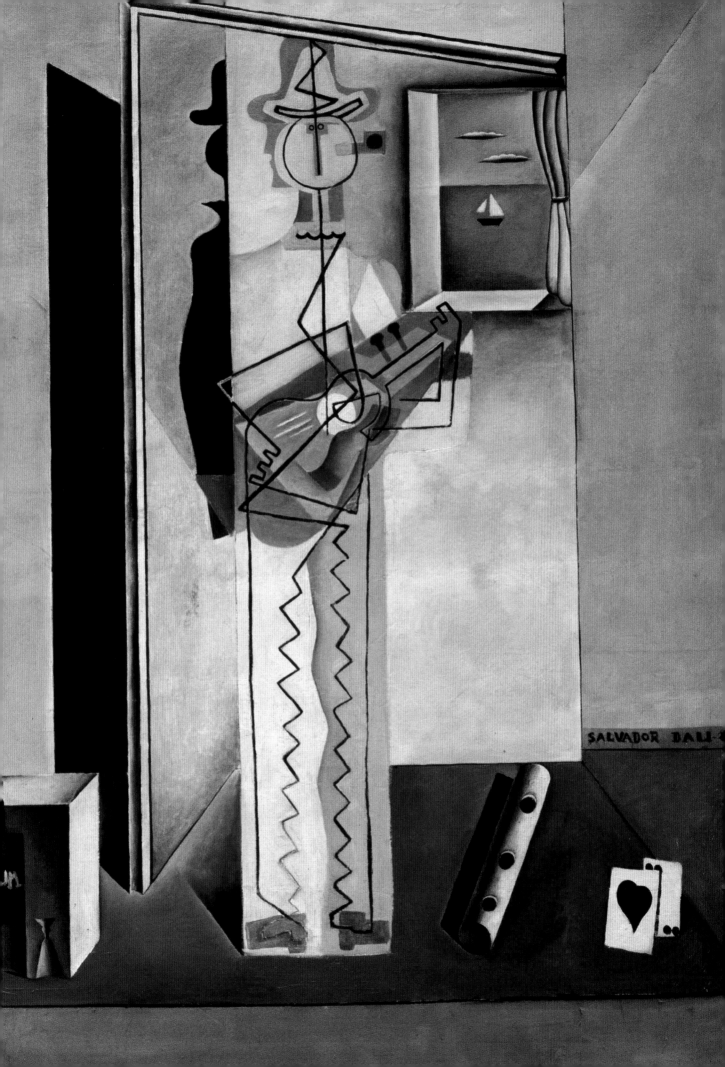

FIGURE STANDING AT A WINDOW (1925)
Courtesy of AiSA

BOTH *Girl Standing at a Window* and *Seated Girl Seen from the Rear* were painted in 1925, using oil on canvas. The model was Ana Maria, Dalí's younger sister and only sibling. For a long time Dalí and Ana Maria were extremely close, especially after their mother's death, when Ana Maria took on the role of mother to the demanding Dalí. Ana Maria was the only female model Dalí used until Gala replaced her in 1929.

In 1949, Ana Maria wrote an autobiography that portrayed a very different view of Dalí to the one he had carefully constructed in his autobiographies; this led to the collapse of their relationship. In revenge for Ana Maria's disloyalty, Dalí painted another version of *Figure Standing at a Window* in 1954 and called it *Young Virgin Autosodomized by her Own Chastity*.

As with *Seated Girl Seen from the Rear*, we can not see the face of the girl and so our focus is drawn to the view that she is looking at from her window. The view is the bay of Cadaqués, a Spanish seaside town where the Dalís spent their summers. The predominant colors of light blues and lavenders give the painting a peaceful feel that is unusual in much of Dalí's work.

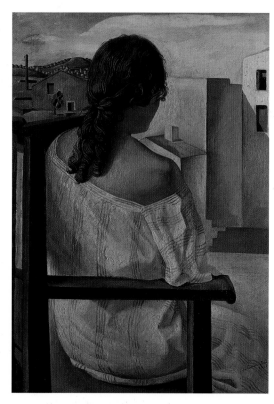

Seated Girl Seen from the Rear (1925)
Courtesy of AiSA. (See p. 32)

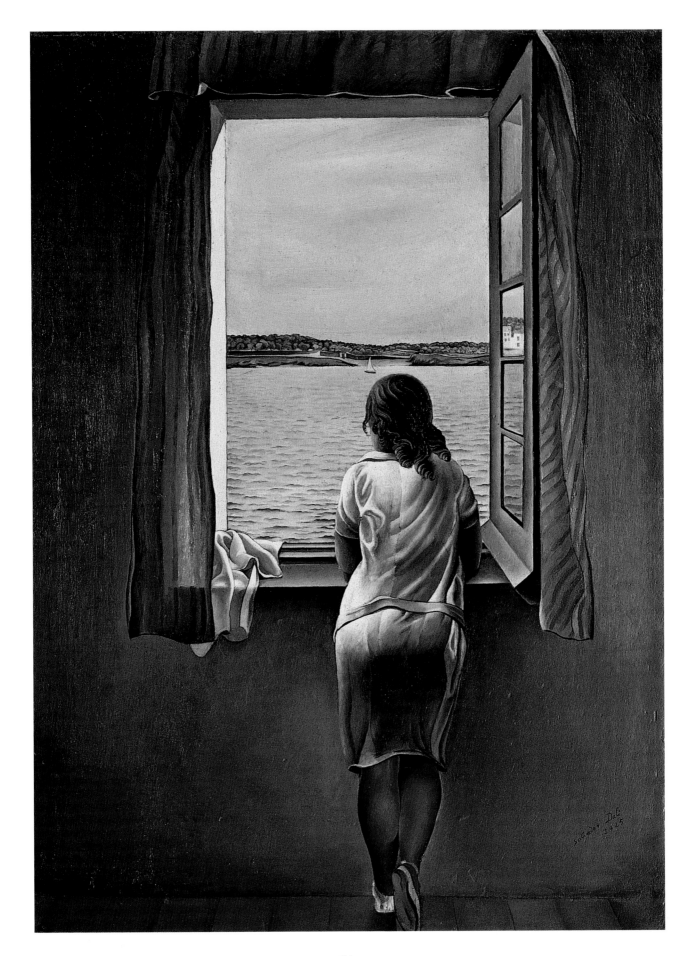

SEATED GIRL SEEN FROM THE REAR (1925)
Courtesy of AiSA

*S*EATED *Girl Seen from the Rear* was painted in 1925, using oil on canvas. The girl in the painting is Ana Maria, Dalí's younger sister. She was also the model for *Woman at the Window at Figueres*. *Seated Girl* was included in Dalí's first solo exhibition at the Dalmau Gallery in Barcelona in 1925, where it was viewed favorably by Pablo Picasso, who Dalí was to meet in Paris the following year.

The painting is almost Classical in style; it is simple and harmonious in content and form, harking back to an earlier period of art that was in revival at the time. As with *Woman at the Window*, Dalí has painted Ana Maria from the rear so that her face is not seen. This viewpoint, while lending the picture an air of intrigue, ensures that the viewer's eye is drawn, like the girl's, to the landscape ahead. The golden-brown of the girl's skin contrasts with the white of the rectangular buildings that stand in the sun ahead of her. The distant hills to the right of the picture repeat the exact color of her skin. The curve of the girl's naked shoulder accents the lines and corners of the buildings.

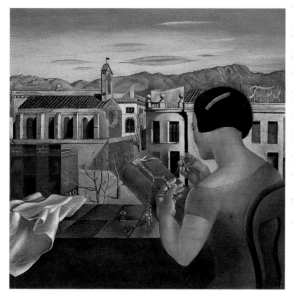

Woman at the Window in Fugueres (c. 1926)
Private Collection, Barcelona. Courtesy of AiSA.
(See p. 38)

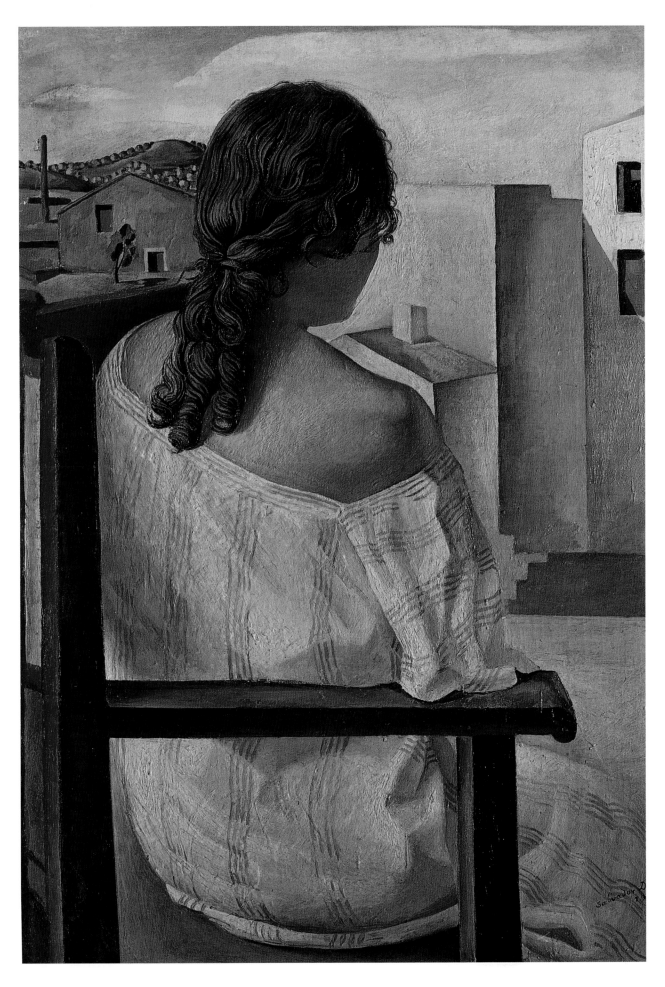

PORTRAIT OF MY FATHER (1925)

Museum of Modern Art, Barcelona. Courtesy of AiSA

*P*ORTRAIT *of my Father* is one of several portraits of his father that Dalí painted in the Twenties. His father was a strict, authoritarian man who tried for many years to control his wayward son before disowning him in 1930. Although years later they were reconciled for a while, their relationship was always a difficult one. Dalí believed his father preferred the son that had died before his birth. Dalí explained that "when he looked at me, he was seeing my double as much as myself. I was in his eyes but half of one person, one being too much".

The palette of the painting is very close to that of the *Portrait of Luis Buñuel*; both paintings are dominated by dark grays, black and shades of brown. The portrait shows Dalí senior seated in casual clothes, with a pipe in his hand. Earlier portraits show him in an official black suit, standing proudly and looking into the distance. These differences indicate that this was meant to be a more personal portrait. Dalí's father stares out with a piercing look. The positioning of his head, so that his eyes are looking sideways, helps to give the impression that he is judging his audience.

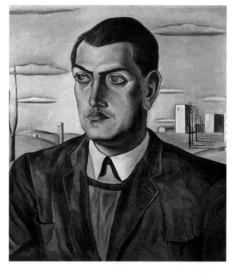

Portrait of Luis Buñuel (1924)
Courtesy of Giraudon. (See p. 24)

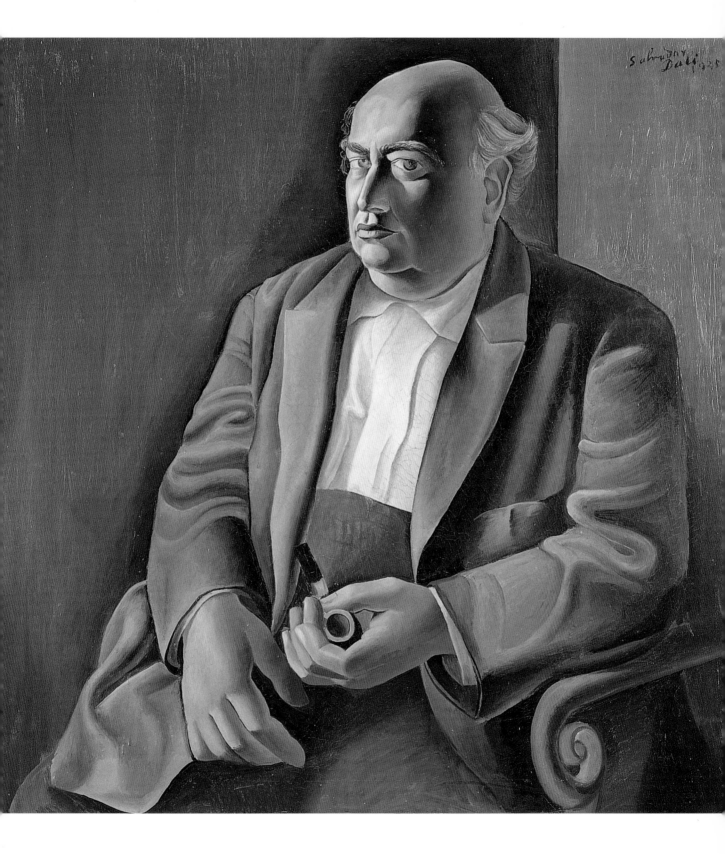

VENUS AND A SAILOR (1925)

Courtesy of AiSA

*T*HIS painting is one of three works that were given the title of *Venus and a Sailor*, all painted in 1925 and shown in Dalí's first solo exhibition at the Dalmau Gallery in Barcelona. The *Venus and the Sailor* (also called *Departure*) shows Dalí to be still exploring his "Neo-Cubist" style, similar to the 1924 painting, *Pierrot Playing the Guitar* (1925). Dalí combined the modern with the old through his choice of subject as well as the manner of the portrayal.

The dominating figure of Venus fills most of the foreground, in true Cubist style she seems large and heavy. She is framed by the window behind her, through which can be seen a boat decorated with flags that is standing ready to leave, (explaining the alternative title of *Departure*). On Venus's lap is a sailor who, because of the awkward position of his limbs, as if wooden, and his diminutive size, appears to be a toy. Venus is puckering her lips to kiss the vague image of a sailor; only his profile is painted. Dalí also used this ghostly quality in *Pierrot Playing the Guitar* to give just an impression of the harlequin.

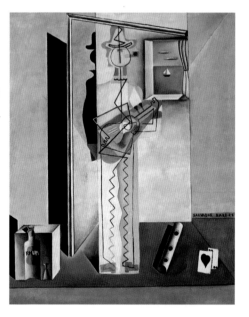

Pierrot Playing the Guitar (1925)
Courtesy of AiSA. (See p. 28)

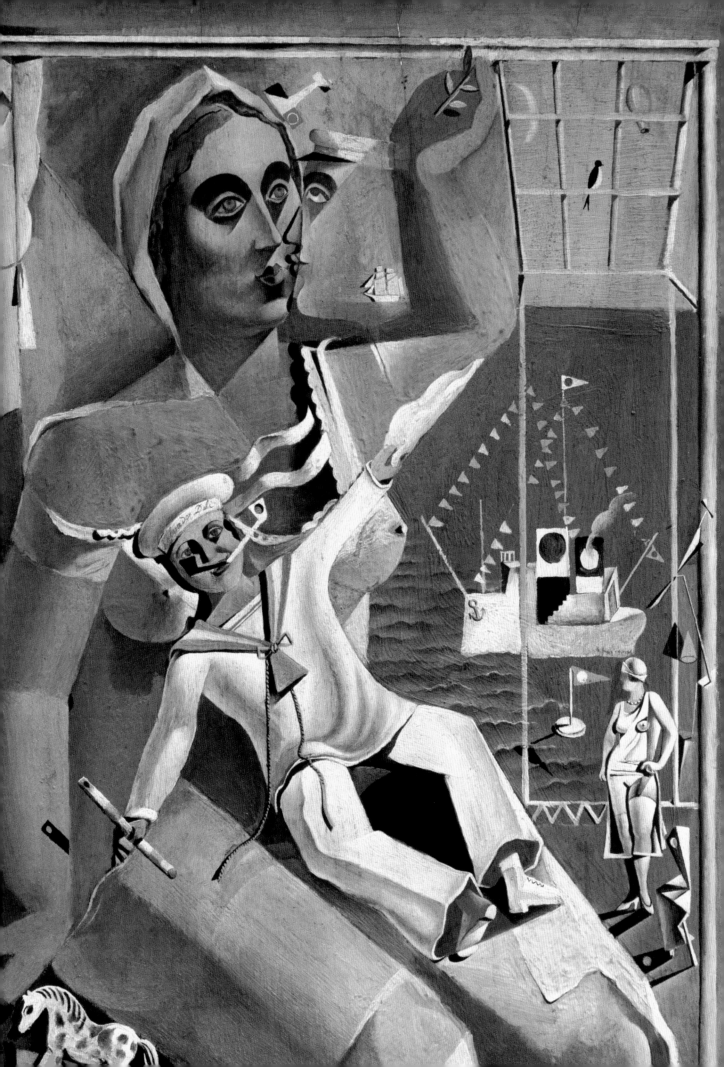

WOMAN AT THE WINDOW IN FIGUERES (c. 1926)

Private Collection, Barcelona. Courtesy of AiSA

ALTHOUGH Dalí did not date the *Woman at the Window in Figueres*, it was probably painted in 1926, as the style, both of the brushwork and the content, are comparable to other paintings of this period. The *Portrait of my Father*, painted a year earlier, shows similar strong lines and structure of form; both figures in these paintings are depicted with a solidity of presence.

The woman in the painting is Ana Maria, as was usual during this period. Due to the subject of the *Woman at the Window*, the painting can be seen as an early attempt by Dalí to re-work *The Lacemaker*. The painting by the seventeenth-century Dutch painter Jan Vermeers, became an obsession with Dalí during the Fifties.

Ana Maria sits sewing on a balcony. As with other paintings of Ana Maria at this time, she is turned away from the viewer so that her face can not be seen. The balcony overlooks the town of Figueres, Dalí's home town. The blue color of the distant mountains and of the sky contrasts with the sunlit stone of the buildings to capture the viewer's eye. This blue is repeated in the shimmering blue-black hair of Ana Maria.

Portrait of My Father (c. 1920)
Museum of Modern Art, Barcelona. Courtesy of AiSA.
(See p. 34)

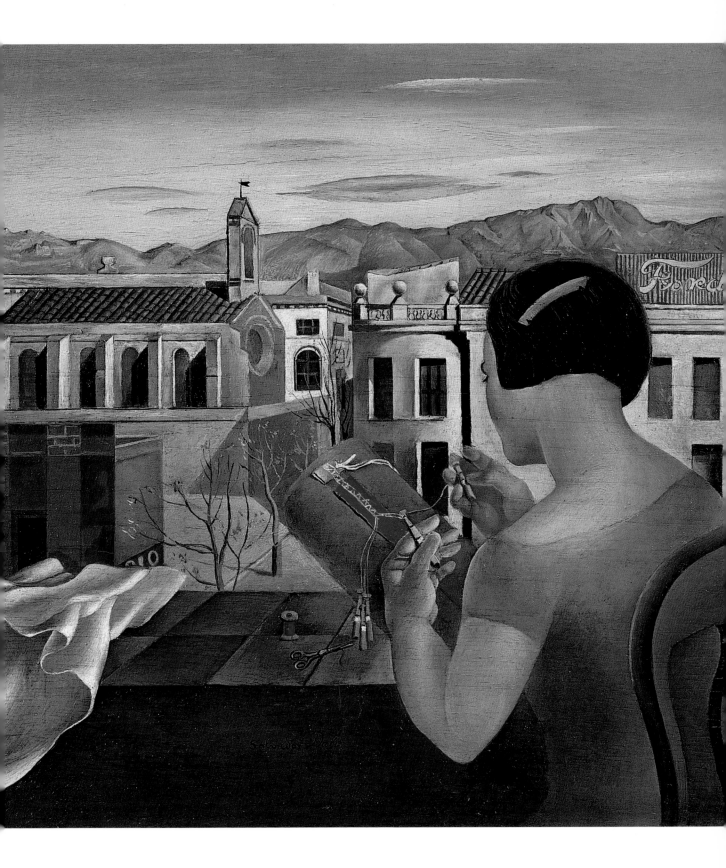

SENICITAS (1927–28)

Courtesy of AiSA

SENICITAS, (also known as *Summer Forces* or *The Birth of Venus*), was painted using oil on panel, during 1927–28, when Dalí was completing his military service. It is one of a series of paintings that mark the emergence of themes and symbols that were to dominate Dalí's work. It also shows Dalí producing a more definite Surrealist style, as does *The Wounded Bird*.

Senicitas is Spanish for "little cinders," referring to the red marks that are attacking the limbless body. The body, though it is more male than female, has no genitals but to the right of it a hand forms the shape of male genitalia. There are also several headless female bodies; one covered in dark veins squeezes her lactating breast. Dalí uses various techniques of depiction here: some images are painted quite realistically, like the female body in the bottom-middle of the painting, while others like the donkey above, appear as a scattered outline only.

The decapitated head of Dalí's friend Lorca appears as if dead, lying on the ground underneath the body. One of their favorite games was for Lorca to pretend he was dead; he could do this quite convincingly for long periods of time.

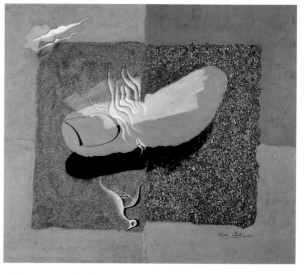

The Wounded Bird (1928)
Courtesy of AiSA. (See p. 42)

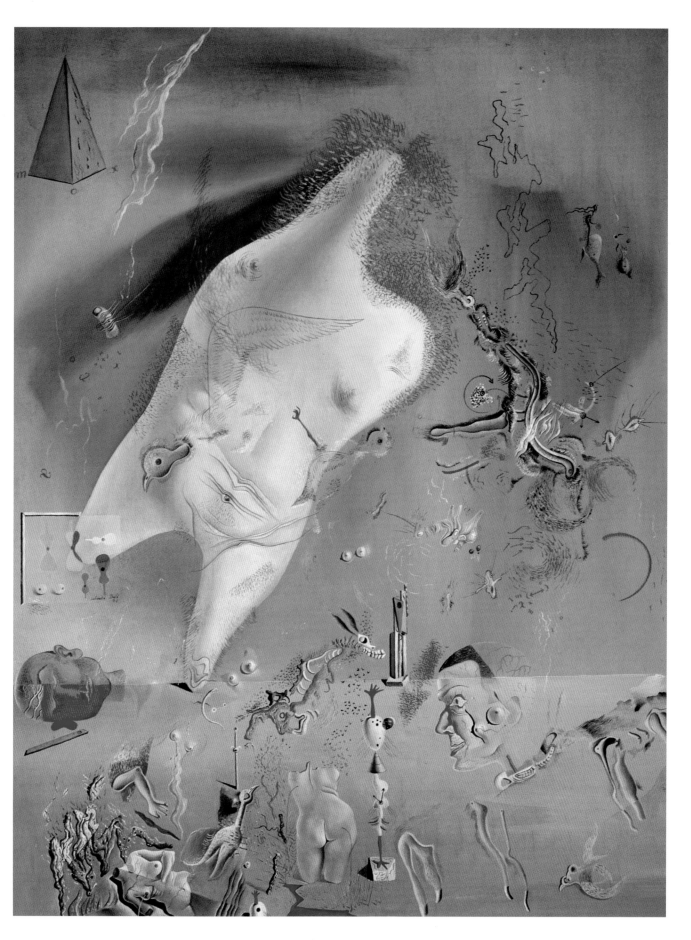

THE WOUNDED BIRD (1928)

Courtesy of AiSA

*T*HE title of *The Wounded Bird* refers to a Surrealist poem by André Breton called *Clair de Terre*. The Surrealist movement had begun as a literary one and poetry was still an important and influential medium for Surrealist artists. Many works of art were inspired by poems and the artists wrote poems, as Dalí did in later years.

The part of *Clair de Terre* that this painting represents was a dream: Breton shot a bird that fell into the sea and transformed into a cow before dying. Dalí also interpreted this dream in his painting *The Spectral Cow*, which was painted in the same year as *The Wounded Bird*. References to Breton's dream can also be seen in *Senicitas*, where there are many ghostly birds with the same simplistic form as the bird in this painting. This is one of several paintings Dalí completed during 1928 which experimented with the use of mediums other than oil. He had always been experimental in his choice of mediums, once finishing a painting using stems from cherries. Here Dalí has used sand; this gives the painted finger a stronger, more striking appearance against the textured sand.

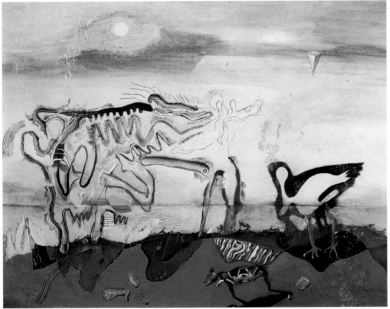

The Spectral Cow (1928)
Museum of Modern Art, Paris. Courtesy of Giraudon. (See p. 46)

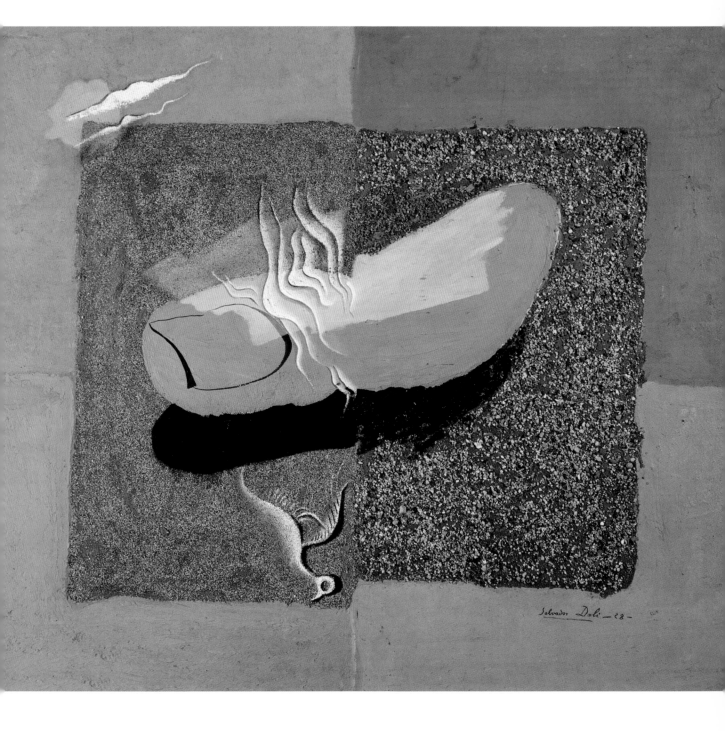

THE UNSATISFIED DESIRE (1928)

Private Collection. Courtesy of Giraudon

*T*HE *Unsatisfied Desire* can be viewed as one of a series that includes *Senicitas*. The two paintings share a brilliant blue background, which Dalí was to adapt for his classic 1929 paintings, including *The Great Masturbator*. They also share the same image of the separated body parts, painted an unnatural pink.

Both *Senicitas* and *The Unsatisfied Desire* share a sexual theme; the theme which was to dominate Dalí's work the following year is now beginning to emerge. Two pink shapes lie opposite each other. The hand on the left portrays both male and female genitalia, in an obvious reference to masturbation (a hand mimicking male genitalia can also be seen in *Senicitas*). On the right of the painting a bodiless pair of open legs lies on the ground, as does the hand, surrounded by real sand and small shells. On the left leg instead of a knee there is a vagina, from which a thin line of red (blood) is spurting. Above the two figures is a line that sketches the shape of a huge bulbous finger, the nail tipped with the same red line that appears from the legs beneath it, implying a fear of castration.

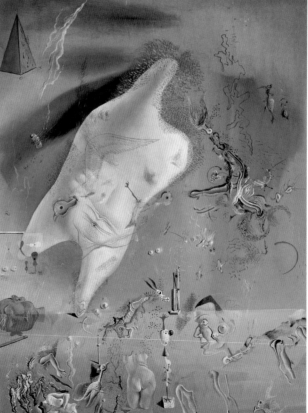

Senicitas (1927–28)
Courtesy of AiSA.
(See p. 42)

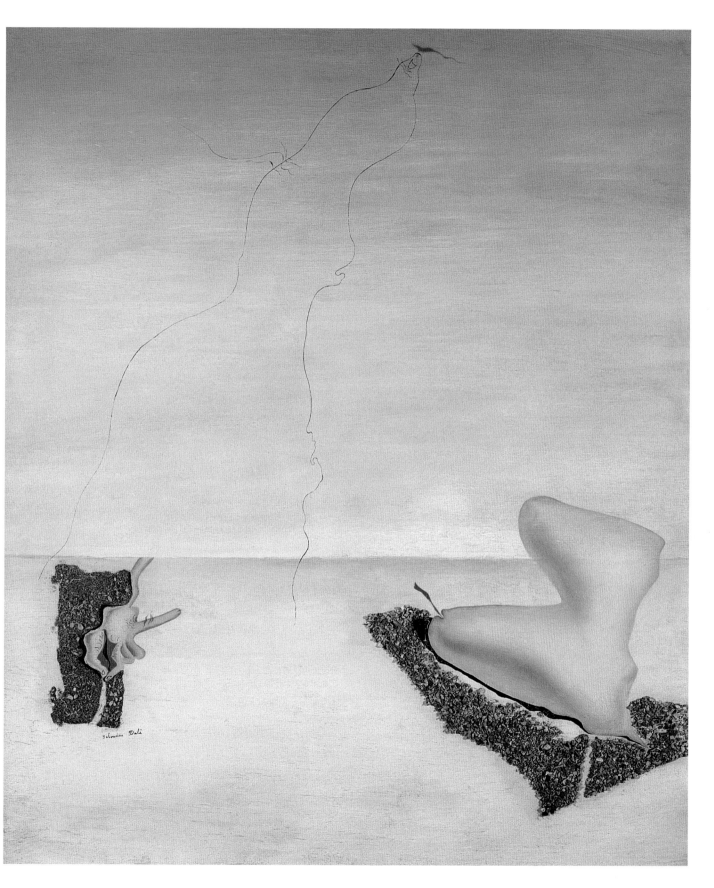

THE SPECTRAL COW (1928)

Museum of Modern Art, Paris. Courtesy of Giraudon

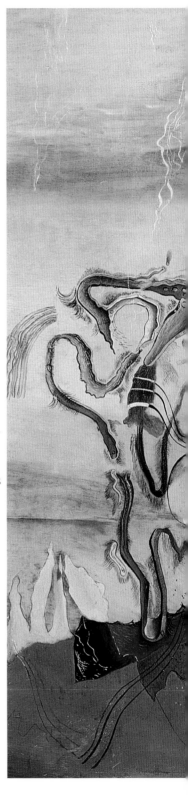

*T*HE *Spectral Cow* was painted using oil on plywood. The painting dates from a period in Dalí's work where his own inimitable style had still not been set and it owes much to other Surrealist artists' work. At the time Dalí was not officially a Surrealist, (he did not actually join the Surrealist group until Gala's intervention a few years later), but this painting together with *The Unsatisfied Desire*, is an indication of the direction that he was now taking.

The aims of Surrealist painting was to portray dreams, the unconscious and the irrational in an effort to shake the viewer's own belief in a fixed reality. Surrealist painters often depicted poetry in their work. Dalí has tried to do this with *The Spectral Cow,* which interprets a dream in André Breton's *Clair de Terre.* The cow in the painting is only hinted at, with its delineation formed by several jagged lines of varying width, color and also of apparent texture. Dalí has "feathered' some lines, while others appear to be made of powder. To the right of the cow stands the ghostly form of a duck, its body formed from the air, like a stencil reversed.

The Unsatisfied Desire (1928)
Private Collection. Courtesy of Giraudon. (See p. 44)

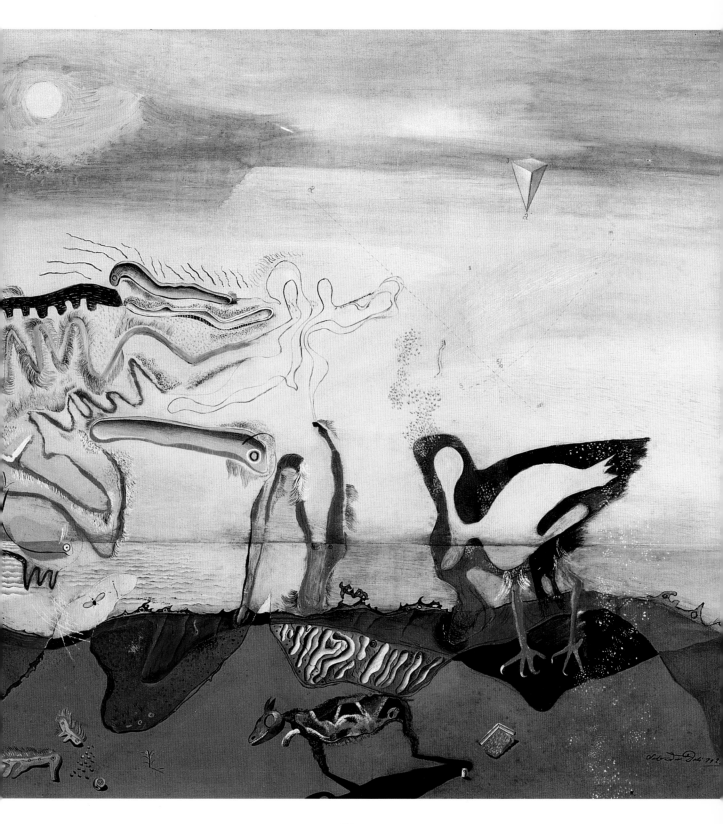

THE GREAT MASTURBATOR (1929)

Private Collection. Courtesy of AiSA

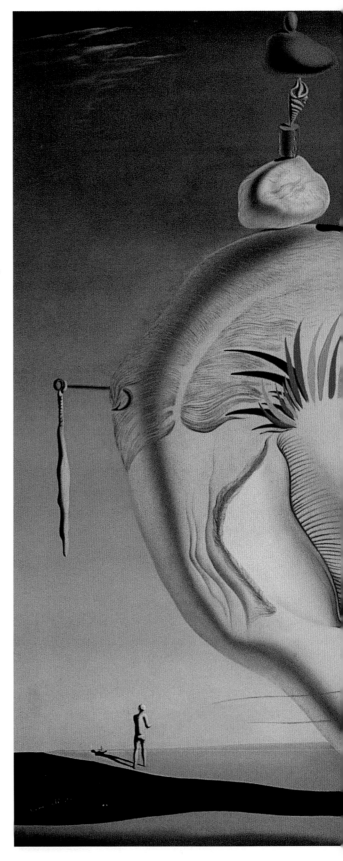

THE *Great Masturbator* is a self-portrait painted in 1929. Dalí's head has the shape of a rock formation near his home and is seen in this form in several paintings dating from 1929. The painting deals with Dalí's fear and loathing of sex. He blamed his negative feelings toward sex as partly a result of reading his father's, extremely graphic book on venereal diseases as a young boy.

The head is painted "soft," as if malleable to the touch; it looks fatigued, sexually spent: the eyes are closed, the cheeks flushed. Under the nose a grasshopper clings, its abdomen covered with ants that crawl onto the face where a mouth should be. From early childhood, Dalí had a phobia of grasshoppers and the appearance of one here suggests his feelings of hysterical fear and a loss of voice or control.

Emerging from the right of the head, a woman moves her mouth toward a man's crotch. The man's legs are cut and bleeding, implying a fear of castration. The woman's face is cracked, as though the image that Dalí's head produces will soon disintegrate. To reiterate the sexual theme, the stamen of a lily and tongue of a lion appear underneath the couple.

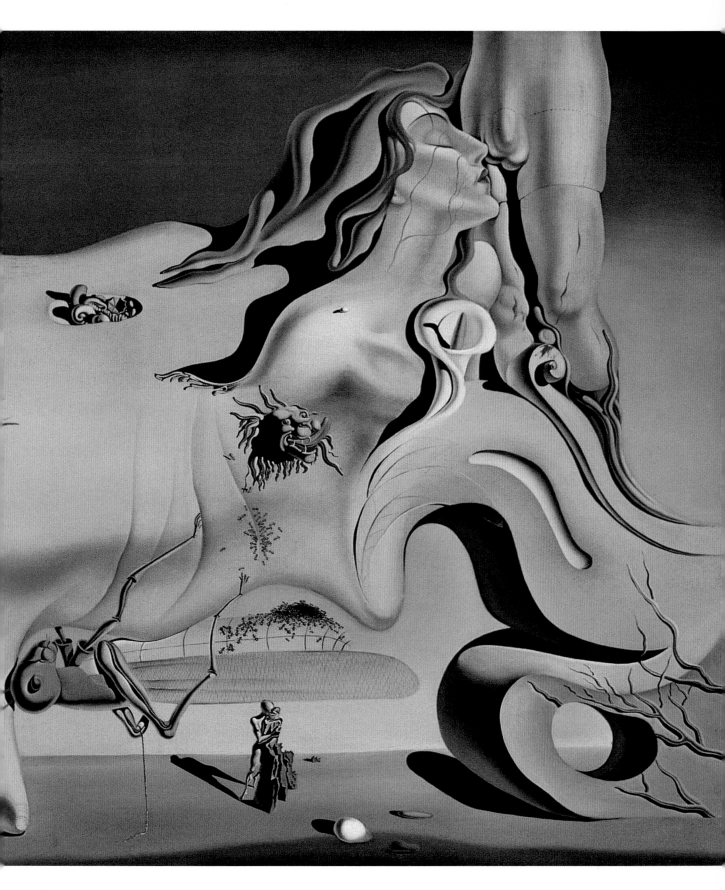

PORTRAIT OF PAUL ELUARD (1929)

Courtesy of Christie's Images

*T*HIS portrait dates from the same year as *The Great Masturbator* and shares the same themes of sexual frustration and fear. Although it is a portrait, the painting tells us more of Dalí's emotional state at this time than that of the subject, Paul Eluard, who was a French poet of the Surrealist movement. Together with his wife Gala, Eluard visited Dalí at Cadaqués during the summer of 1929. Dalí and Gala fell in love, beginning their fifty-year relationship.

The bust of Eluard hovers over a bleak landscape. From the right of his head a lion appears. This features heavily in Dalí's work during

The Great Masturbator (1929)
Private Collection. Courtesy of AiSA. (See p. 48)

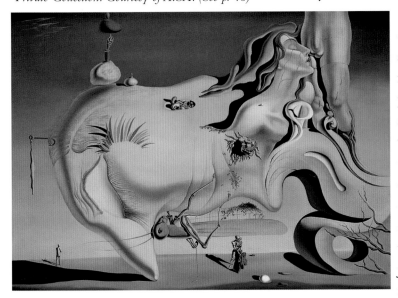

1929–1930—he defined the head as symbolic of his fear of sexual performance with a woman; he was a virgin when he met Gala. The lion's head often appears, as it does here, next to a woman's head which is shaped as a jug. Dalí's Freudian interpretation of the lion leads us to see the jug/woman as a vessel that eagerly waits to be filled; she grins at the lion lasciviously. On the left, Dalí has placed a self-portrait with a grasshopper across his face; to the artist the grasshopper represented hysterical fear and disgust.

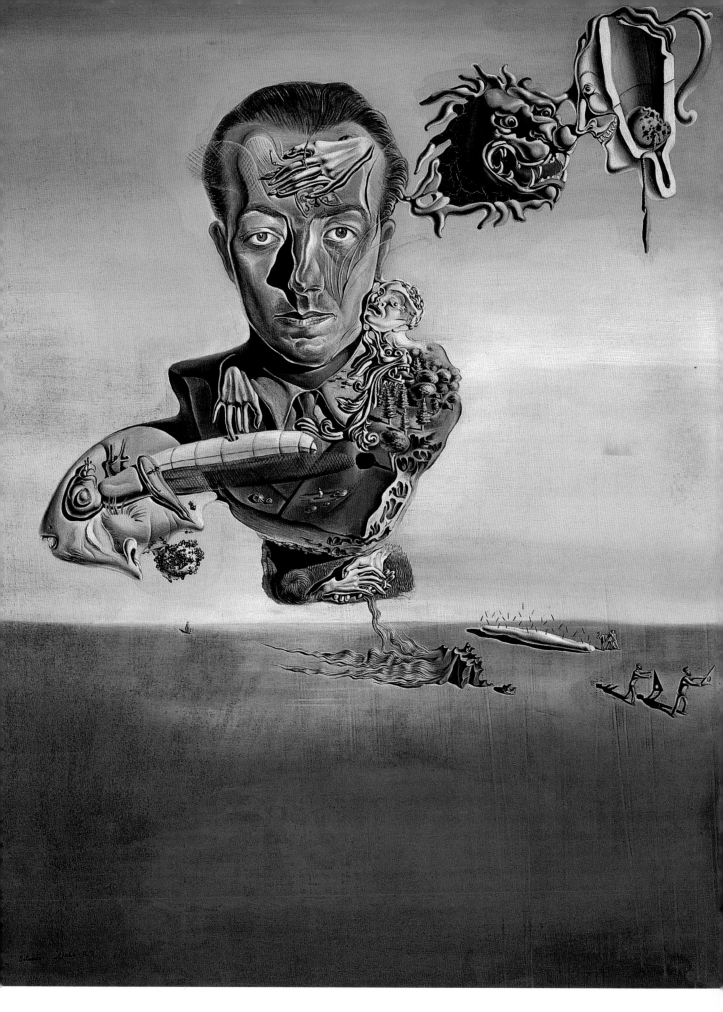

THE ENIGMA OF DESIRE (1929)

Courtesy of Christie's Images

*T*HE *Enigma of Desire—My Mother, My Mother, My Mother* was executed with oil on canvas. Dalí had been extremely close to his mother who died in 1921, when he was just sixteen. The influence of Sigmund Freud's theories on Dalí is made apparent by the dominance of recurring symbols in his paintings during the late Twenties and early Thirties, particularly those from 1929–1930.

As with Paul Eluard's portrait, Dalí has painted the head of a lion that grins with bared teeth. The lion is at the top of an eroded, womblike shape that grows from Dalí's head, which lies spent on the ground. Freud wrote that the appearance of a wild animal, a lion, represented sexual urges that a person was afraid of letting go. Dalí's inclusion of the words "Ma Mère" (my mother) repeatedly along the shape, gives the implication that this painting manifests Dalí's sexual feelings toward his mother.

Among the merged figures in the background is a dagger, a Freudian phallic symbol. The lion appears again, as does the sexually threatening jug/woman and the fearful grasshopper. On Dalí's face there is a dark cluster of ants, his personal symbol of death and decay.

Portrait of Paul Eluard (1929)
Courtesy of Christie's Images. (See p. 50)

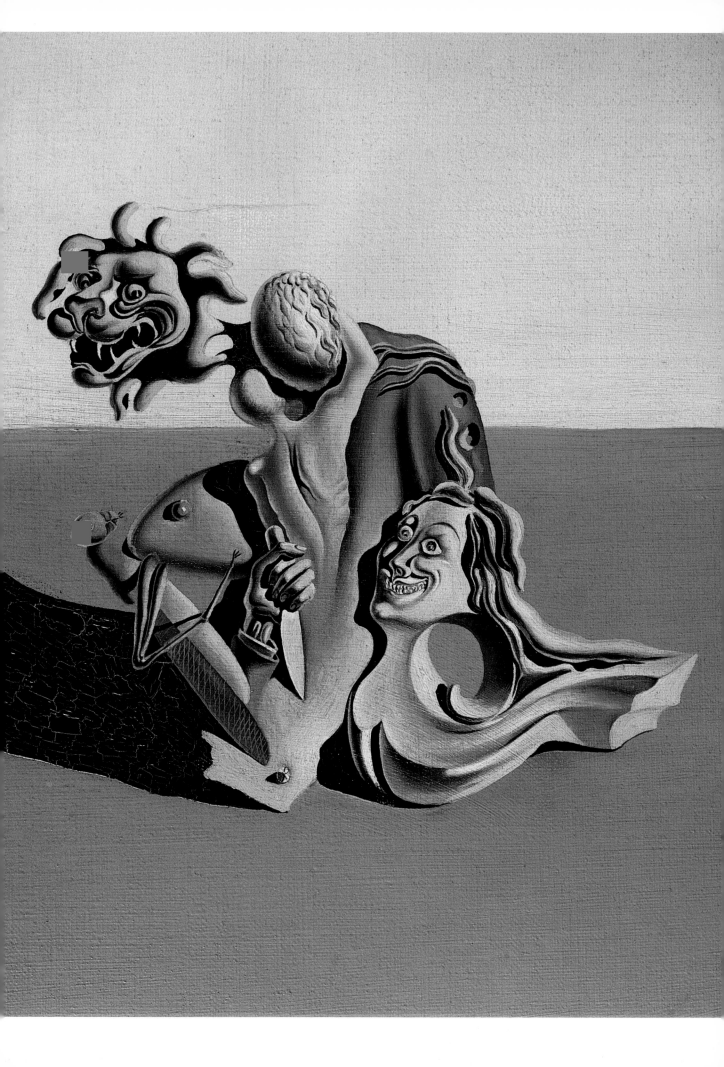

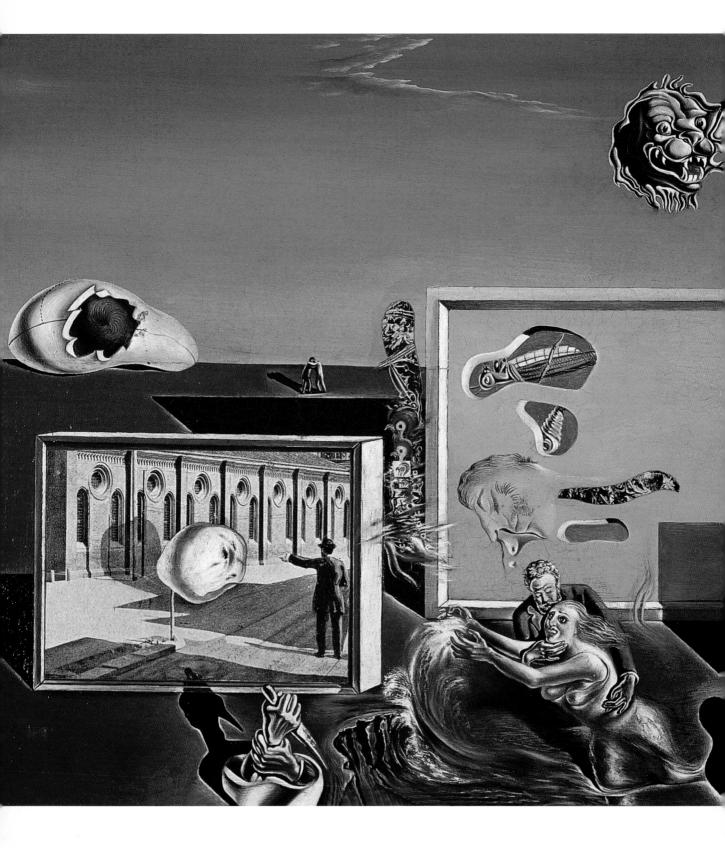

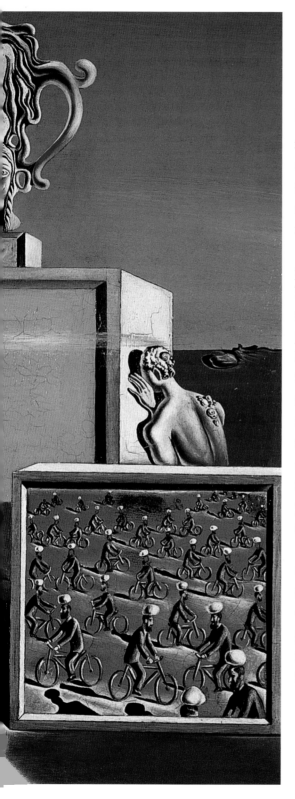

ILLUMINED PLEASURES (1929)

M.O.M.A., New York. Courtesy of Topham

*I*LLUMINED *Pleasures* was created using oil and collage on panel.

The canvas of the painting is small, measuring only 10 in x 14 in (24 x 34.5 cm); its size compared with the mass of detail Dalí has managed to cram into it, clearly reveals Dalí's great talent as a miniaturist painter.

Other Surrealist artists, in both paintings and objects, had made use of boxes. Here Dalí uses them to create scenarios—pictures within the main picture. In the middle box is a self-portrait, like that of *The Great Masturbator*. Blood flows out of the nose and above the head is a grasshopper: both symbolise an hysterical fear. The box to the left shows a man shooting at a rock. This rock can be construed as a head, with blood flowing from the holes. The box to the right has a pattern of men on cycles with sugared almonds placed on their heads.

The painting has a chaotic, frenzied energy; it is filled with violent images. In the foreground, a couple is struggling. The woman's hands are covered in blood as she grasps at a swirl of a blue that emanates from the self-portrait, as if trying to catch the essence of Dalí.

THE ARCHITECTONIC ANGELUS OF MILLET (c. 1929)

Courtesy of Giraudon

*T*HE *Architectonic Angelus of Millet* shows how Dalí used the "paranoia-critical" method, employing Millet's *The Angelus* as the catalyst. Dalí saw a reproduction of *The Angelus* in 1929, not having thought about it since childhood. He had been obsessed with the image as a child, finding parallels between that and two cypress trees that stood outside his classroom. Upon seeing this reproduction, he became very upset and distressed; to discover why he employed psychoanalytical methods. He also began to see *The Angelus* in "visions" in objects around him: once in a lithograph of cherries, once in two stones on a beach. *The Architectonic Angelus of Millet* was based upon this latter "vision".

Unlike *Gala and The Angelus of Millet*, *The Architectonic Angelus* has no reproduction of *The Angelus*. Instead, the Angelus couple are transformed into two huge, white stones that loom over the Catalonian landscape. Dalí pointed out that although the male stone on the left appears to be dominant due to its size, the female stone is the aggressor here, pushing out a part of herself to make physical contact with the male. The often-used image of the young Dalí with his father can be seen sheltering underneath the male stone.

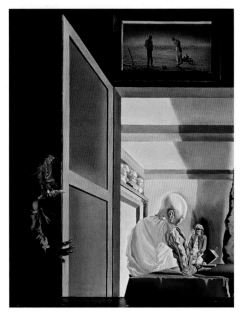

Gala and the Angelus of Millet (1933)
National Gallery of Ottawa. Courtesy of Giraudon. (See p. 88)

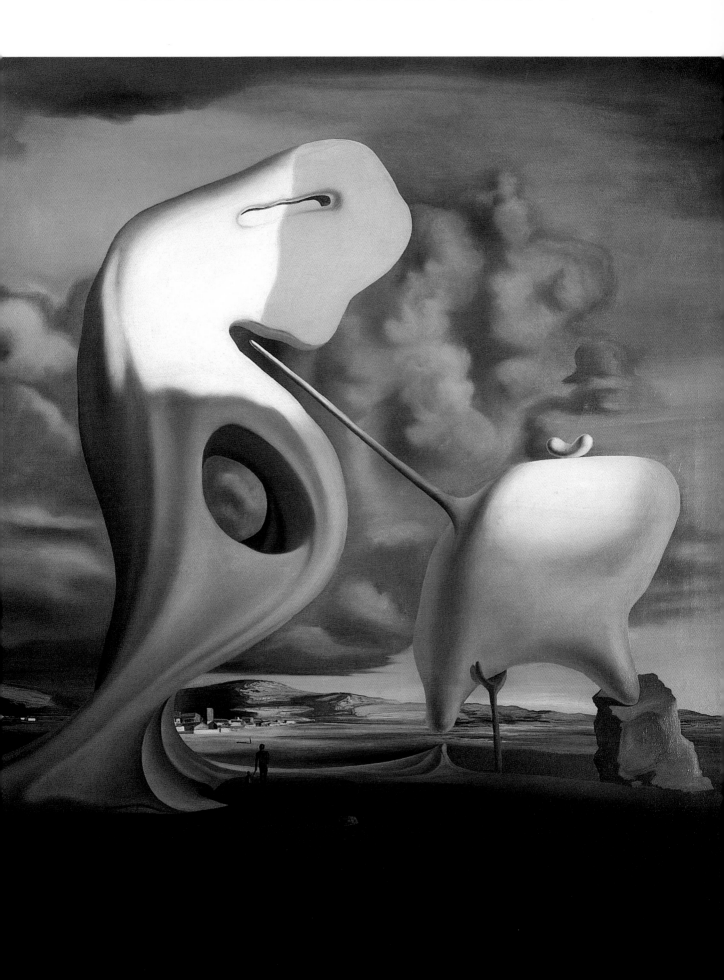

THE INVISIBLE MAN (1929–32)
Courtesy of AiSA

Though begun in 1929, *The Invisible Man* was not completed until 1932. It was the first painting in which Dalí began to use the double images that were to flood his work over the next decade, during his "paranoia-critical' period. The double images used here are not as successful as the later painting, *Swans Reflecting Elephants* (1937). The viewer is aware of the illusions that Dalí is creating before they are aware of what the overall form is meant to be.

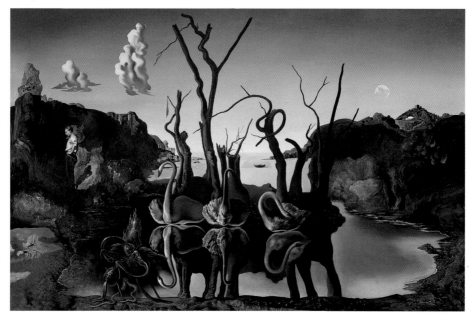

Swans Reflecting Elephants (1937)
Courtesy of Giraudon. (See p. 124)

The yellow clouds become the man's hair; his face and upper torso are formed by ruined architecture that is scattered in the landscape and a waterfall creates the vague outline of his legs. As with almost all Dalí's work in 1929, this painting deals with his fear of sex. The recurring image of the "jug woman' appears on the left of the picture. To the right of her is an object with a womb shape, part of which delineates the right arm of the man. The dark shape outlining the fingers and legs of the man suggests the female form. Beneath the man a wild beast is prowling—another of Dalí's recurring sexual symbols.

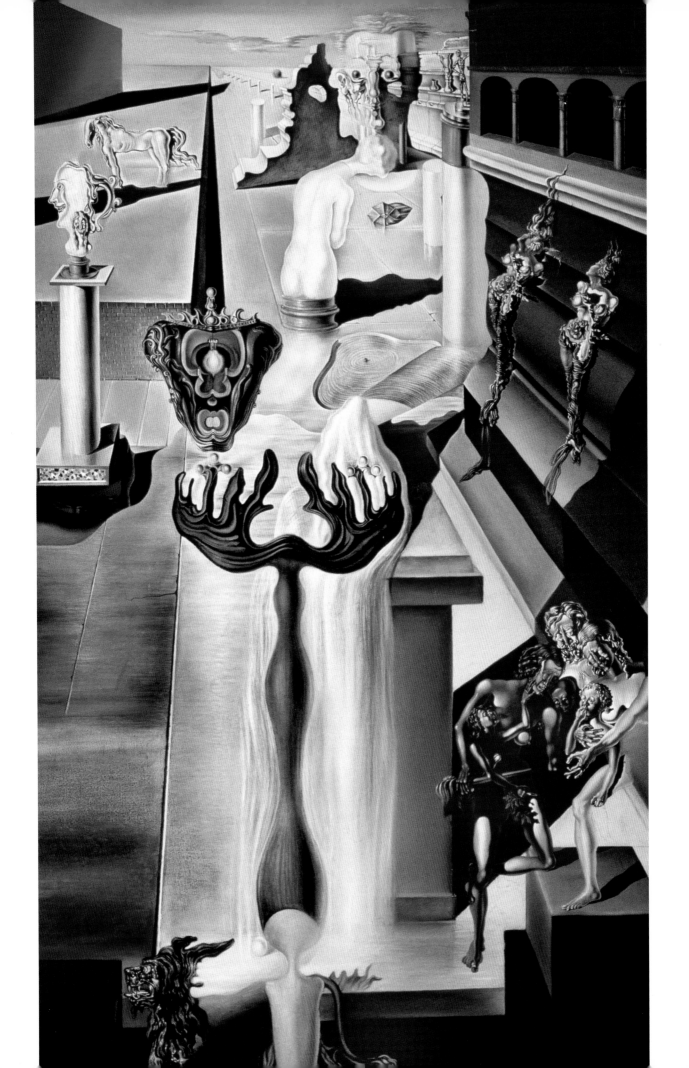

CHOCOLATE (c. 1930)

Courtesy of Christie's Images

FOR Dalí, food was one of the great pleasures of life as well as being a great source for his Surrealist images. For many years, he pushed the image of bread in his paintings and for his own publicity; once arriving in New York with a fifteen-foot loaf. His use of food is related to his view that "beauty will always be edible," reminding us of our temporal nature.

The woman on the right of the picture has evolved from the woman with a jug-shaped head that appeared in several paintings of the time, including *Illumined Pleasures* (1929). The jug-shaped woman symbolized fear of the sex act, as the woman grins lasciviously waiting to be filled. This is a play on the Freudian dream definitions that interpret any vessel or jug as a symbol of the female. In *Chocolate*, Dalí has used this analogy again, but here the woman is shaped like an urn, with her neck and mouth forming the spout. Chocolate is dribbling from her mouth to the cup below her, and some spills down her side to land on the apple beneath. To the left, a figure on bended knee looks up to the woman as if in worship of a queen.

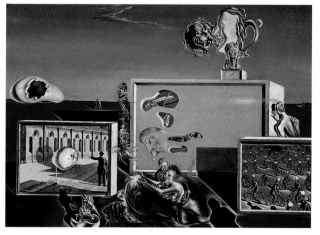

Illumined Pleasures (1929)
M.O.M.A., New York. Courtesy of Topham. *(See p. 55)*

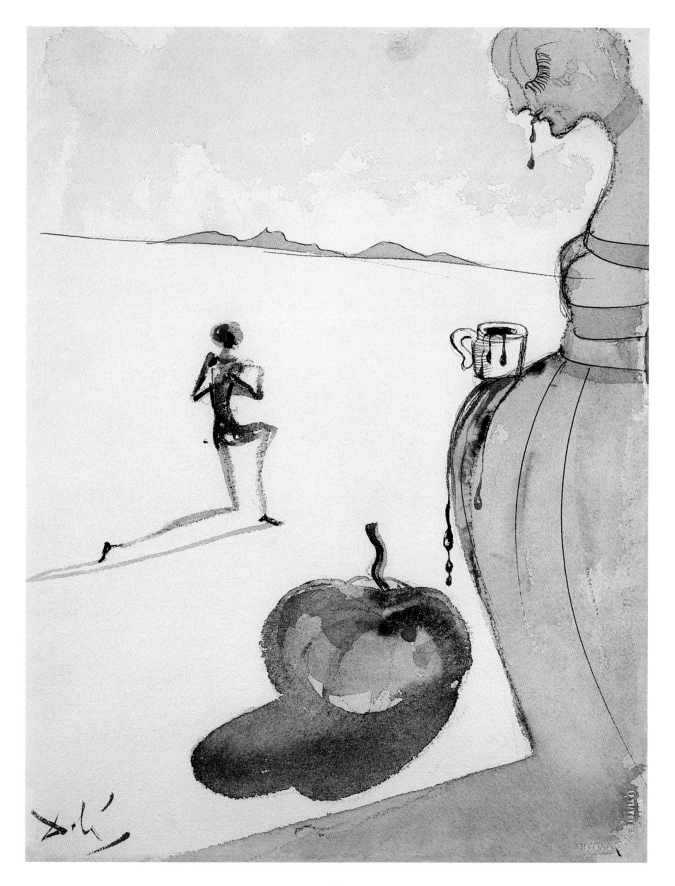

MME. REESE (c. 1931)

Courtesy of Christie's Images

DALÍ painted portraits through most of his career, starting with his family in his earlier years and quickly moving on to paying subjects when he realized the demand that there was for his work. Other members of the Surrealist group criticized Dalí for choosing to paint portraits of paying customers. They saw such work as lowering creative standards, believing that artists should only paint what inspired them, despite a long tradition of portrait painting.

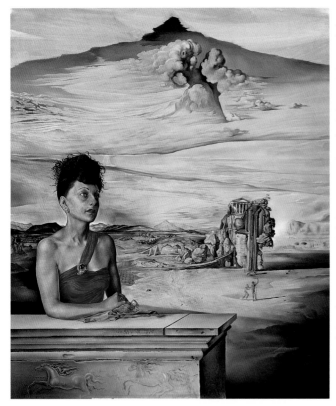

As was often the case for Dalí, this portrait is set against a Catalan landscape of a desert with hills in the far distance. There are other images that are typical of Dalí, such as the domed building without a center and the man sitting on a rearing horse.

Mme. Reese stands against this background, lit up by rays of light from the dense cloud above her. She is dressed up in a ball gown and wearing pearls, suggesting that she is one of the wealthy elite that Dalí often painted. The portrait is conventional, unlike the slightly Surrealist *Portrait of Mrs. Jack Warner*.

Portrait of Mrs. Jack Warner (1945)
Courtesy of Christie's Images. (See p. 162)

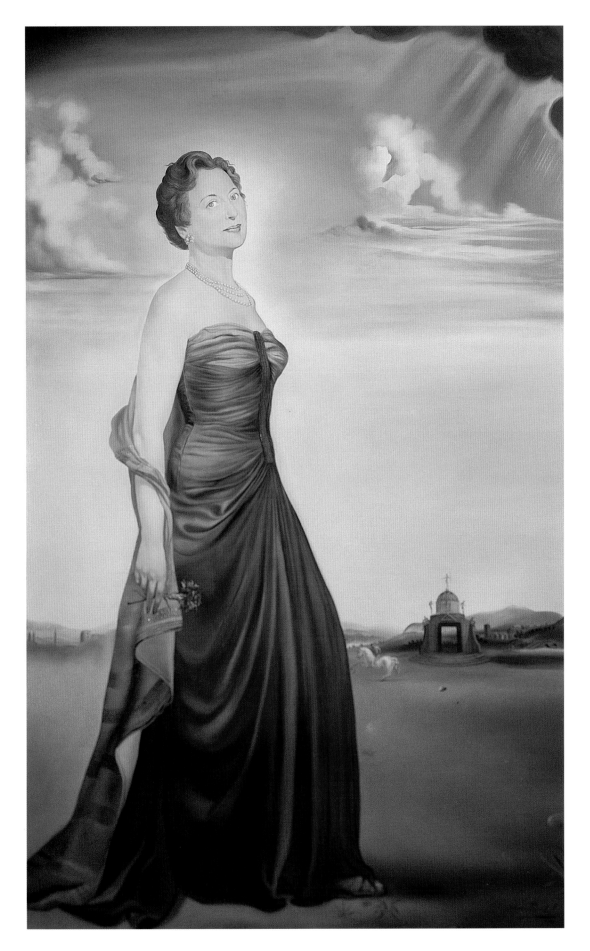

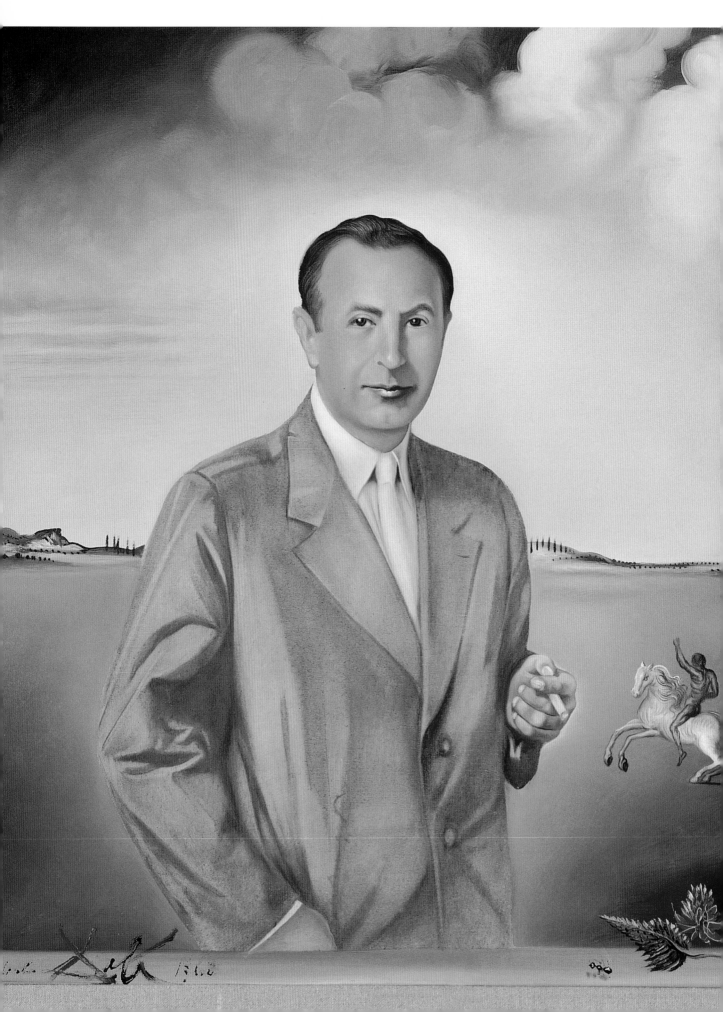

THEY WERE THERE (1931)
Courtesy of Christie's Images

DALÍ had many different ways of signing a painting; sometimes using an emblem or a crown. *They Were There* is signed "Gala Dalí"; he had begun signing his work with both his and Gala's names in 1931. Dalí said that this was because it was mostly with Gala's blood that he painted. The signature on this painting was made with blood-red paint to emphasize this point.

 They Were There is a portrait, though the subject is unknown. The man stands in the foreground staring straight out at the viewer, which was unusual for Dalí's portraits. He appears relaxed with one hand in the pocket of his casual suit, a cigarette in the other hand. The background of the painting is the usual desert, bounded by green hills.

The man on the rearing horse is an image also seen in *Mme. Reese. They Were There* does not show Dalí's usual eye for the miniature details, the trees in the background are basic and little effort seems to have been taken over the clouds either. In both *Mme. Reese* and *They Were There* the brushwork on the people is very smooth; there are no wrinkles or lines, giving an almost plastic quality.

Mme. Reese (c. 1931)
Courtesy of Christie's Images.
(See p. 62)

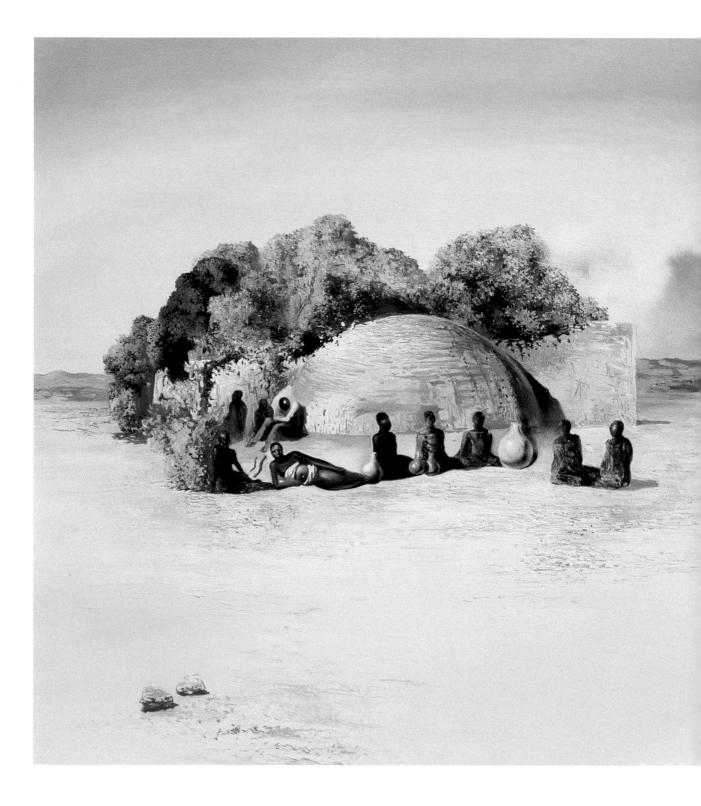

PARANOIAC FACE (c. 1932)

Courtesy of Christie's Images

THIS oil painting is the second version of *Paranoiac Face*. An earlier drawing had previously been published in 1931 in the Surrealist journal *Le Surrealisme au Service de la Revolution*, for which Dalí wrote articles. He produced many new ideas and techniques while with the Surrealist group—probably the major one was his "paranoia-critical" method. Dalí used this method to envisage the double images employed in *Paranoiac Face* and *Invisible Afghan with the Apparition*. Towards the end of the Thirties, he was criticized by André Breton, the leader of the Surrealist movement, for descending to what he termed "puzzle" paintings; their only purpose being for the viewer to decipher the images.

In *Paranoiac Face*, a stone hut forms the face, the trees transform into bushy hair and seated people become the eyes, nose and mouth. The painting was based on a photograph of African villagers. At first sight, Dalí believed that the photo was of a Picasso face, as he had recently studied them. He showed the card to Breton, who thought it

was a picture of the Marquis de Sade, who interested him. Therefore Dalí rationalized that the individual's mind gives an image the desired characteristics; viewers see what they want to see.

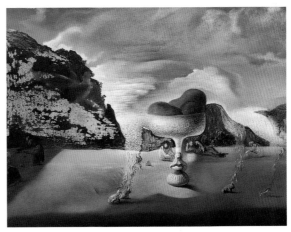

Invisible Afghan with the Apparition on the Beach (1938)
Private Collection. Courtesy of Giraudon. (See p. 130)

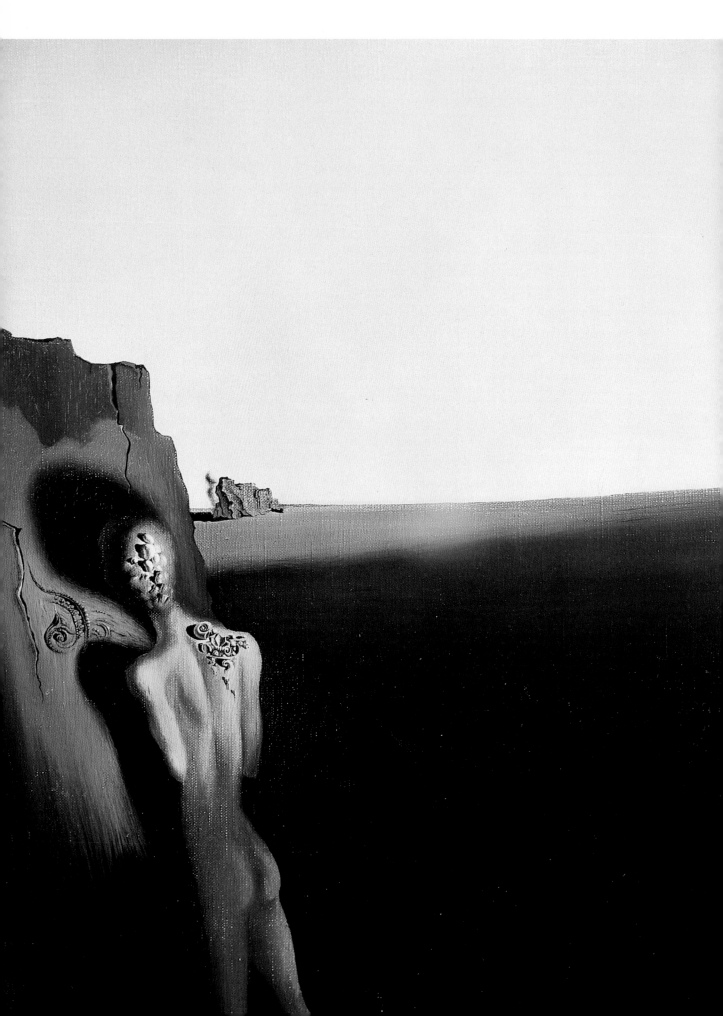

SOLITUDE (1931)

Filipacchi Collection. Courtesy of Giraudon

SOLITUDE (also known as *Anthropomorphic Echo*) was painted in 1931, using oil on canvas. To Dalí, solitude was a precious thing. He spent long hours on his own and this isolation was important to his creative process. Before he and Gala were intimately involved, Dalí had had impulses to throw her off the high cliffs they walked along. Dalí explained this as due to his fear of her love. He saw Gala as a threat to his very self; "she too had come to destroy and annihilate my solitude'.

The landscape within *Solitude* is bleak; the sky almost colorless and the land is darkened by shadow. On the left of the painting, leaning against a rock is a lean, naked man.

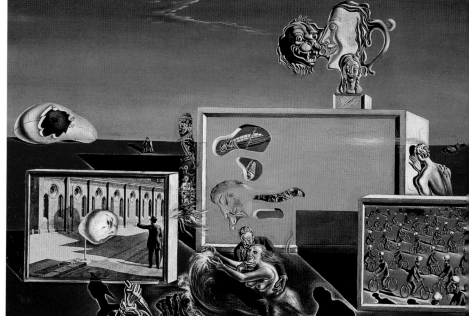

Illumined Pleasures (1929)
M.O.M.A., New York. Courtesy of Topham. (See p. 55)

The man's head seems made from the rock itself, inside there are several egg-shaped stones. On the right shoulder of the man is a hole in the flesh out of which shells and fossils spill; Dalí had a fascination with crustaceans because of their built-in ability to protect their own vulnerable, soft inner selves. This visual rendering of solitude also appears, in the same posture, in the 1929 painting *Illumined Pleasures*, next to a self-portrait.

THE PERSISTENCE OF MEMORY (1931)

M.O.M.A., New York. Courtesy of Topham

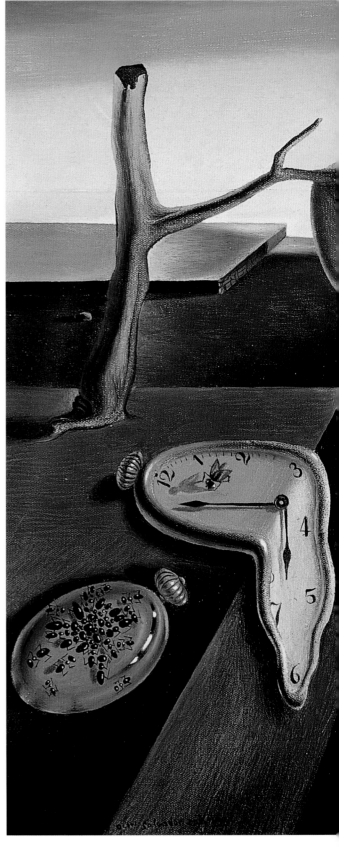

THE *Persistence of Memory* is one of Dalí's most popular paintings. It includes the first appearance of what is perhaps his most enduring image: the "soft watch." The "soft watch" acts as a metaphor for the ephemeral nature of mankind, our inevitable decay and our subsequent obsession with the nature of time set against us.

Set in a realistic landscape, a "soft" self-portrait of Dalí lies melting on to the rocks beneath it. Dalí uses the rocks and strange blocks as "hard" contrasts to the softness of the watches and the head. One watch droops over the side of a block to emphasize this difference in their substances. Another watch hangs from the branch of a dead tree, while across Dalí is another; he too has been conquered by time.

In his autobiography, Dalí explains the image of soft watches came to him after contemplating the "super-softness" of Camembert cheese. Dalí writes that Gala (whom he always painted "hard") protected him from the harshness of reality so that while "to the outside world I assumed more and more the appearance of a fortress, within myself I could continue to grow old in the soft, and in the supersoft".

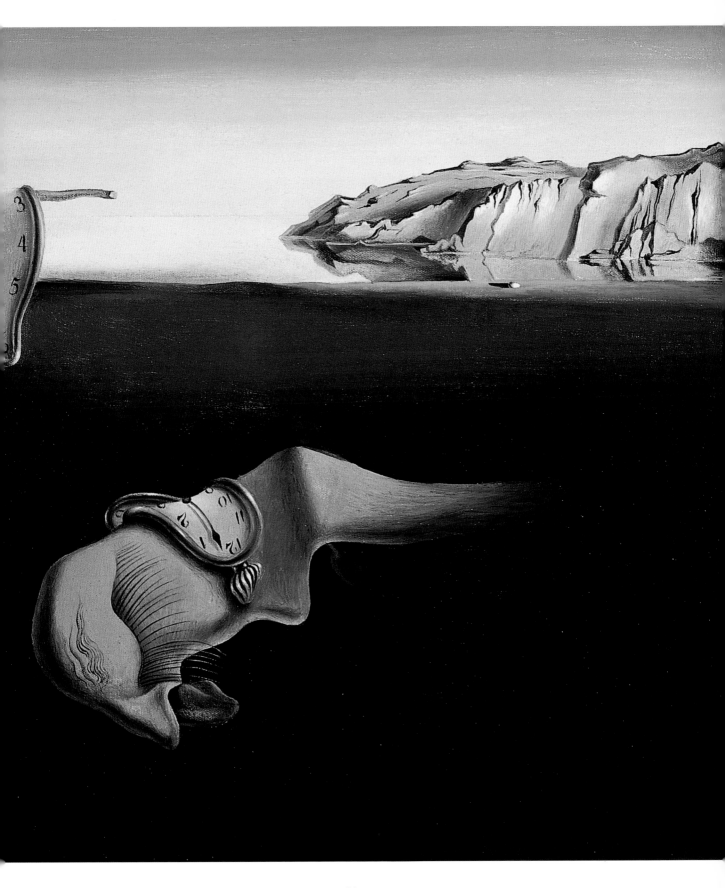

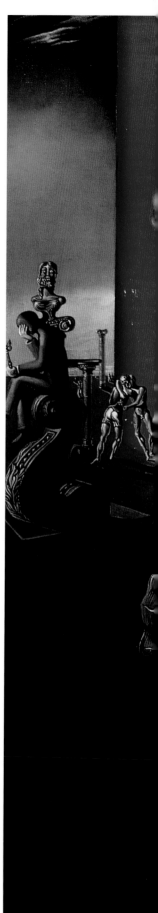

THE DREAM (1931)

Courtesy of Giraudon

BY the Thirties, Surrealist painting had moved toward the arena of dreams for inspiration and relied less on the ideas of automatism that had marked the beginning of the movement. *The Dream* was painted in 1931 but the main image, the woman's head, had first appeared the year before in *The Fountain*, where, although in the background, it was a striking and dominant feature. Dalí found the inspiration for the woman from a scene on a box and a monument in Barcelona.

In the foreground of this dark painting is the bust of a woman, painted in dull, metallic grays, her hair floating above her as if frozen in movement. The colors used and her apparent immobility bring to mind the Classical myth of Medusa. The woman has no mouth and her eyes also appear sealed shut, like those of the giant head in *Sleep*. The absence of a mouth, together with the seeming immobility of the woman implies a loss of control, of paralysis. Ants crawl across the face in the place where a mouth should be. As a child, Dalí had found a pet bat crawling with ants and so, for him, they became symbols of death and decay.

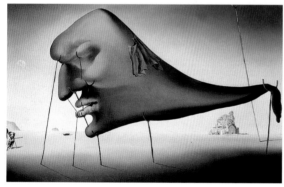

Sleep (1937)
Courtesy of Christie's Images. (See p. 123)

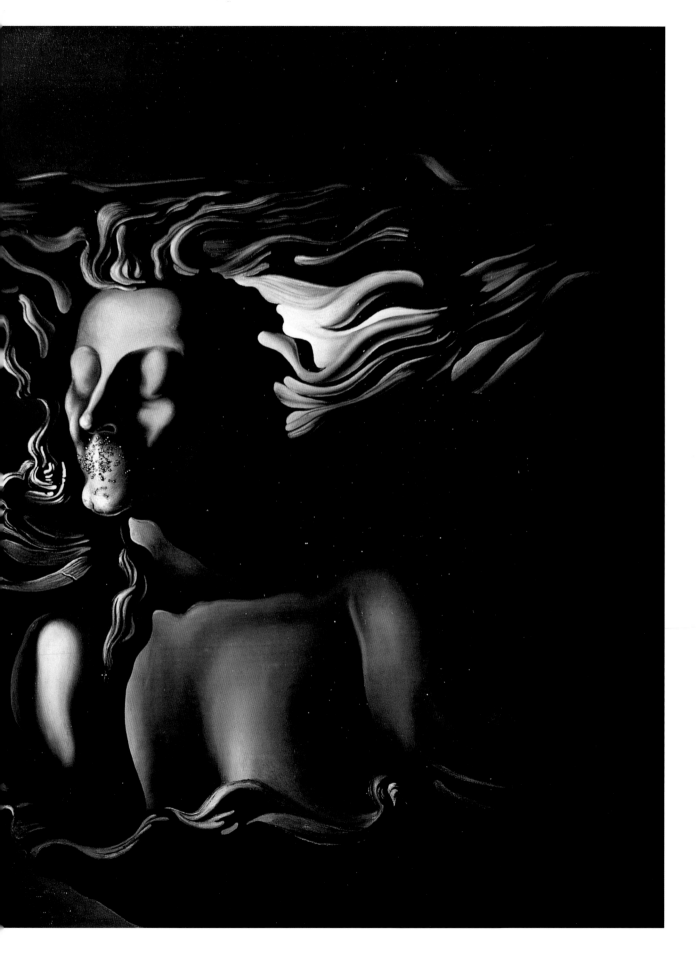

GRADIVA FINDS THE RUINS OF ANTHROPOMORPHIS (1931)

Courtesy of Giraudon

GRADIVA Finds the Ruins of Anthropomorphis was painted in 1931, using oil on canvas. The paining was based on a German story, analyzed by Freud, of an archeologist who falls in love with Gradiva, a girl he sees in a Greek stone relief. He later finds his true love, who is the reincarnation of Gradiva. The Surrealists took this myth for their own. For them, Gradiva meant "she who advances," a woman who would lead to self-discovery. To Dalí, Gradiva was Gala, the realization of his fictional past loves and his muse.

In *Gradiva Finds the Ruins*, Dalí plays with the story of Gradiva. Set against a flat, dark landscape, she is in the foreground with her arms wrapped around a human shape that is made from stone, (Anthropomorphis). Parts of the figure are cracked and there are holes where the face, heart and genitals should be, implying that this creature is without any of the parts that constitute a human. The form of Anthropomorphis is similar to that of a figure, which can be interpreted as Dalí, in the painting *Solitude* (1931). The figure has a Dalínian inkwell on his shoulder and as Gradiva appears as Gala, the implication here is that Dalí is Anthropomorphis.

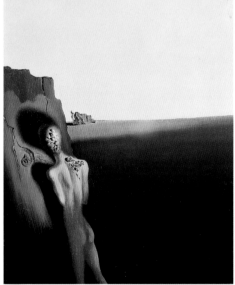

Solitude (1931)
Filipacchi Collection. Courtesy of Giraudon.
(See p. 69)

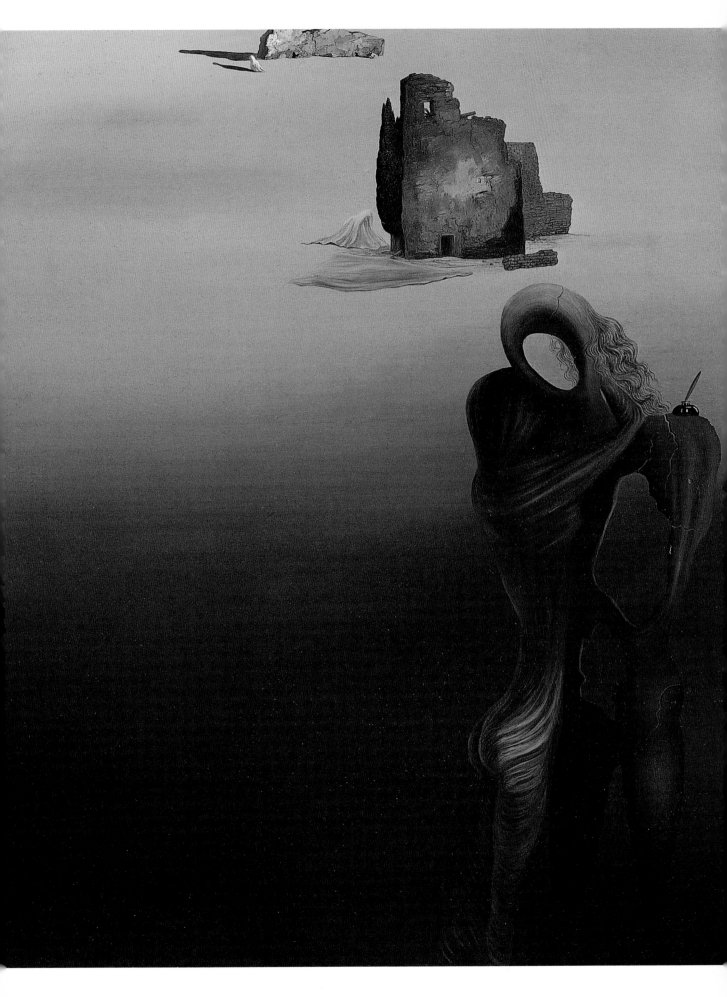

THE DREAM APPROACHES (1932)

Courtesy of Christie's Images

*T*HE *Dream Approaches* was painted in 1932, using oil on canvas. The painting has the haunting atmosphere of a dream, aided by a luminescent pre-dawn sky. In the foreground of the painting is a potentially coffin-shaped form, over which white material is draped. On the right side of this block is a large cocoon shape, its opening suggesting the female genitalia. Standing on the sandy beach is a naked man, Classical in form as well as stance, with one hand raised and his hips tilted. The brushwork on his body creates the illusion that dark flames are swirling along his back.

On the right, next to two trees that are still half in darkness, is a tall tower with one solitary window at the top. The tower seems like a ruin as the plaster is falling away and there are cracks along it. Amongst

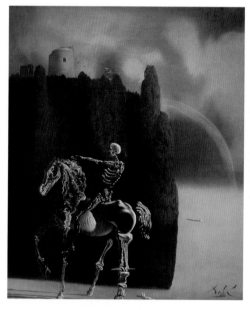

other paintings, this tower can also be seen in *The Horseman of Death* (1934). Towers appear in Dalí's work as a symbol of desire and death. In his autobiographical writings, Dalí explained this as owing to his childhood memories of a mill tower, where he had felt both sexual and violent urges toward a girl.

The Horseman of Death (1934)
Courtesy of AiSA. (See p. 94)

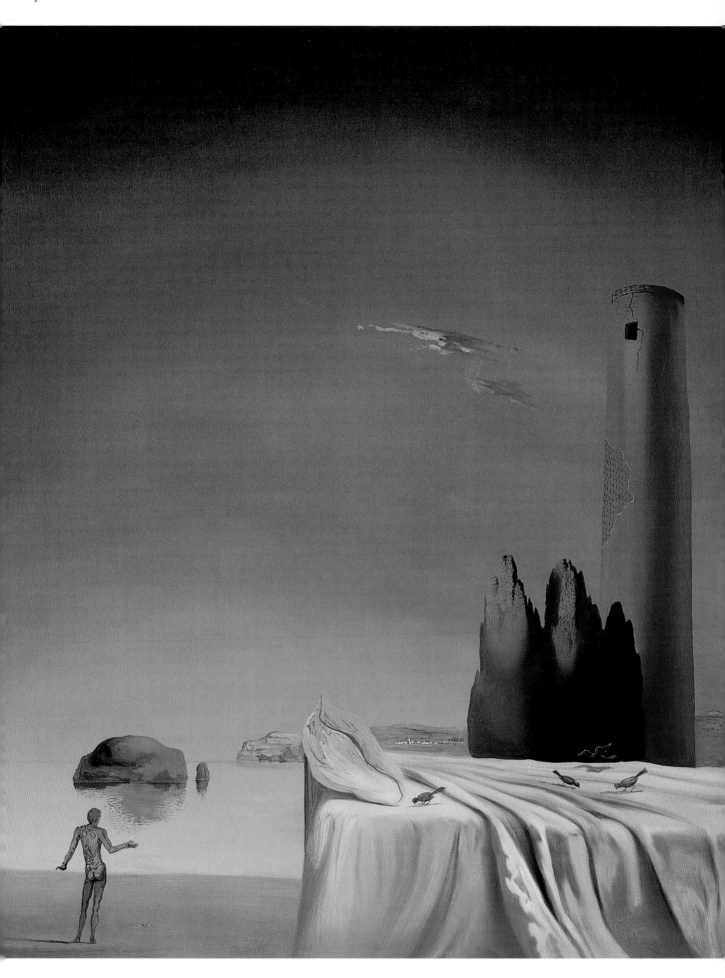

THE TRUE PICTURE OF THE "ISLAND OF THE DEAD' BY ARNOLD BÖCKLIN AT THE HOUR OF THE ANGELUS (1932)

Van der Heydt Museum. Courtesy of Giraudon

*T*HE *True Picture of the "Island of the Dead' by Arnold Böcklin at the Hour of the Angelus* was painted in 1932, using oil on canvas.

The painting is Dalí's reworking of the German painter Arnold Böcklin's piece, *Island of the Dead*; Dalí was writing a study on Böcklin during this period. Böcklin said that the *Island of the Dead* was a painting "to dream over," deliberately leaving it untitled so that the meaning remained open to interpretation by the viewer. Böcklin's thoughts were very close to views held by the Surrealists, especially Dalí. On the left appear the only objects: a cup with a thin rod attached to it sitting on a block. Using Freudian dream interpretation (which is evident throughout

Paranoiac Face (c. 1932)
Courtesy of Christie's Images. (See p. 67)

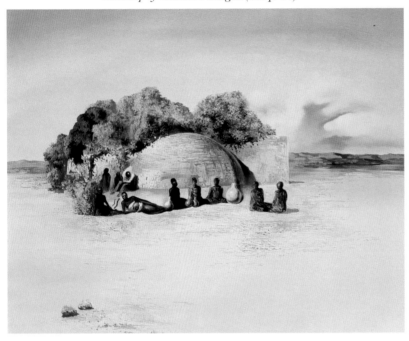

Dalí's early work) any receptacle is female and any rod is regarded as phallic. Read as male and female, these objects could be the reason for Dalí's inclusion of the "Angelus' in the title.

The island does not resemble the island in the Böcklin painting; it resembles more the shape of the head in *Paranoiac Face*, painted around the same time. It is probable that both of these paintings were based upon the same rocky, coastal scenery.

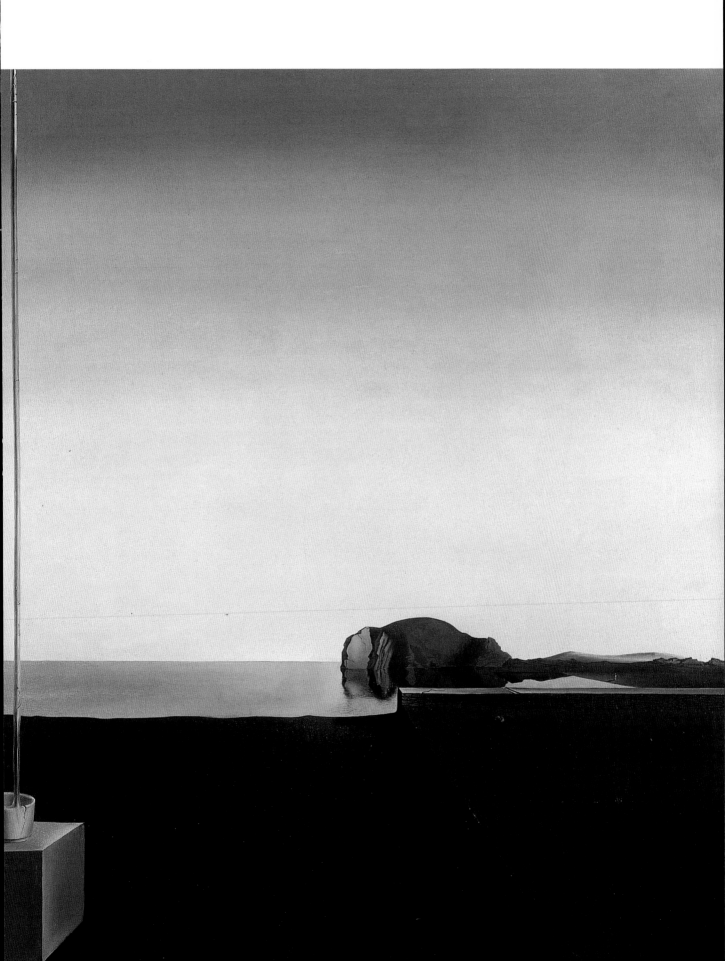

RETROSPECTIVE BUST OF A WOMAN (1933)
Courtesy of Giraudon

*T*HIS piece is a reconstruction of an object that Dalí created in 1933 to be shown at a Surrealist exhibition in the Pierre Colle Gallery in Paris. He relates the story of the bust's demise in his autobiography, saying that the object was attacked by Picasso's dog, who devoured the bread on the top of it. This delighted his sense of irony.

The porcelain bust is contrasted by the modern cartoon strip about the neck. Ants spread over the face of the woman, symbolizing decay. On top of her head is the bread. Dalí explained the frequent use of bread in his work as his attempt to make "useless and aesthetic that thing so completely useful, symbol of nutrition and sacred subsistence'.

At the top of the sculpture is a bronze reproduction of Millet's *The Angelus*. The "Angelus" was a theme that Dalí kept returning to, even as late as 1979, when he painted *Dawn, Noon, Sunset, and Twilight*, showing that his fascination with the threatening female was still alive.

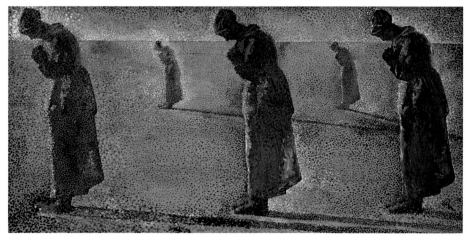

Dawn, Noon, Sunset, and Twilight (1978)
Courtesy of AiSA. (See p. 238)

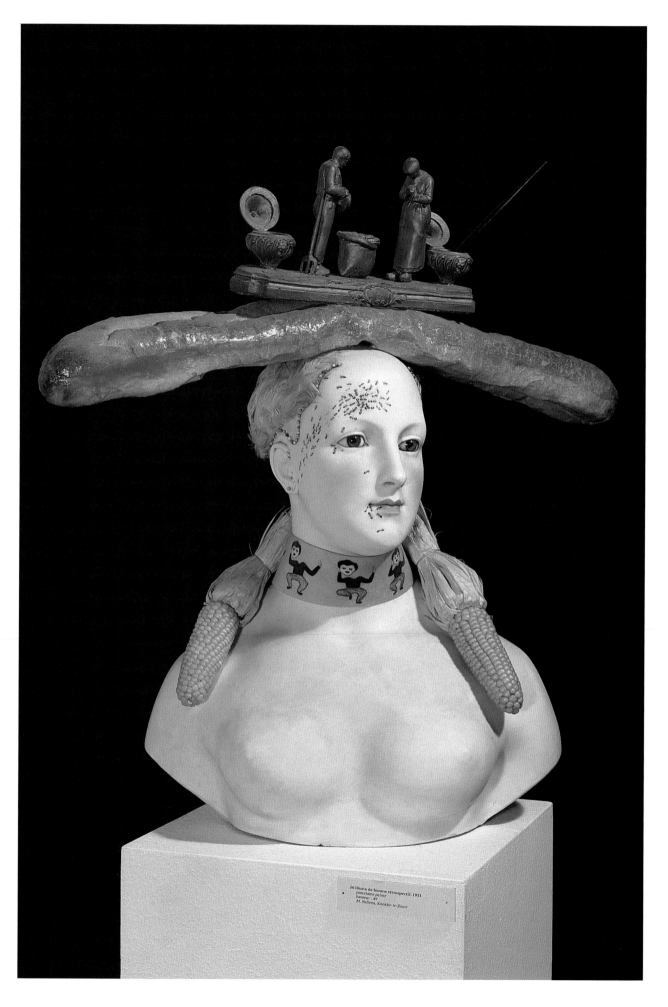

NECROPHILIC SPRING FLOWING FROM A GRAND PIANO (1933)

Private Collection. Courtesy of Giraudon

ECROPHILIC *Spring Flowing from a Grand Piano* was painted in 1933, using oil on canvas. The painting shows one of the many appearances that grand pianos make in Dalí's work during the Thirties. Dalí explained their Surrealistic appearance on the beaches or plains in his paintings, as a sight he had seen in reality: the Pitchot family, who were close friends of the Dalís, performed outdoor concerts, sometimes going to the extent of bringing a grand piano with them.

The piano has a puddle-shaped hole in the middle of its back, out of which a cypress tree grows. Cypress trees often appear in Dalí's paintings of the Thirties, for example in *The Dream Approaches* (1932). These trees reminded Dalí of the Pitchot estate, where he would spend long, happy hours in erotic daydreams.

The word "necrophilic' in the title recalls Dalí's neurotic fears that penetrative sex would lead to his death. The hole in the piano seems reflective as if filled with water; it is the origin of the "necrophilic spring." From the middle of the piano underneath the keys, the spring flows into a piano-shaped hole in the ground. This hole insinuates a grave and death, so that the spring has become a necrophiliac.

The Dream Approaches (1932)
Courtesy of Christie's Images. (See p. 76)

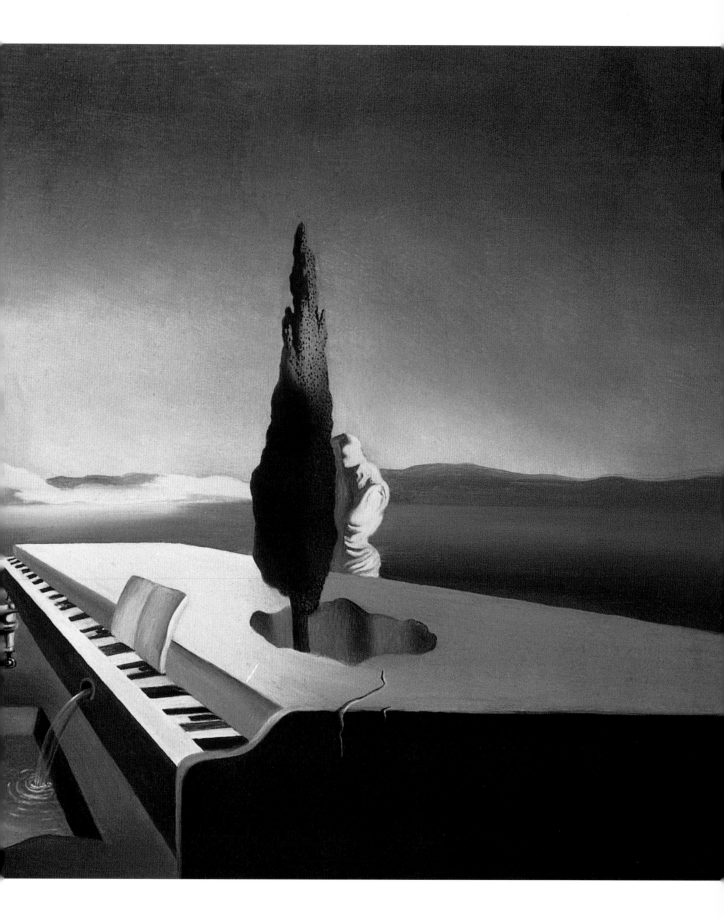

THE TRIANGULAR HOUR (1933)

Chatelard Collection, France. Courtesy of AiSA

*T*HE *Triangular Hour* was painted using oil on canvas. After their first appearance in *The Persistence of Memory* (1933), Dalí's "soft watches' were to become a regular image throughout his work. The watch in *The Triangular Hour* differs from other "soft watches' in that it has no metal casing. In addition it appears to be actually made from stone; it has a crack across its face that is similar to the cracks in the rock that it is placed on. It also does not appear as melted, as "soft," as other watches seen in earlier paintings; here it is merely misshapen.

The watch is mounted on a rock formation as if hung on a kitchen wall. Underneath is a hole in the rock through which we see an Ampordán plain, where the figure of a child with a hoop can be seen. At the top of the rock formation is the bust of a Classical man, his face in a grimace. Dalí has placed rocks on top of the bust, as well as on top of the rock formation and on the other rock in the shadowy foreground. One interpretation of this painting is that Dalí is viewing mankind and time as governed by the solidity of nature.

The Persistence of Memory (1931)
M.O.M.A., New York. Courtesy of Topham. (See p. 70)

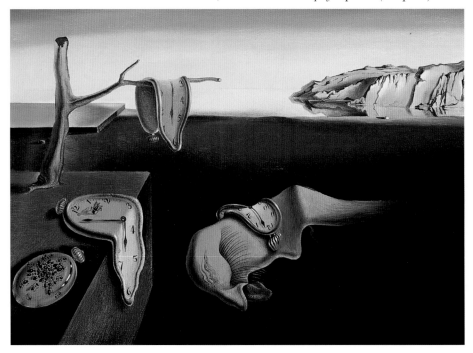

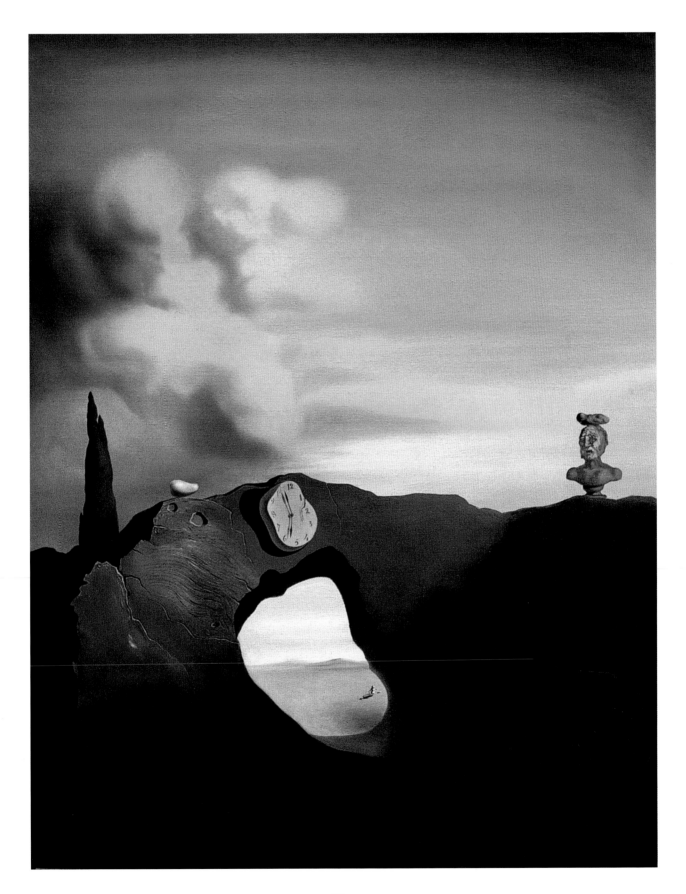

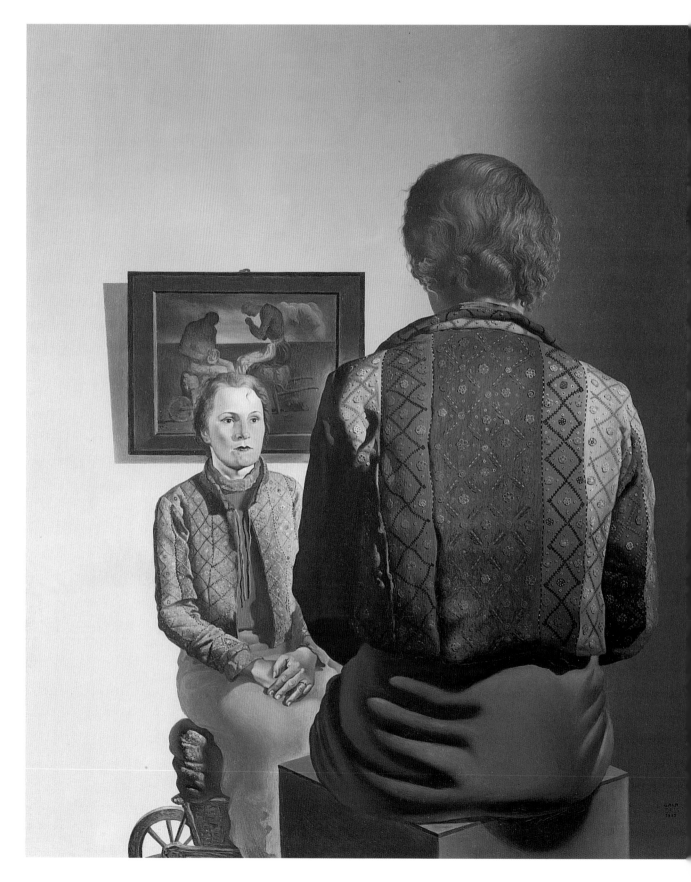

THE ANGELUS OF GALA (1933)

M.O.M.A., New York. Courtesy of Giraudon

*T*HE *Angelus of Gala* was painted in 1933, using oil on canvas. Out of the series of paintings using the theme of Millet's *The Angelus*, this painting portrays the emotional fears that the painting aroused in Dalí the most effectively. In *The Secret Life of Salvador Dalí*, Dalí writes that he saw *The Angelus*, which to most people is a religious work showing humble folk praying, as a "monstrous example of disguised sexual repression."

The Angelus of Gala contains two versions of *The Angelus*: the first is the unusual portrait of a double Gala, the second is the copy of *The Angelus* above Gala's head. The Gala that we see here is, unusually, unattractive; her mouth clenches tightly together, her eyes stare aggressively at her double. Looking at the reproduction of *The Angelus* above Gala, the female perches on the wheelbarrow, as does the main figure. The female in *The Angelus* is sexually aggressive; like a praying mantis, ready to devour her mate after receiving the attention that she hunts for. This explains the fierce look on Gala's face as she stares at her double, who is the male counterpart to her female "Angelus."

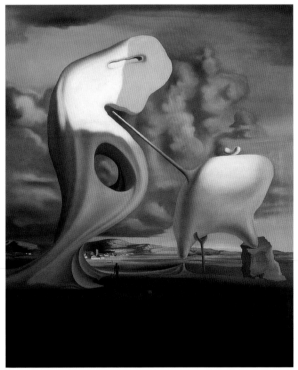

The Enigma of Desire (1929)
Courtesy of Christie's Images. (See p. 56)

GALA AND THE ANGELUS OF MILLET BEFORE THE IMMINENT ARRIVAL OF THE CONICAL ANAMORPHOSES (1933)

National Gallery of Ottawa. Courtesy of Giraudon

*G*ALA *and The Angelus of Millet* is one of a series of paintings dating from 1933–1935 that portray "paranoia-critical" interpretations of *The Angelus*. *The Angelus* was a painting by nineteenth-century French painter Jean-François Millet. Painted in 1859, it shows a couple praying in a field at sunset, a basket at their feet and a wheelbarrow full of hay behind them.

There was a reproduction of *The Angelus* hanging outside Dalí's classroom and he would stare at for hours. It was not until he utilized his "paranoia-critical method" that he discovered the wealth of images, emotions, and psychological meanings that this painting held for him.

We look into the painting through a door, behind which is a man with a lobster attached to his head (the "conical anamorphoses"

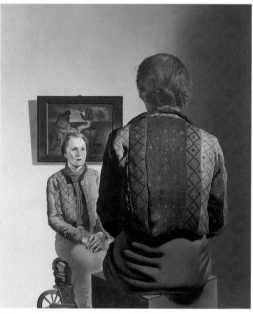

referred to in the painting's title). Above the door is a quite faithful copy of *The Angelus*, although the landscape of this painting is a bleak desert, not a field as it was in the original. The form of *The Angelus* is repeated by Gala smiling at the man who stares at a strange object that sits on the table between them.

The Angelus of Gala (1933)
M.O.M.A., New York. Courtesy of Giraudon.
(See p. 86)

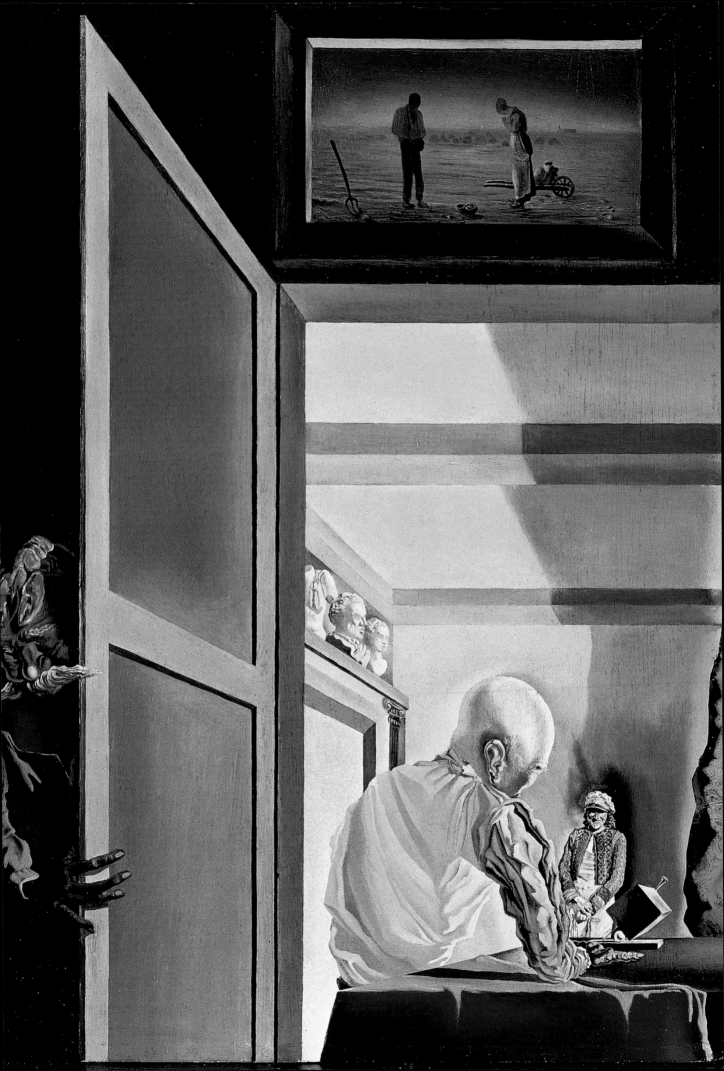

THE MASOCHISTIC INSTRUMENT (1933)
Courtesy of AiSA

*T*HE *Masochistic Instrument* interprets a childhood scene in which Dalí manipulated a female fruit-picker into climbing up a ladder placed outside his room in order for her breasts and torso to be framed by his window.

The viewer's eye is led to the naked woman by the insinuation of the angles that are created between the sloping roof beneath the window and the blue of the sky. The paleness of the woman's skin is highlighted by the use of shadow and by the contrasting, vividly colored walls of the house in which she stands. Her face can not be seen, lending an air of mystery to the piece. In her hand she holds a violin between two fingers as if in disgust. She looks ready to throw

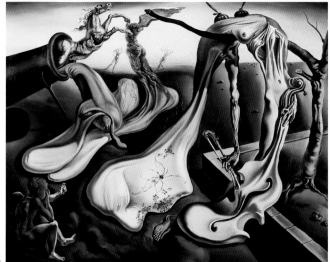

Daddy Longlegs of the Evening ...Hope! (1940)
Courtesy of Topham. (See p. 145)

the fatigued violin away. It is "soft' and distorted like the cello seen in *Daddy Longlegs of the Evening...Hope!* (1940). The shape of the violin repeats the female form, but here the inference is that the violin should be read as a phallic object. The erect pole with a piece of cloth flowing from the end of it attached to the tree can also be read as phallic.

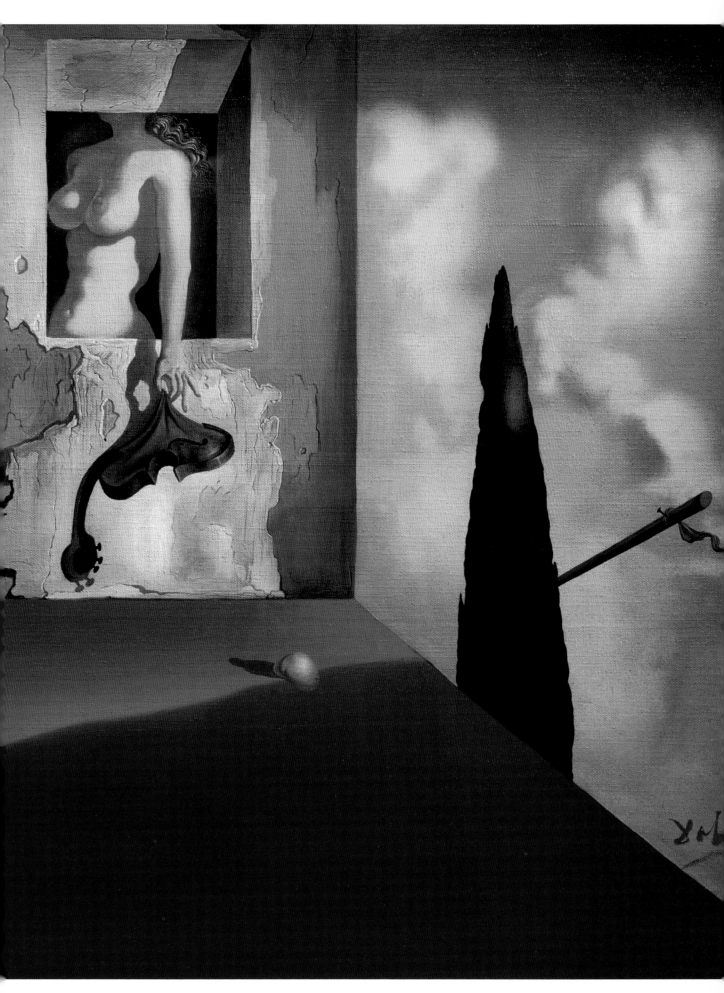

THE JUDGES (1933)
Courtesy of Christie's Images

THE Judges shares many similarities with *Le Mendicant*, although the latter was painted ten years later than this work. The most obvious comparison is that both works share the medium of pen and ink on paper. Working in pen and ink must have been somewhat of a relief to Dalí after hours of laborious painting, where he would endeavor to create a realistic, almost photographic quality to his images. Here the images are sketched, sometimes detailed and at other points vague, producing more of an insinuation at certain forms than an exact configuration; this can be seen particularly in the image of the figure on horseback.

Both drawings also share images, such as a figure on horseback and the Classical style of architecture. The two drawings also have the recurring image of the father with the son. The figure on horseback is partly outlined by blobs of ink, which give it an air of heaviness, of importance. The figure seems to be a statue, as it stands upon an obelisk in the square in front of a grand building. The two figures on the side of the building with their arms held victoriously aloft, echo the configuration of the figure on horseback.

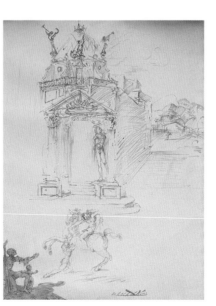

Le Mendicant (1943)
Courtesy of Christie's Images. (See p. 152)

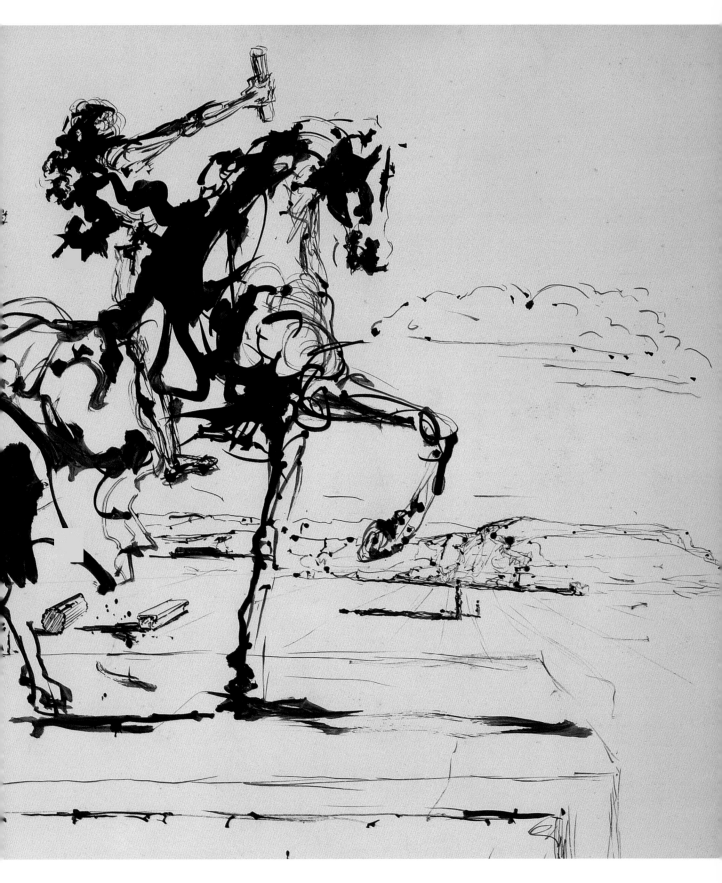

THE HORSEMAN OF DEATH (c. 1934)
Courtesy of AiSA

*T*HE *Horseman of Death* was painted around 1934. It shares images from several of Dalí's works dating from this time. The rainbow set against dense clouds is an image that Dalí also used in *Le Spectre et le Fantôme*. Dalí interpreted this combined image as a representation of the spectre from the title of the painting. The tower in the background can also be seen in several other paintings, such as *The Dream Approaches*. Dalí explained that the significance of this tower was a sexual one, as it was an image that formed the background to many of his long, erotic daydreams. A dense cluster of cypress trees hides the tower from our view. The cypress tree is also a familiar image in Dalí's paintings of the early to mid Thirties, their

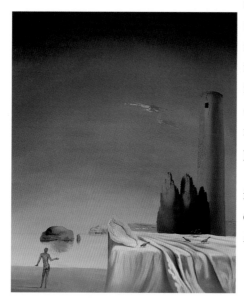

significance, once again, having roots in Dalí's childhood memories. The horseman itself is a frequent image, although here he is in a state of disintegration, parts of his horse still has flesh remaining, while the horseman is purely skeleton.

Dalí wrote of this piece that it reminded him, with a sense of déjà vu, of the interior of the *Island of the Dead* by Böcklin.

The Dream Approaches (1932)
Courtesy of Christie's Images. (See p. 76)

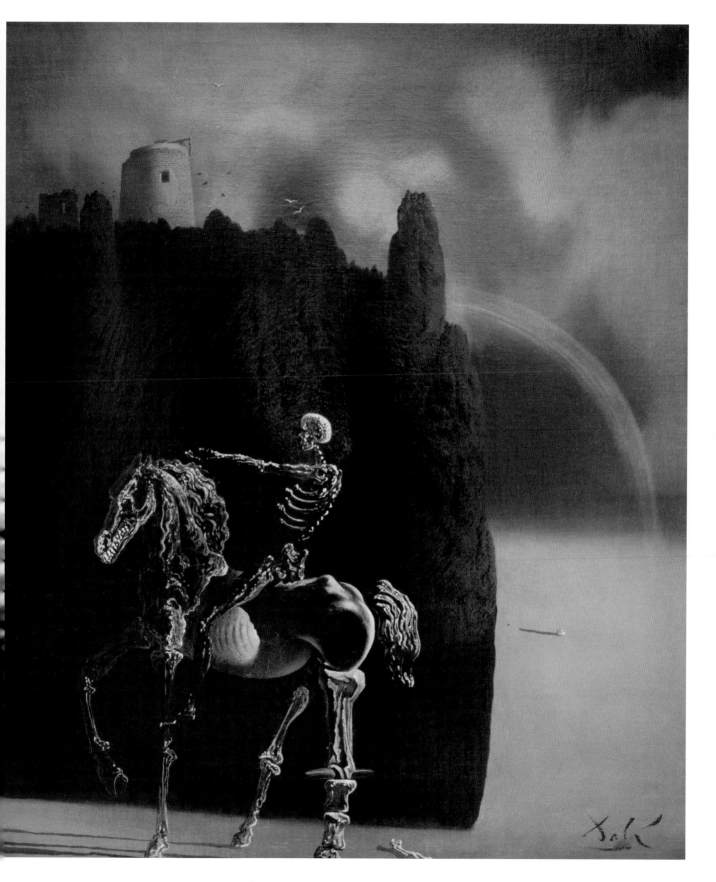

HAIRDRESSER DEPRESSED BY THE PERSISTENT GOOD WEATHER (1934)

Perls Collection. Courtesy of Giraudon

HAIRDRESSER Depressed by the Persistent Good Weather was painted using oil on canvas, in 1934. This painting is a good example of Dalí's bizarre choice of titles. They usually refer directly to the subject of the work, describing in detail what he has depicted. One of Dalí's collectors once said that the price of a Dalí painting was merited by the title alone.

Hairdresser Depressed portrays a depressed hairdresser looking mournfully out at the viewer. The hairdresser and the figures behind

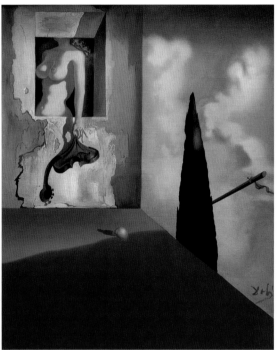

The Masochistic Instrument (1933)
Courtesy of AiSA. (See p. 90)

him are framed within the picture by the blocks to the left of his head and in front of him. The blocks appear two-toned due to the shadow cast on them, the blue of the shaded block by the hairdresser echoing the blue of the sky.

Behind the hairdresser stands an old man holding a cloth, his buttocks and skull have been exaggerated. In front of this man, an enormous skin-colored shape seems to be held up by a crutch. We can not see where this phallic object originates

from, but the viewer's attention is drawn to it by the angle of the framing building, a trick used in *The Masochistic Instrument* (1933).

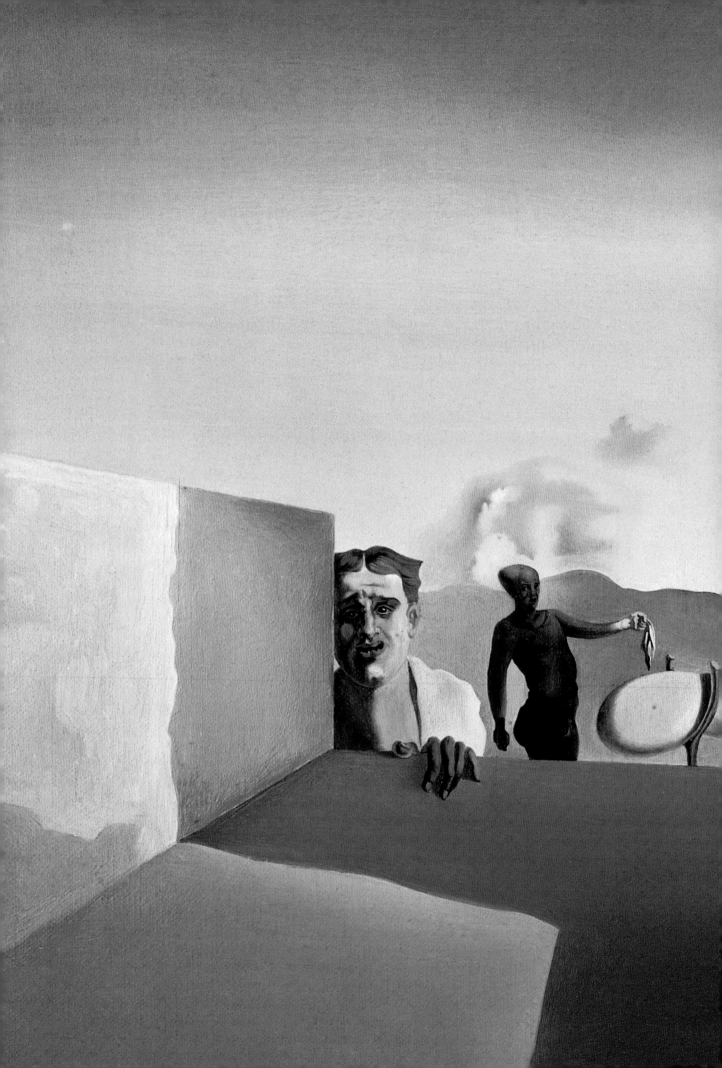

THE MOMENT OF TRANSITION (1934)

Private Collection. Courtesy of Giraudon

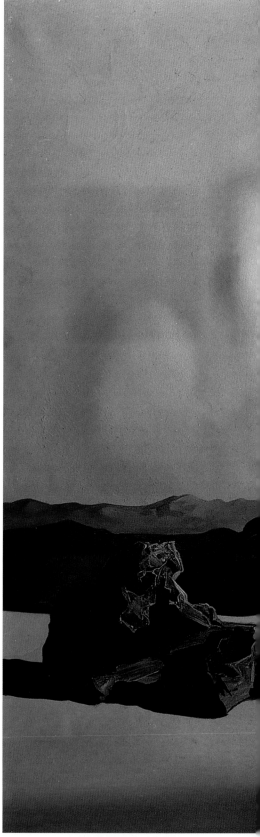

THE *Moment of Transition* was painted in 1934. On the left, a woman dressed entirely in white, the material flowing behind her, stands facing the cart. The image of the woman in white is repeated in several of Dalí's paintings, either directly or suggestively. In *Gradiva Finds the Ruins of Anthropomorphis* the woman's shape is implied by the shape of the white rocks in the background. This woman was Dalí's first cousin, Carolinetta, who died aged seventeen from consumption, when Dalí was still a child.

The cart in the painting looks like a hollowed-out bone. On first glance the cart has two people in it, but upon closer inspection, the people take on the form of a building in the town it approaches and the rear end of a horse.

The Moment of Transition continues the theme of Dalí's painting *The Phantom Wagon* (1933) in which the same cart, landscape, and visual illusion are shown. In the latter painting, however, the cart appears at a further distance from the town that it heads for. As we see the cart in closer detail in *The Moment of Transition* Dalí's visual illusion becomes more apparent, explaining the title of the work.

Gradiva Finds the Ruins of Anthropomorphis (1931)
Courtesy of Giraudon. (See p. 74)

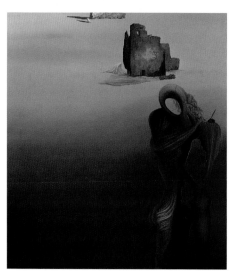

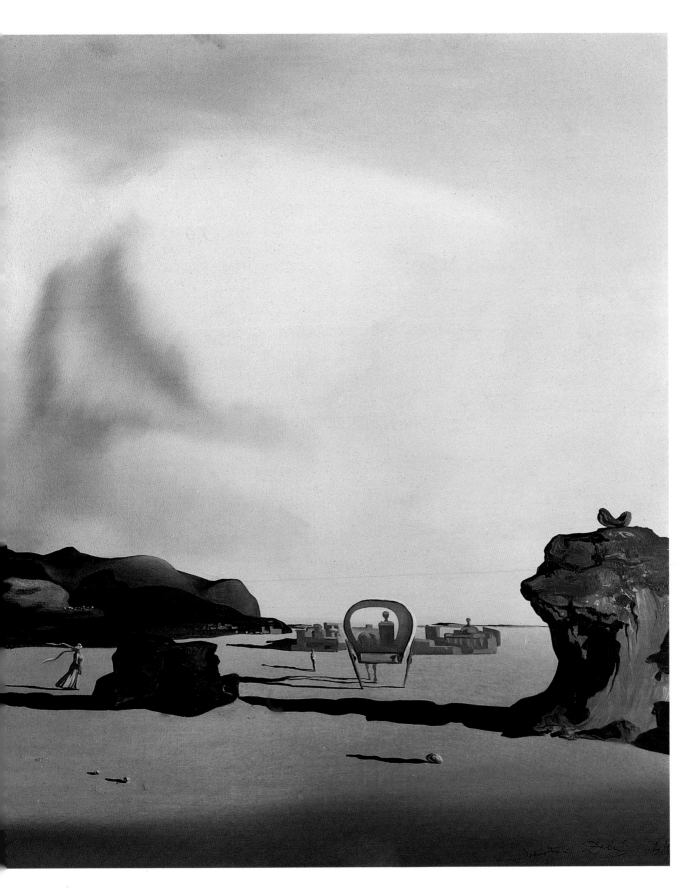

LE SENTIMENT DE LA VITESSE (1934)

Courtesy of Christie's Images

*L*E Sentiment de la Vitesse - the feeling of speed—was painted in 1934, using oil on canvas. The canvas is surprizingly small, measuring only 13 x 10 in (33 x 24 cm). In the Thirties, especially in 1930–31, Dalí often used small canvases, and sometimes he would cram them with intricate details. Here, however, he has left the picture bare.

Dalí has placed three objects on a flat blue expanse: in the foreground a white, gleaming skull, a cypress tree and on the left, a rock in the shape of a shoe. Shoes were one of Dalí's many "fetishes," incorporating them into objects and hats. Shoes obsessed Dalí because for him they represented sin, based on the idea of the foot being the starting point of all sin.

Dalí used the image of a rock with a "soft' watch mounted on it in *The Triangular Hour* (1933). However in this painting the emphasis is placed more on the rock than on the watch. The watch is flat against the rock and seems to be a part of it, a shadow from an unseen cypress tree creates the hands. Dalí has painted two further shoes to ensure that the viewer recognizes the shape of the rock.

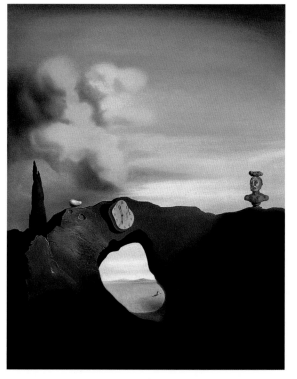

The Triangular Hour (1933)
Chatelard Collection, France. Courtesy of AiSA. *(See p. 84)*

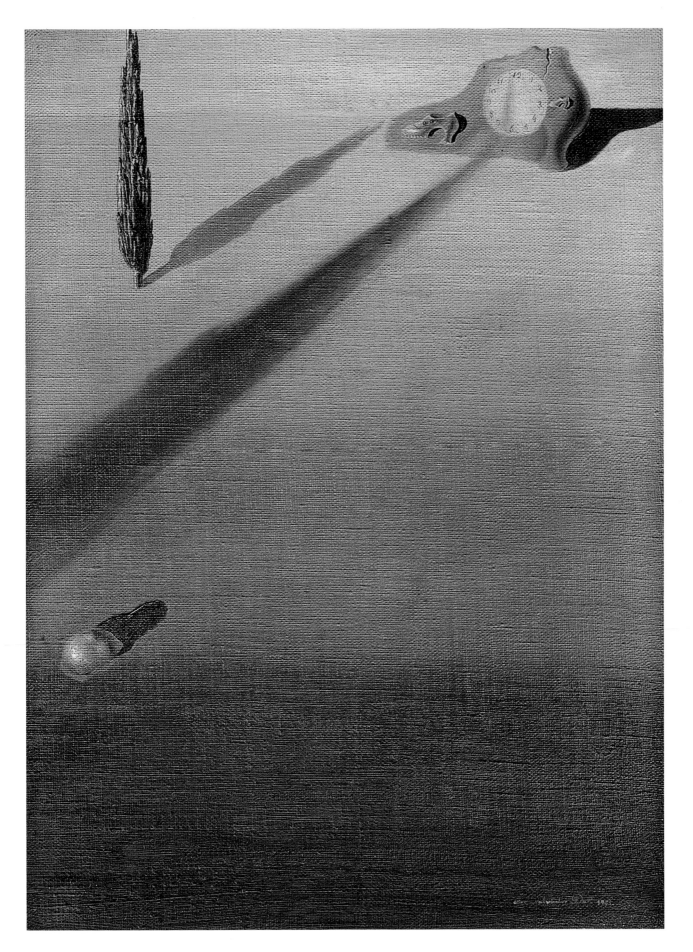

LE SPECTRE ET LE FANTÔME (1934)

Courtesy of Christie's Images

*L*E Spectre et le Fantôme—the spectre and the phantom—was painted in 1934, using oil on canvas. It is one of a series of paintings that shared a theme of spectral and phantom appearances. In a letter to the French Surrealist poet Paul Eluard, Dalí defined the clouds and the rainbow as being the spectre and the brick shape as being the phantom. The clouds take on forms as the viewer stares at them, reflecting the basis of Dalí's paranoia-critical method.

The work has the same female figure as *Mediumistic-Paranoaic Image*. The woman is in the foreground, sitting in a puddle on a beach. She is a combination of Dalí's nurse, his friend Lidia and another of Dalí's obsessions from that time which was to cause him trouble in the future: Hitler. His obsession with Hitler was partly caused by what he called the "soft flesh' of his back, which was tightly held in by his uniform. He dreamt of him as a wet nurse sitting knitting in a puddle. The woman in the painting has a small cut taken out of her back that emphasizes this obsession with "Hitlerian" flesh.

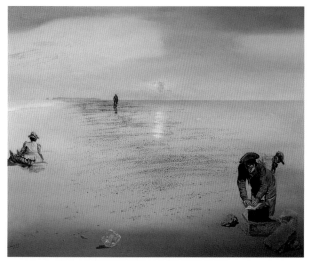

Mediumistic–Paranoiac Image (1935)
Courtesy of Christie's Images. (See p. 106)

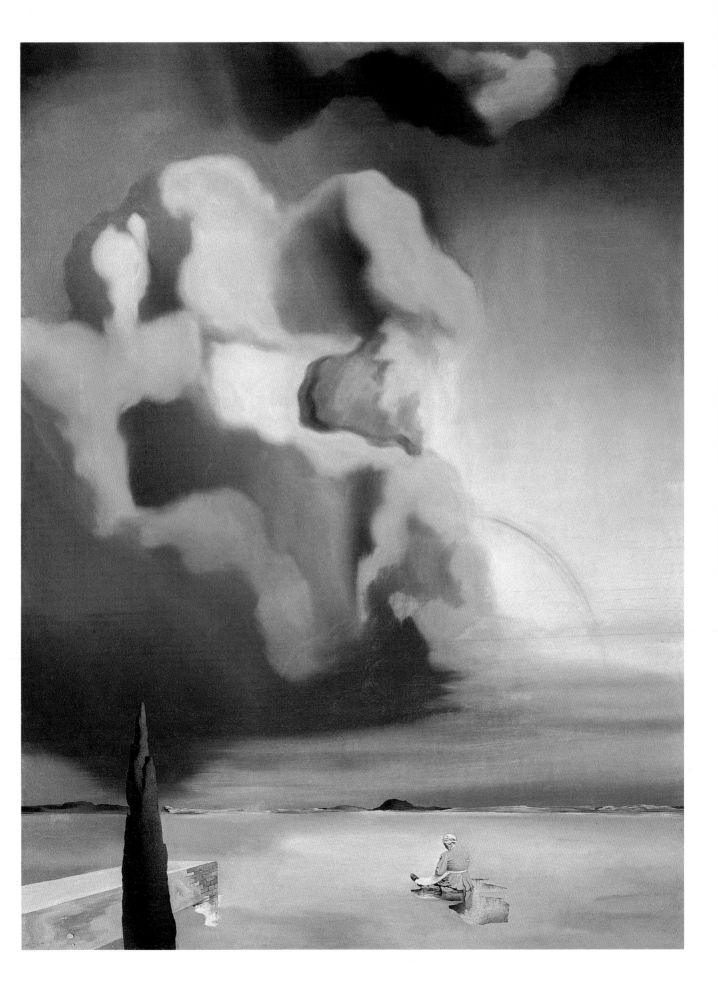

ALLEGORY OF AN AMERICAN CHRISTMAS (1934)
Courtesy of Christie's Images

*A*LLEGORY *of an American Christmas* was painted in 1934, while Dalí and Gala were on the first of what was to become many visits to the US. The country had long intrigued Dalí and on this first trip he was greatly impressed with it, especially with the media, who afforded him the attention that he needed and craved. Dalí loved the idea of a "new country" and the opportunities he saw there; these feelings are reflected in the painting.

Dalí used the image of an egg-shaped stone often during the Thirties. As a form that represents a human head, it can be seen in *Illumined Pleasures*. In the *Allegory of an American Christmas*, as with the later painting *The Metamorphosis of Narcissus*, the egg produces the idea of a hatching, or a birth of something new; of a change taking place. Here, the huge stone egg fills the painting, hovering ominously over the flat, blue land. The dark clouds on the horizon heighten the atmosphere of expectancy. A distorted golden plane is breaking free from a hole in the egg. The black hole forms the shape of northern US, with South America painted in golden colors beneath it.

The Metamorphosis of Narcissus (1937)
The National Gallery, London. Courtesy of Topham. (See p. 120)

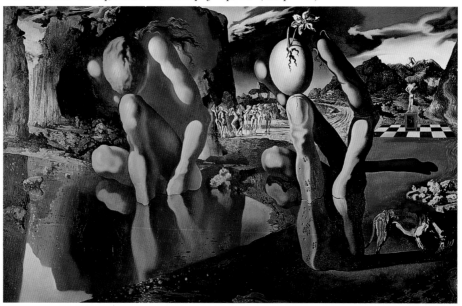

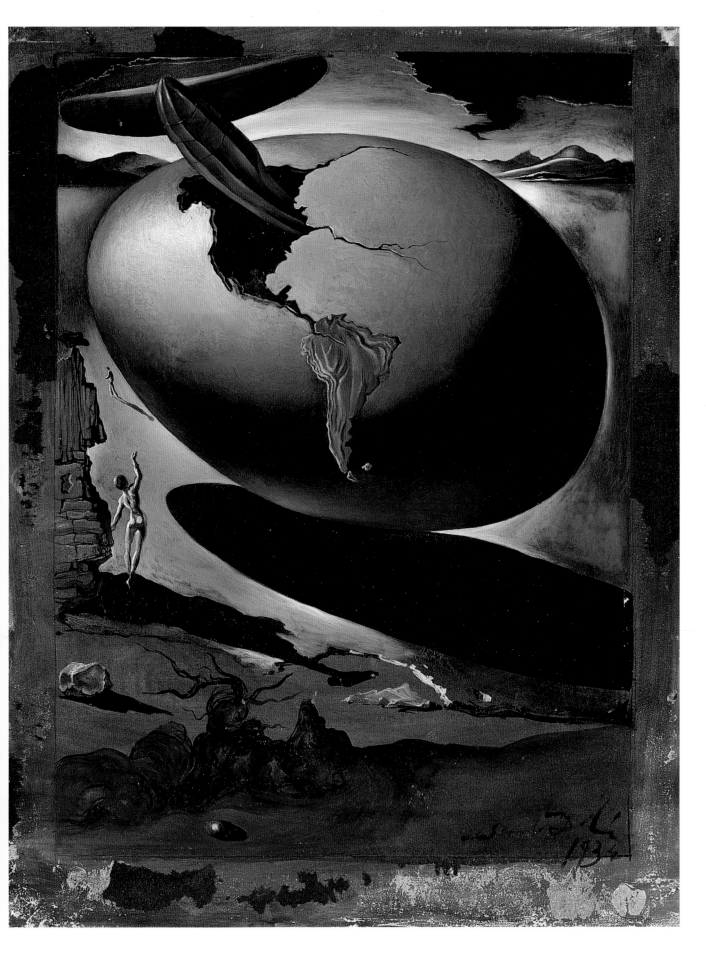

MEDIUMISTIC-PARANOIAC IMAGE (1935)

Courtesy of Christie's Images

MEDIUMISTIC-*Paranoiac Image* was painted in 1935, using oil on panel. Despite the inference of the title, this painting is quite conventional in its subject and style. There are no visual illusions, as was common in Dalí's other "paranoia-critical" paintings. However, Dalí intended the figures to seem "instantaneous," as if they were images from elsewhere that had been suddenly cast on to the landscape that he painted. This intention explains the "normality" of the surroundings.

The woman on the left of the painting is based on Lidia Nogueres, an eccentric local with whom Dalí was friends for most of his life. In his autobiography, he wrote of Lidia that she "possessed the most marvellously paranoiac brain aside from my own, that I have ever known."

Mediumistic-Paranoiac Image shows a wide, open beach and sky; a sinking sun gives the wet sand mother of pearl colors. The beach is Rosas, on the Costa Brava. Dalí used this beach for several paintings during this time. In the foreground is an amphora, which could be a further explanation of the title: Dalí painted this amphora in several other paintings and it was probably a recurring shape that he "saw" around him.

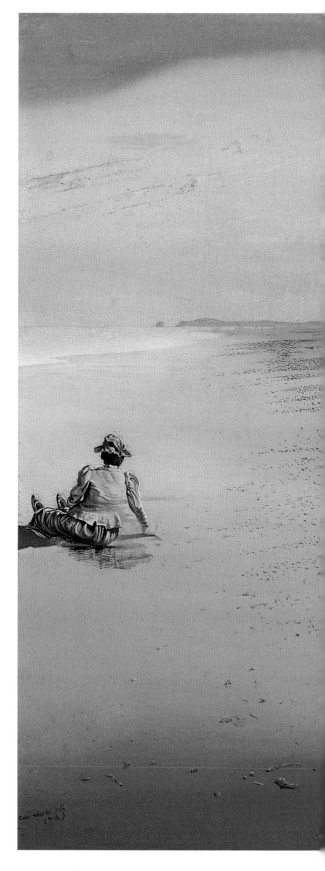

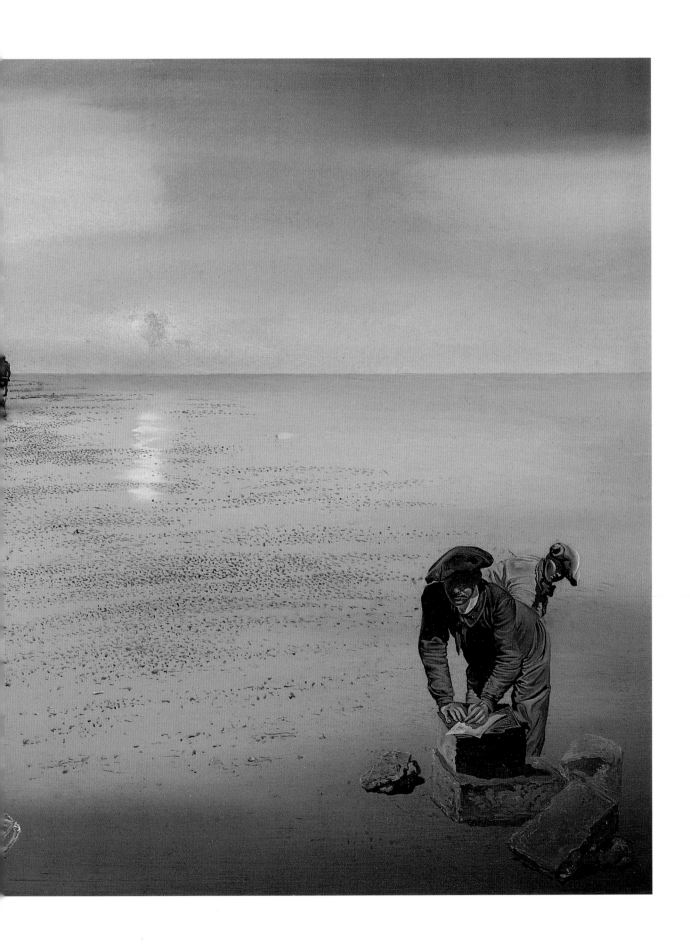

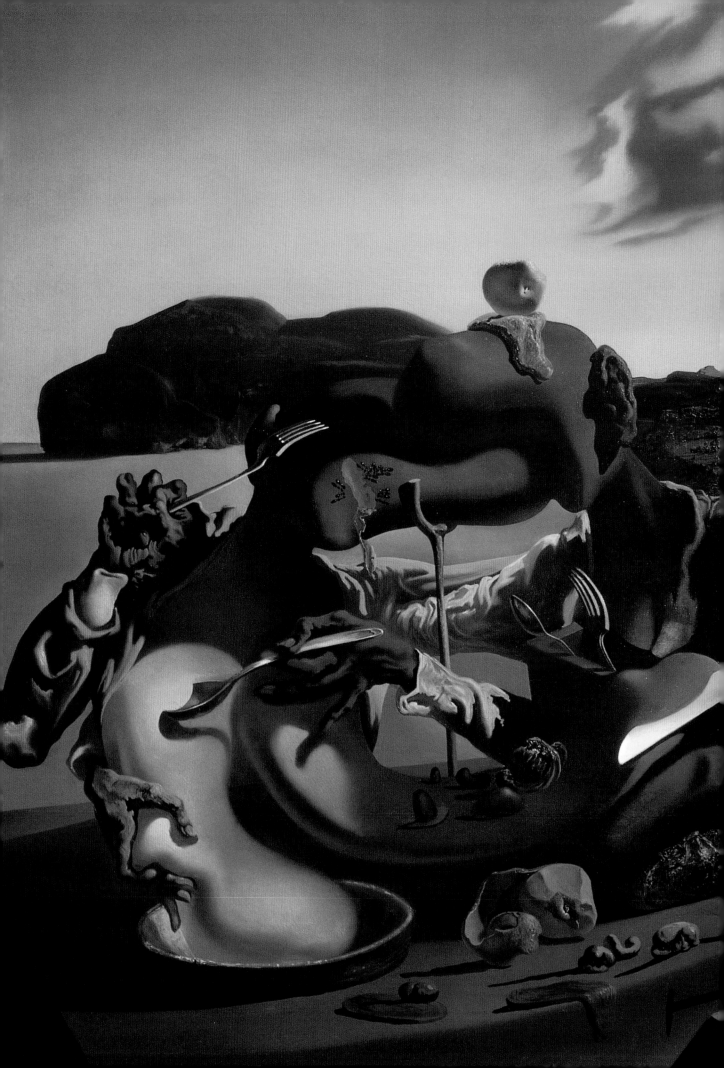

AUTUMNAL CANNIBALISM (1936)

Courtesy of the Tate Gallery

AS with many artists, Dalí was to depict war and conflict in several of his major works. *Autumnal Cannibalism* was painted in 1936, the year the civil war began in Spain. The painting is an evocative interpretation of the horror and destruction of war, and also comments on the devoring nature of sexual relationships.

On a chest of drawers placed on a Catalonian beach sit the top halves of two people. They are so entangled that the viewer has to look carefully to see which arm belongs to which figure. One figure holds a fork pointed to the other one's head, while it dips a spoon into the malleable flesh. A languid hand holds a gleaming knife that has sliced into the soft flesh of the other. Their featureless heads merge into each other, their individuality becoming indistinguishable.

Pieces of meat are draped about the painting, symbolizing death. The meat also alludes to the temporary nature of life and to the bestial nature of human beings. On one head is an apple, which to Dalí represented a struggle between father and son, (the son being the apple, the father William Tell), and beneath the figures is a peeled apple, symbolizing the destruction of the son.

LOBSTER TELEPHONE (1936)

Courtesy of Christie's Images

THE *Lobster Telephone* is Dalí's most celebrated Surrealist object. It combines two images that often appear in his work at this time. In *The Enigma of Hitler* he painted a huge telephone with the mouthpiece taking the shape of lobsters' claws. Dalí saw the forms as interchangeable, once writing, "I do not understand why, when I ask for a grilled lobster ... I am never served with a cooked telephone".

The aim of the Surrealist object was to surprise and confront the spectator by offering an alternative view of reality. The Surrealists wanted to ensure the viewer became personally involved in the artists' work by causing them to question the significance (if there was any significance) of the object and the thoughts and feelings that it had aroused in them.

Lobster Telephone brings together two ordinary objects in a way that had never been seen before. The object causes the viewer to question the seemingly innocent telephone by combining it with the vivid, red lobster, the claws of which are placed where the earpiece should be. The allusion seems to be that the telephone is taken for granted as a means of communication but is also potentially dangerous.

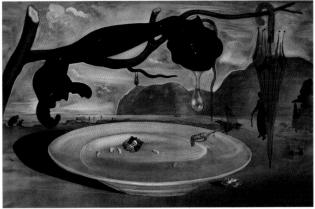

The Enigma of Hitler (1939)
Courtesy of AISA. (See p. 138)

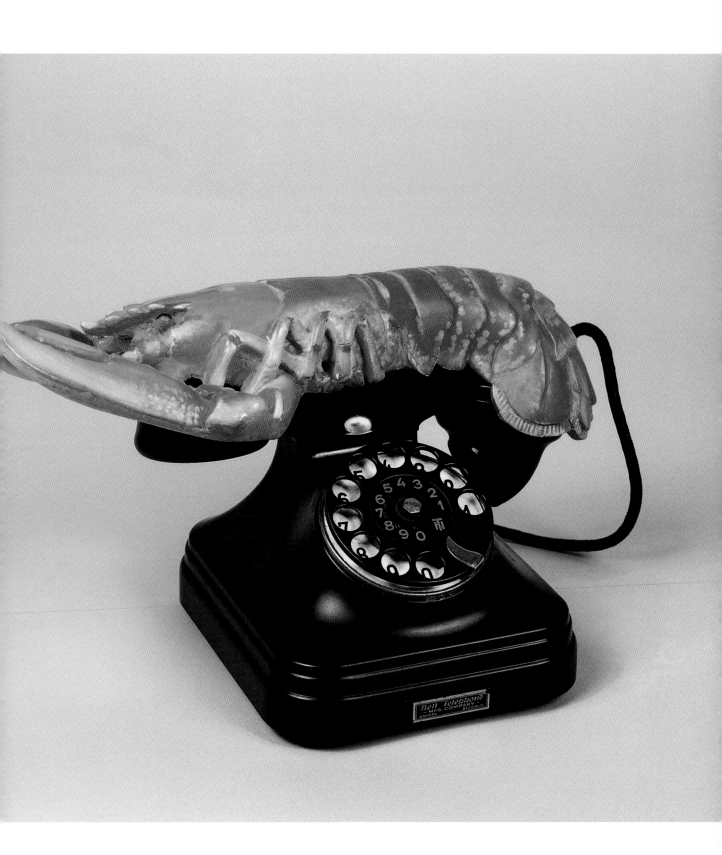

MESSENGER IN A PALLADIAN LANDSCAPE (c. 1936)
Courtesy of Christie's Images

*M*ESSENGER *in a Palladian Landscape* was drawn using pen and ink on pink paper. The drawing is undated but it dates from about 1936. Around this time, Dalí was beginning to incorporate Classical images into his work, although the works as a whole would retain their Surrealist flavor. To the Surrealists, referring back to an older style of painting or subject matter went against their ideals of attempting to find the new, the different, the subconscious images.

This drawing is a forewarning of the breach that was to occur between Dalí and the Surrealists. He was moving further away from the Surrealist ideals and closer to the Classical ideals that he was to embrace in the Forties with paintings such as *My Wife, Looking at Her Own Body*. Dalí has made a concessionary Surrealist touch to this work by the addition of an asymmetrical gilt frame, which was probably influenced by the Belgian Surrealist painter René Magritte.

Palladian is a style of architecture that copied the Classical style. It is based on the work of the sixteenth-century Italian architect Andrea Palladio. The landscape of this drawing does indeed show a Palladian architectural style, with use of Classical arches and columns.

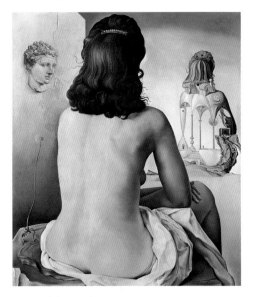

My Wife, Naked (1945)
Private Collection. Courtesy of Giraudon. (See p. 160)

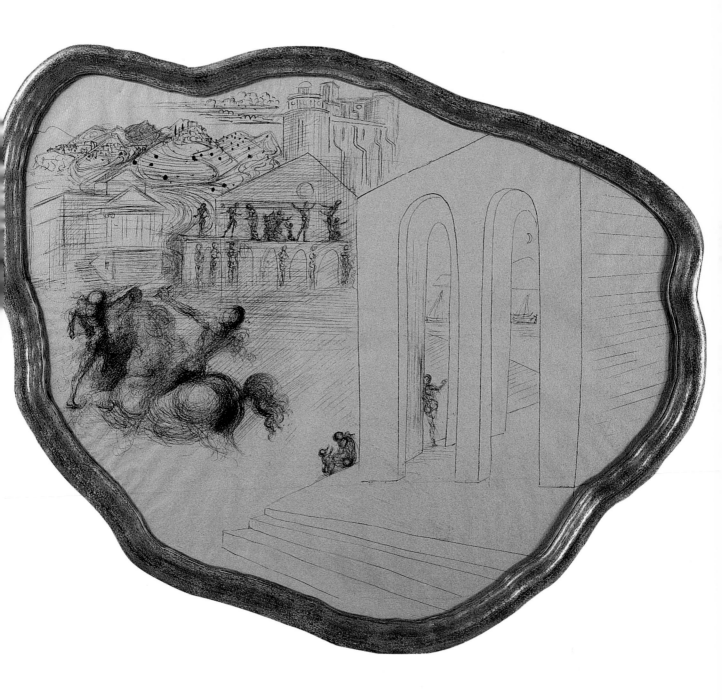

THE BURNING GIRAFFE (1936–37)

Kunstmuseum. Courtesy of Giraudon

*T*HE *Burning Giraffe* was painted, using oil on panel, during 1936-37. Dalí believed that both *The Burning Giraffe* and *The Invention of Monsters* were premonitions of war. Both of these paintings contain the image of a giraffe with its back ablaze, an image which Dalí interpreted as "the masculine cosmic apocalyptic monster." He first used this image of the giraffe in flames in his film *L'Age d'Or* (*The Golden Age*) in 1930.

The Burning Giraffe appears as very much a dreamscape, not simply because of the subject but also because of the supernatural aquamarine color of the background. Against this vivid blue color, the flames on the giraffe stand out to great effect.

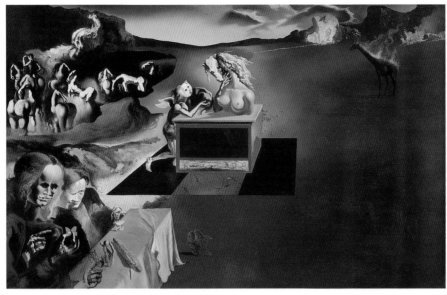

The Invention of Monsters (1937)
Institute of Art, Chicago. Courtesy of AiSA. (See p. 118)

In the foreground, a woman stands with her arms outstretched. Her forearms and face are blood red, having been stripped to show the muscle beneath the flesh. The woman's face is featureless now, indicating a nightmarish helplessness and a loss of individuality. Behind her, a second woman holds aloft a strip of meat, representing death, entrophy, and the human race's capacity to devour and destroy. The women both have elongated phallic shapes growing out from their backs, and these are propped up with crutches—Dalí repeatedly uses this symbolism for a weak and flawed society.

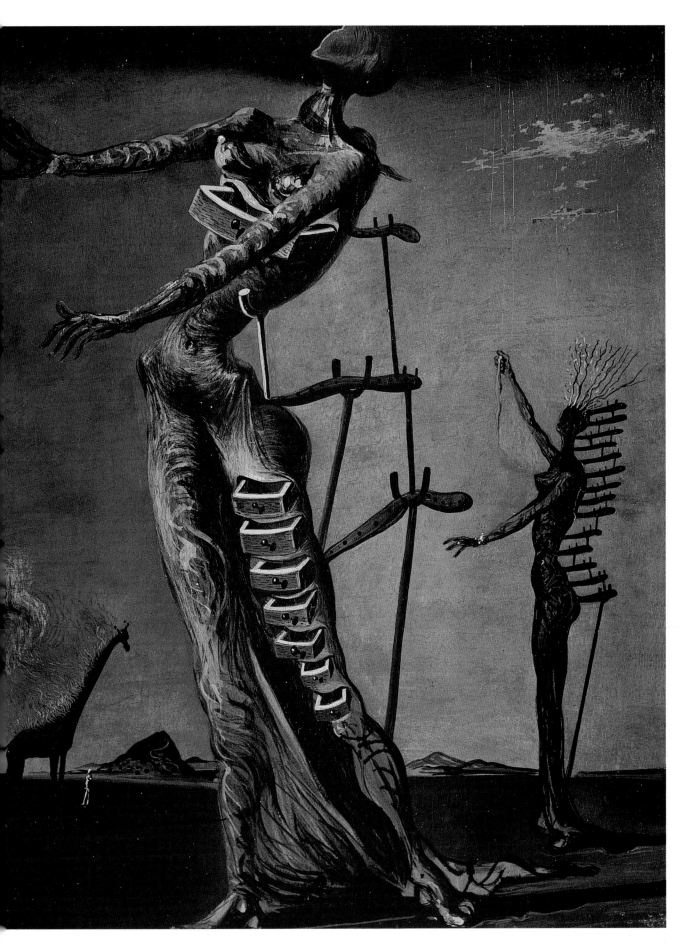

THE WOMAN IN FLAMES (c. 1937)

Courtesy of Christie's Images

THE *Woman in Flames* is a cast of a figure taken from the painting *The Burning Giraffe* (1936–37). The figure was cast in a silvered bronze and is 26 in (65 cm) high. The flames can be seen licking their way up the woman's dress, and the lines etched along her body also give the illusion of flames, as if her whole body were on fire. She holds one hand to her mouth and bends back with her arm held up, as if trying to repulse something horrific that approaches; Dalí interpreted the original painting as premizing the onset of war. The placement of the crutches exaggerates the curve of the woman's back.

Like the figure in *The Burning Giraffe*, the woman has drawers set into her leg and up along her chest. Dalí first began to include drawers set into bodies as a play on the English term "chest of drawers." The image appealed to him and he began to include it in many works, creating the *Venus de Milo with Drawers* in 1936. Making the drawers part of a human body exemplifies the bodily orifices that Dalí, with his scatological nature, was so obsessed with.

The Burning Giraffe (1936–37)
Kunstmuseum. Courtesy of Giraudon.
(See p. 114)

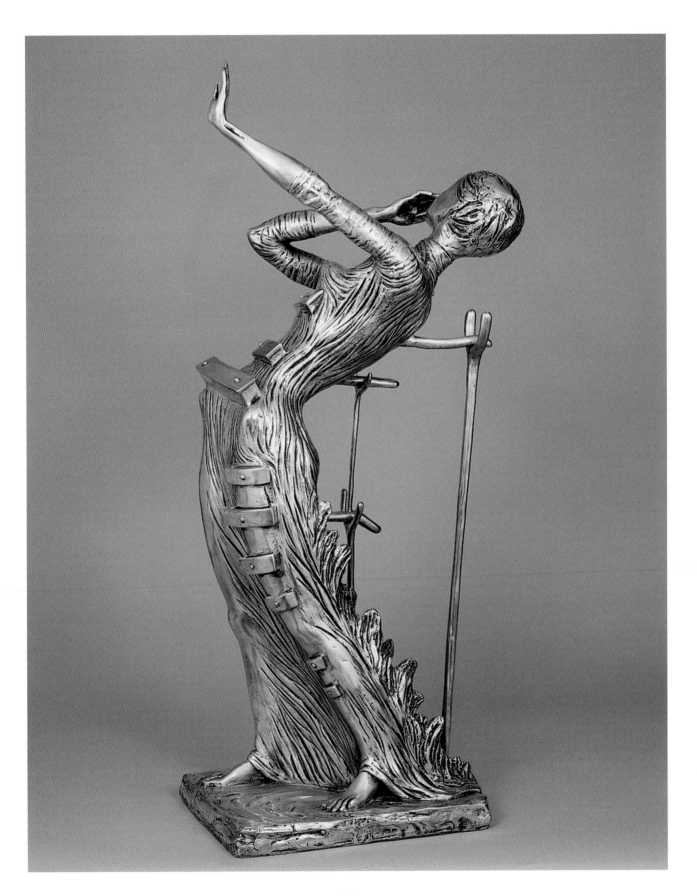

THE INVENTION OF MONSTERS (1937)

Institute of Art, Chicago. Courtesy of AiSA

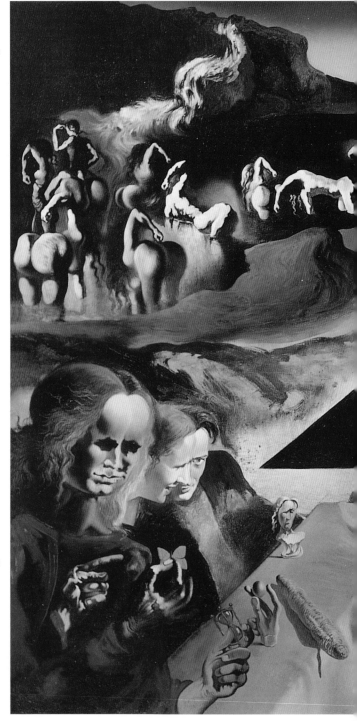

*P*AINTED in 1937, using oil on canvas, *The Invention of Monsters* is one of several paintings that Dalí believed were premonitions of war. He described the work as prophetic because of Nostradamus' words that the manifestation of monsters meant that war would shortly follow. It was painted while he was in Austria just a few short months before the Anschluss.

The Invention of Monsters contains several visual illusions. The face of the figure holding a butterfly is actually two heads, both turned to reveal only one side but when placed together forming a whole, if somewhat disproportionate face. This technique is also used with the cat and angel wearing masks.

Behind the table at which Dalí and Gala sit is a lake where several figures with skin like statues are washing. The figures are bending over with one arm up, their long hair trailing down to the water. These figures act as double images as they can also be seen as horses; the further away the figure is from the viewer, the more effective this double image becomes. Dalí has combined the image of a horse with a woman for the bust of a woman that the angel and cat look at.

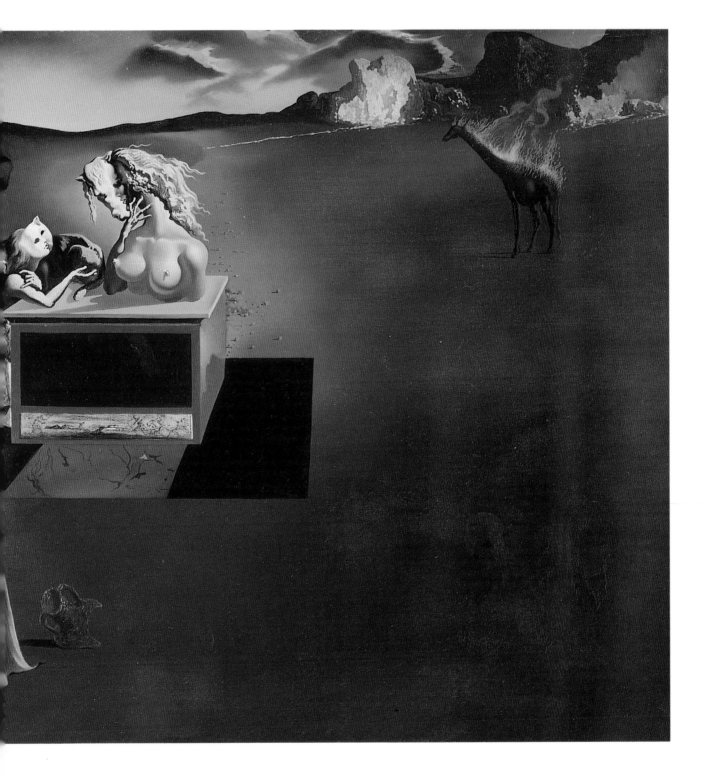

THE METAMORPHOSIS OF NARCISSUS (1937)

The National Gallery, London. Courtesy of Topham.

DALÍ'S inspiration for this painting came from a conversation overheard between two fishermen discussing a local man who would stare at himself in a mirror for hours. One of the men described the man as having a "bulb in his head'; a colloquium meaning that he was mentally ill. Dalí combined this image with the ancient Greek myth of Narcissus, who fell in love with his own reflection and was transformed into the flower that bears his name after his death.

The hand on the right that holds an egg, out of which a narcissus flower grows, echoes the configuration of Narcissus and his reflection in the lake. The same configuration occurs again at the top of the mountains that are directly above the figure of Narcissus, who stands on a dais admiring his body. The familiar sight of ants and a scavenging dog both appear around the hand, symbolizing the death and decay that has taken place.

The Metamorphosis of Narcissus was painted using oil on canvas, while Dalí and Gala were traveling in Italy. The influence of the great Italian masters on Dalí can be seen in the Classical mythic theme to his use of color and form.

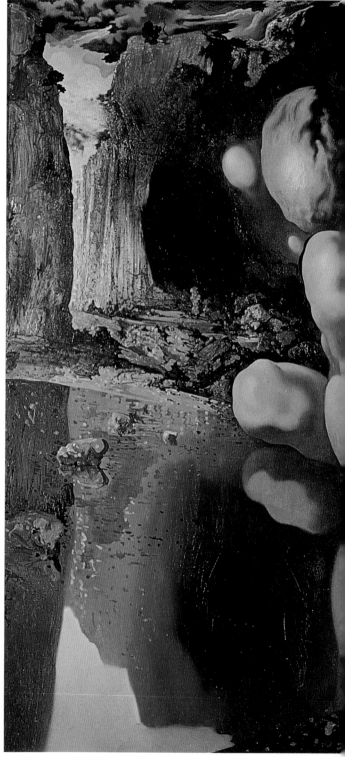

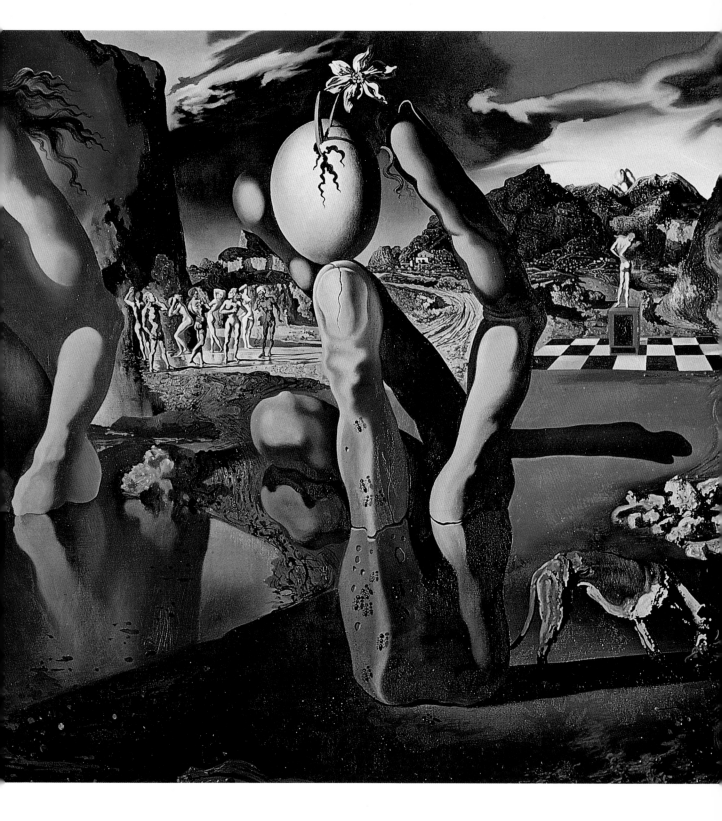

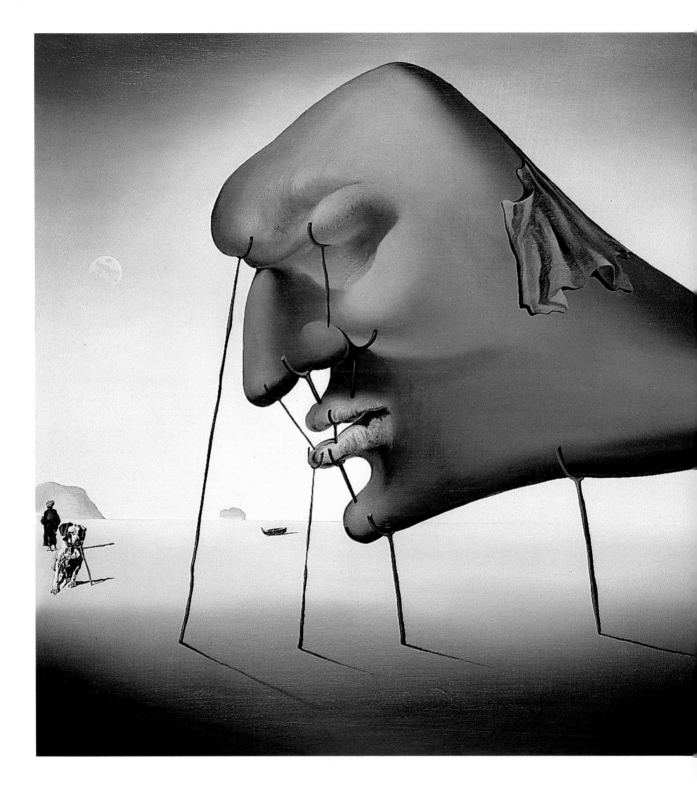

SLEEP (1937)

Courtesy of Christie's Images

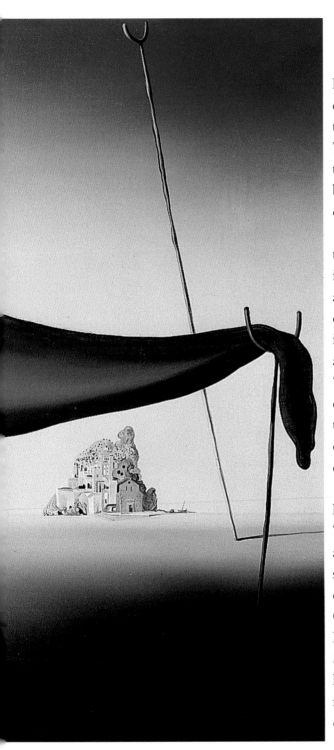

SLEEP was painted with oil on canvas for Edward James, a British millionaire who was Dalí's patron from 1936 to 1939. *Sleep* deals with a subject that fascinated the Surrealists: the world of dreams. They believed that the freedom of the subconscious within sleep could be tapped into and then used creatively.

Sleep is a visual rendering of the body's collapse into sleep, as if into a separate state of being. Against a deep blue summer sky, a huge disembodied head with eyes dissolved in sleep, hangs suspended over an almost empty landscape. The head is "soft," appearing both vulnerable and distorted; what should be a neck tapers away to drop limply over a crutch. A dog appears, its head in a crutch, as if half asleep itself.

The head is propped above the land by a series of wooden crutches. The mouth, nose and also the eyes are all held in place by the crutches, suggesting that the head might disintegrate if they were removed. Crutches were a familiar sight in Dalí's work. In *The Secret Life of Salvador Dalí*, the artist wrote that he had imagined sleep as a heavy monster that was "held up by the crutches of reality."

SWANS REFLECTING ELEPHANTS (1937)
Courtesy of Giraudon

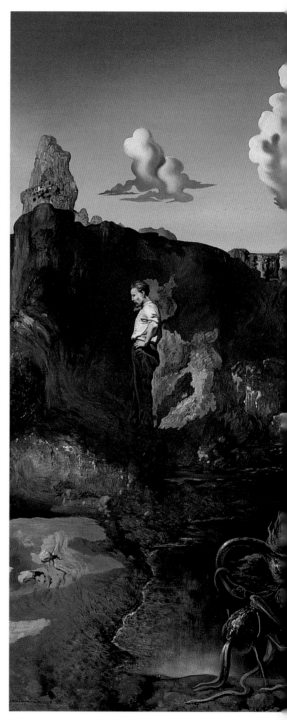

*S*WANS *Reflecting Elephants*, painted using oil on canvas, contains one of Dalí's famous double images. The double images were a major part of Dalí's "paranoia-critical method," which he put forward in his 1935 essay "The Conquest of the Irrational." He explained his process as a "spontaneous method of irrational understanding based upon the interpretative critical association of delirious phenomena." Dalí used this method to bring forth the hallucinatory forms, double images and visual illusions that filled his paintings during the Thirties.

As with the earlier *Metamorphosis of Narcissus*, *Swans Reflecting Elephants* uses the reflection in a lake to create the double image seen in the painting. In *The Metamorphosis of Narcissus* the reflection of Narcissus is used to mirror the shape of the hand on the right of the picture. Here, the three swans in front of bleak, leafless trees are reflected in the lake so that the swans' heads become the elephants' heads and the trees become the bodies of the elephants.

In the background of the painting is a Catalonian landscape depicted in fiery fall colors, the brushwork creating swirls in the cliffs that surround the lake, to contrast with the cool stillness of the water.

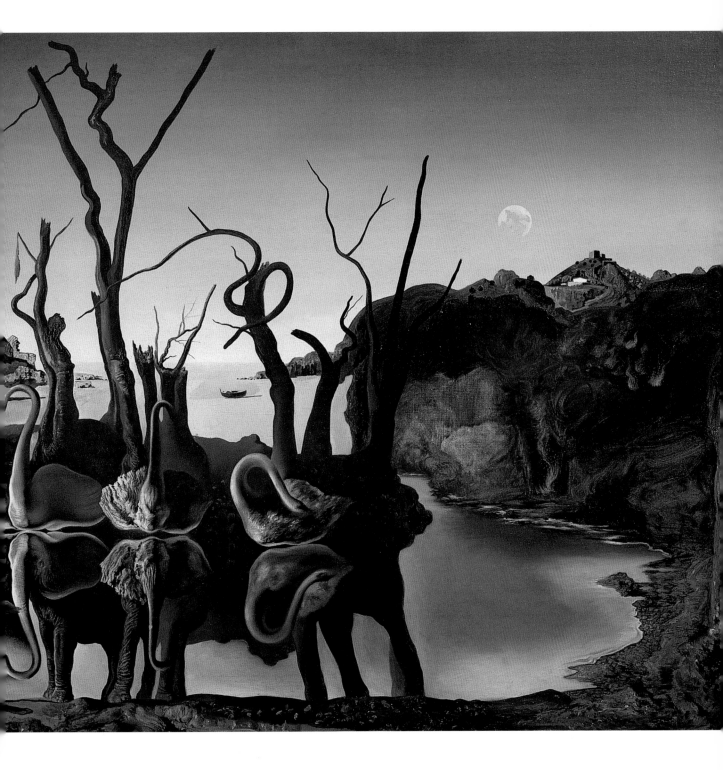

IMPRESSIONS OF AFRICA (1938)

Courtesy of Topham

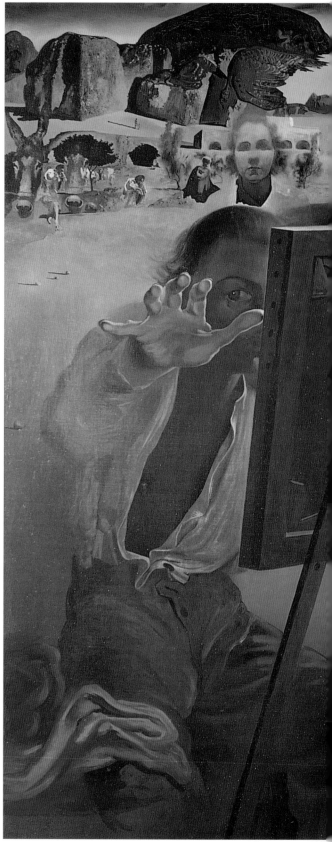

*I*MPRESSIONS *of Africa* is a misleading title as Dalí never visited the country; the title is taken from a play by Raymond Roussel, who was greatly admired for his double meanings—the literal equivalent of Dalí's double visual images. In the background, there are groups of figures clustered together; several are double images or visual illusions. Gala's face is the most dominant image; she appears ghostly, her eyes formed by the dark arches of the building behind her.

In the foreground of the painting is Dalí, one hand reaching out toward the viewer; he has used a foreshortening technique here so that his arm appears almost in 3D. He was greatly interested in techniques that enabled him to create a feeling of space, distance, and depth. During 1938, Dalí was traveling in Italy, ostensibly to study the great Italian artists' techniques. His face is only partially visible and it is in shadow so that the one staring eye that we can see appears more distinct. Dalí wanted to give an impression of extreme concentration, to convey the idea that he is trying to "see like a medium'; to capture subliminal images to be recorded on his easel.

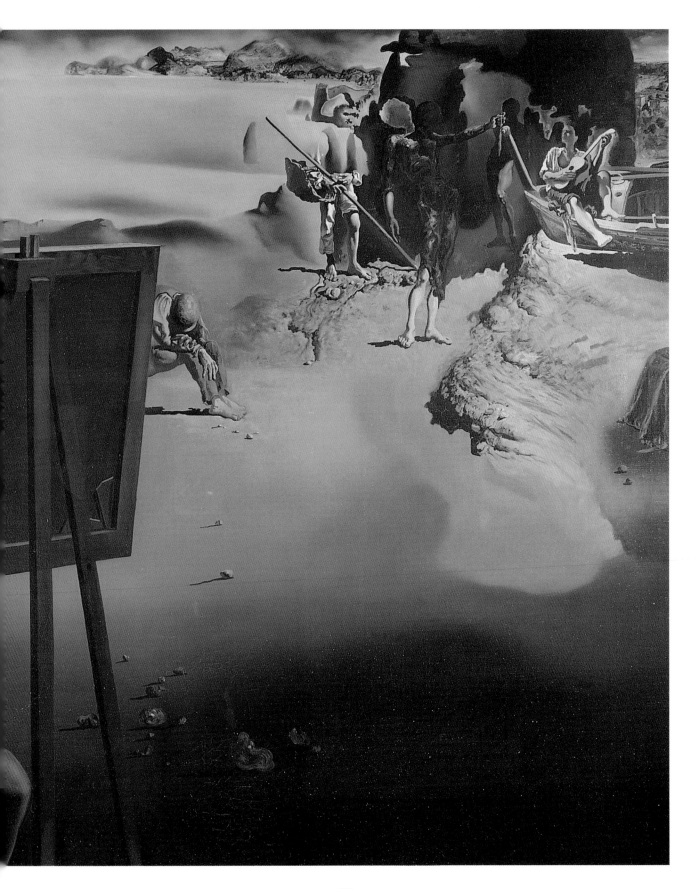

SPAIN (1938)

Edward James Foundation. Courtesy of Topham

SPAIN was painted after two years of the Spanish Civil War. Dalí had alienated himself from many fellow artists because he viewed the war as apolitical and inevitable; a by-product of human nature, specifically of Spanish nature. He was also unpopular because he had fled Spain at the outbreak of war. As in the 1936 painting *Autumnal Cannibalism*, *Spain* depicts the turmoil and devastation of a civil war and a country tearing itself apart.

Set in a burnt, desert landscape, the figure of "Mother Spain" leans against a chest of drawers, from which hangs a blood-stained cloth. Mother Spain is a double-image—her appearance is vague and transparent. She comprizes solid feet and one solid arm, while the rest of her is simply sketched or insinuated in an outline created by the tiny figures, some on horseback, that fight each other. Mother Spain's vagueness acts as a metaphor for her fragility after two years of civil war.

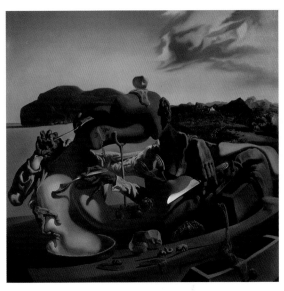

Autumnal Cannibalism (1936)
Courtesy of the Tate Gallery. (See p. 109)

The figures that form the double-image of the face of "Mother Spain' are in the style of the drawings in Leonardo da Vinci's notebooks. The colors in the painting also bring to mind Leonardo, with the use of the muted palette of browns.

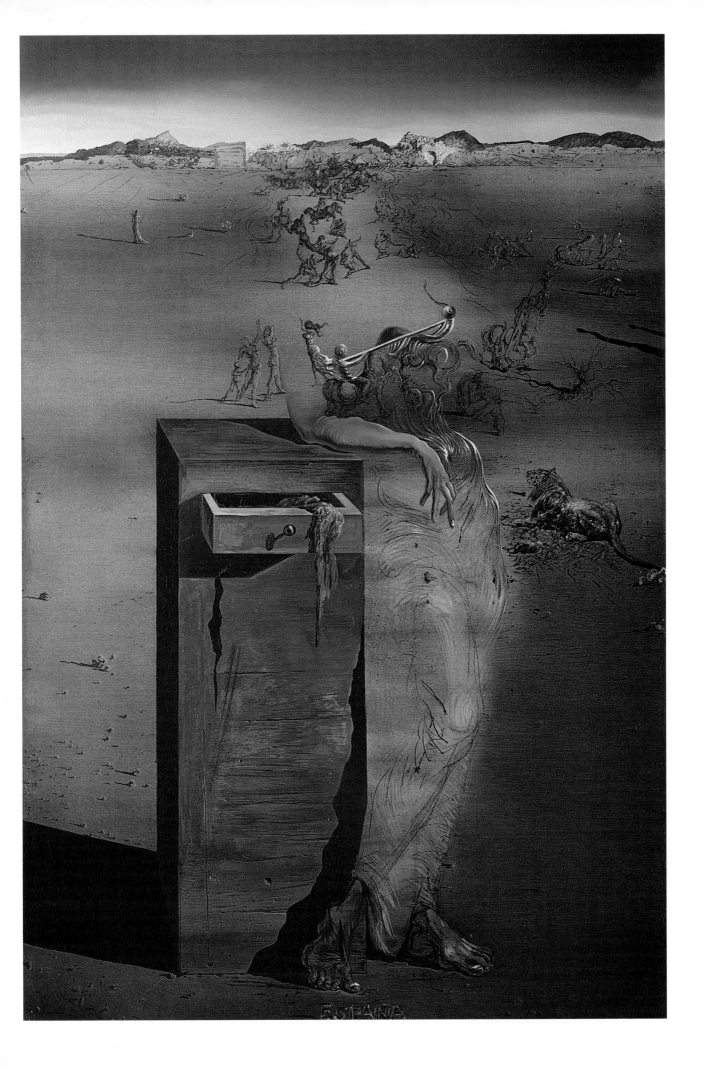

Invisible Afghan with the Apparition on the Beach of the Face of Garcia Lorca in the Form of a Fruit Dish with Three Figures (1938)

Private Collection. Courtesy of Giraudon

*I*NVISIBLE *Afghan with the Apparition* was painted in 1938, using oil on canvas. The title refers to Frederico Garcia Lorca, with whom Dalí formed an intense relationship with in the early Twenties. Lorca was shot and killed in the Spanish Civil War in 1936; this may explain his "apparition' in this painting.

Invisible Afghan is a visual illusion that consists of many objects that, when viewed together, are interpreted by the eye to be one of three possible images. The strongest image is a face that comprizes an urn and two men's heads. A fruit dish with pears also appears, formed by the shape of the rocks against the sea with the urn becoming the base. The third image is that of a very vague dog, formed by the swirling clouds, the head resting on the cliffs, its paws painted in sketchily.

Whilst employing double images such as those seen in *The Invisible Man*, *Invisible Afghan with the Apparition* is a study of the interlocking forms of three images. Dalí used the same three interlocking forms for two other paintings in 1938, *The Endless Enigma* and *Apparition of Face and Fruit Dish on a Beach*; the latter bears a close resemblance to *Invisible Afghan with the Apparition*.

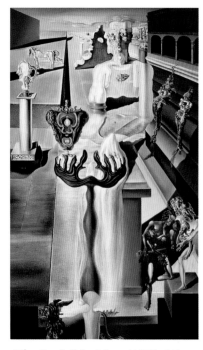

The Invisible Man (1929–32)
Courtesy of AiSA. (See p. 58)

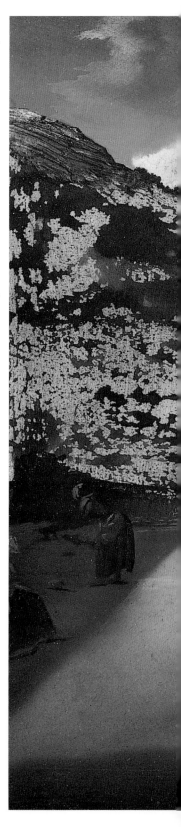

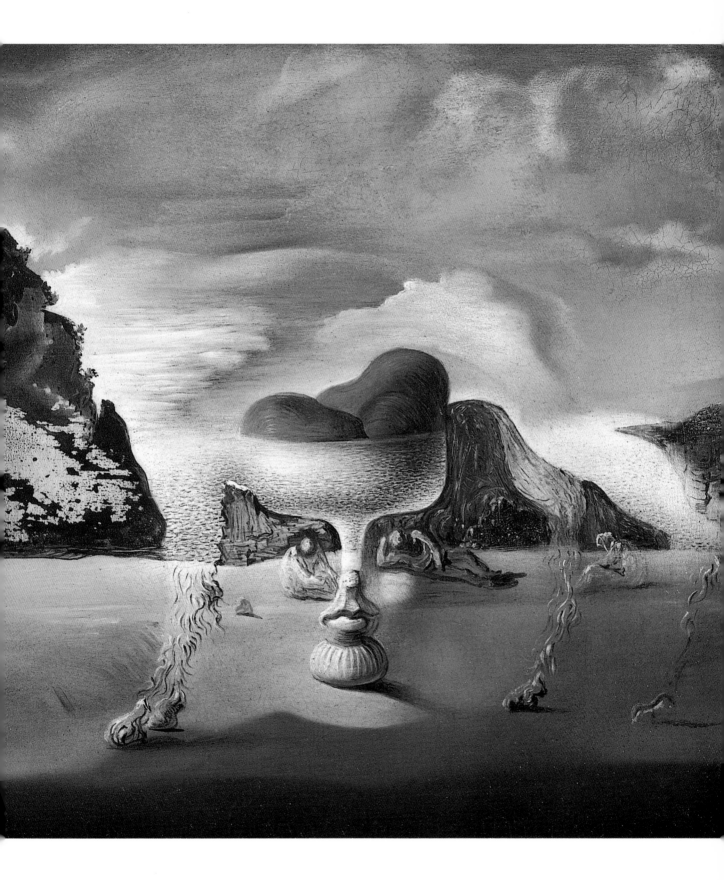

MOUNTAIN LAKE (1938)
Courtesy of the Tate Gallery

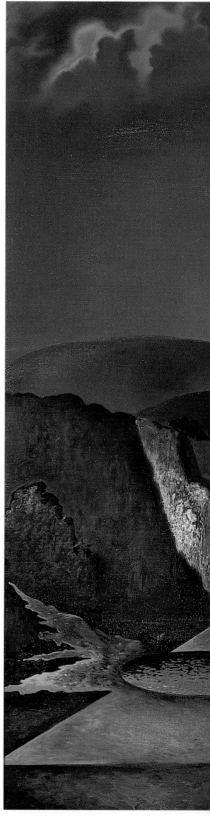

*M*OUNTAIN *Lake*, also called *Beach with Telephone*, was painted using oil on canvas. The telephone was a key image for Dalí during the late Thirties, as seen in his famous *Lobster Telephone* in 1936. Dalí believed this painting was a premonition of the Second World War. In *Mountain Lake*, as with *The Enigma of Hitler* (1936), the telephone can be interpreted as referring to the telephone negotiations between Chamberlain and Hitler to seal the Munich Agreement made in 1938.

The telephone handle is hanging by a crutch, signifying the fragility of the peace that the telephone negotiations have created. To stress this point further, there are snails crawling up the crutch and on to the handle of the phone; Dalí was fascinated with all creatures that have their own shell, with their protected softness and their hidden vulnerability.

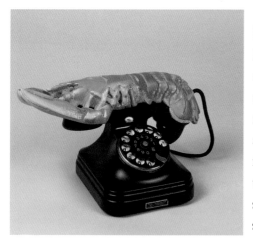

Lobster Telephone (1936)
Courtesy of Christie's Images. (See p. 110)

The mountains in the background are reflected in the lake beneath the phone to give a double image: the lake can also be seen as a fish with the ripples on it forming the scales and the jagged rock to the left forming a tail. Some have seen the image as phallic, with the solitary rock to the right suggesting a female counterpart.

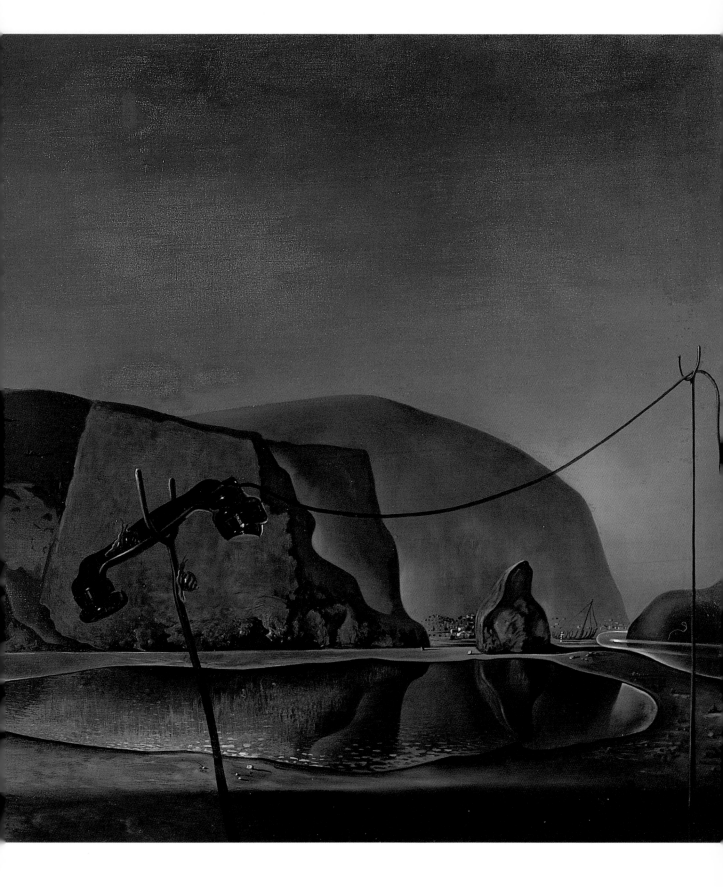

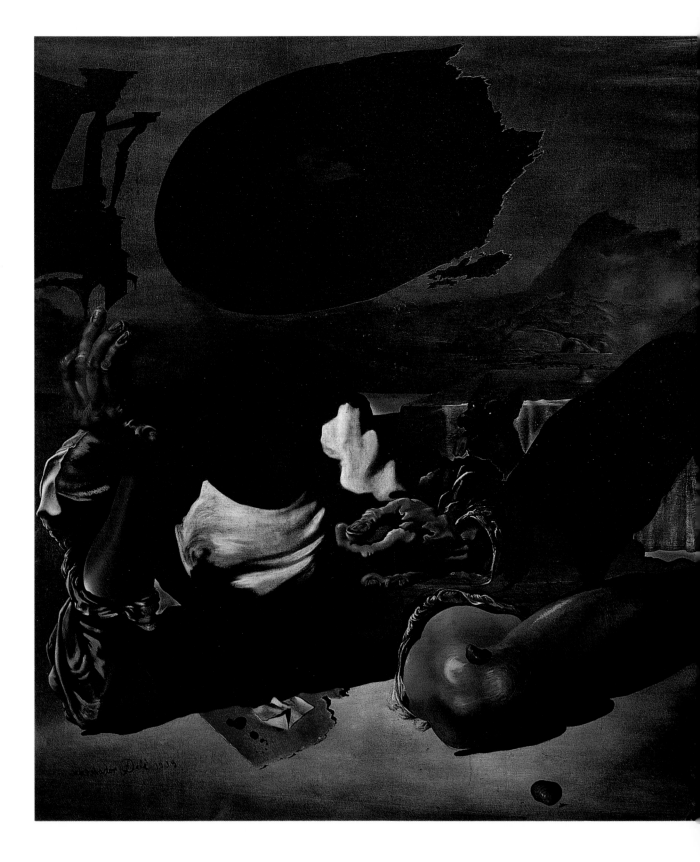

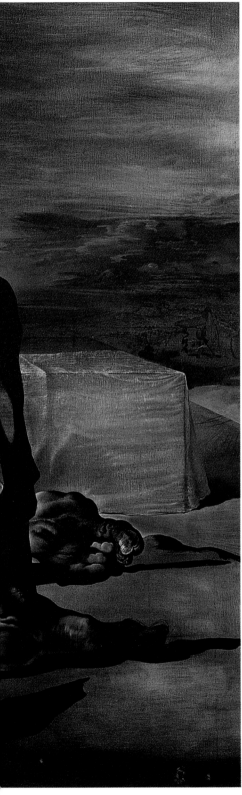

PHILOSOPHER ILLUMINATED BY THE LIGHT OF THE MOON AND THE SETTING SUN (1939)

Private Collection. Courtesy of AiSA

POSSIBLY the darkest of Dalí's paintings, *Philosopher Illuminated* was painted in 1939. The desolate philosopher lies sprawled on the ground, his head held in one hand. He is clothed in tattered shreds and his feet are bare. Against the twilight landscape, he appears to be immense. The little light that there is in the painting is coming from the right, where the sun is setting behind the mountains. The philosopher is in the dark, his face can not be seen and the viewer can not tell if he is reading the piece of paper that lies in front of him or whether he is merely contemplating his fingernails.

A huge oval moon hangs over the figure, seemingly about to crash into the ruins on the left. Thick black clouds cover the moon and it appears as if in eclipse. The egg-shape of this moon refers the viewer to Dalí's use of huge eggs as a symbol of the birth of change, as can be seen in the painting *Allegory of an American Christmas* (1934). Here the dark moon, coupled with the despondent philosopher, suggests that an ominous change is about to occur.

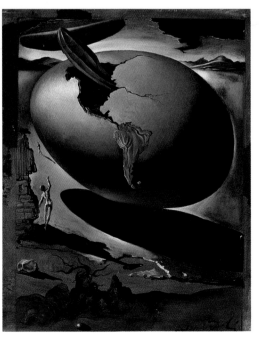

Allegory of an American Christmas (1934)

Courtesy of Christie's Images.
(See p. 104)

MASKED MERMAID IN BLACK (1939)

Courtesy of Christie's Images

IN the late Thirties, Dalí designed clothes, accessories, and jewelry in collaboration with the couturier Elsa Schiaparelli. Fashion was a particular interest of his for many years—he designed *The Woman of the Future* costume in 1953—and recognized a link between high fashion and the art scene; it was a link that was greatly augmented by his work. The Surrealists criticized Dalí's fashion work as demeaning to their art.

Masked Mermaid in Black is a design Dalí made for a pavilion at the World Fair in New York in 1939. James Edward, his patron for much of the Thirties, was the co-sponsor of the event. The other sponsor was a rubber manufacturer from Pittsburgh, who produced the costume of the *Masked Mermaid* in rubber. Dalí has proved himself to be prescient, both with his use of rubber for clothing and the clinging, revealing shape; a look that has subsequently been used by many fetish clothing companies.

The pavilion at the fair was called *The Dream of Venus*; in it mermaids wearing costumes made to the design of the *Masked Mermaid* were placed under water in a tank, performing surrealist tasks such as typing on a rubber typewriter or playing a "soft" piano.

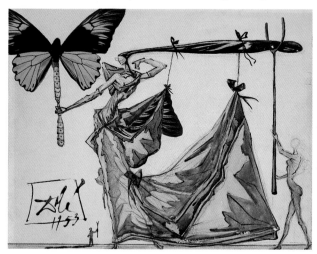

Design for the costume for *The Woman of the Future* (1953)
Courtesy of Christie's Images. (See p. 190)

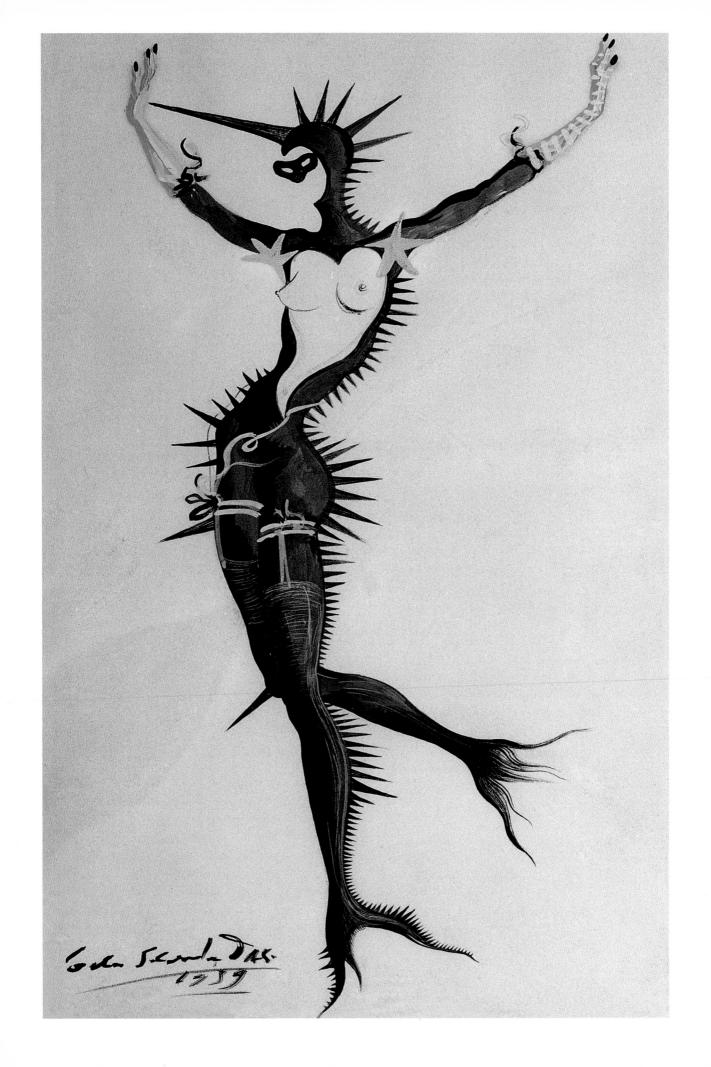

THE ENIGMA OF HITLER (1939)

Courtesy of AiSA

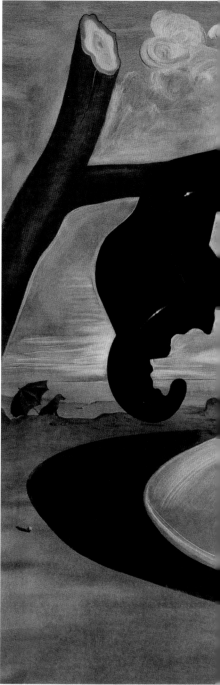

*T*HE *Enigma of Hitler* was painted in 1939, using oil on canvas. It contributed to Dalí's expulsion from the Surrealist movement. Since the early Thirties Hitler had fascinated Dalí, mainly because of the shape of his back. In 1934, he had to be stopped from painting a swastika armband on the figure of a wet nurse (the nurse is seen in this painting at the edge of the sea). The Surrealists saw Dalí's obsession with Hitler as evidence of his dubious moral and political beliefs, however, Dalí had long stated that he was apolitical, viewing wars and dictators alike as inevitable parts of human nature. Dalí explained *The Enigma of Hitler* was an interpretation of several dreams he had about Hitler; one had shown Neville Chamberlain's umbrella turning into a bat—a symbol from his childhood that filled him with fear.

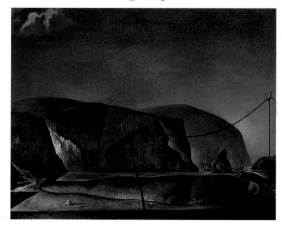

Mountain Lake (1938)
Courtesy of the Tate Gallery. (See p. 132)

The telephone was an image Dalí used often, such as in the 1938 painting, *The Mountain Lake*. In *The Enigma of Hitler* the mouthpiece has mutated into threatening lobster claws, symbolic of the danger of these times with the onset of war. The phone hangs from a mutilated olive branch, signifying the death of hope.

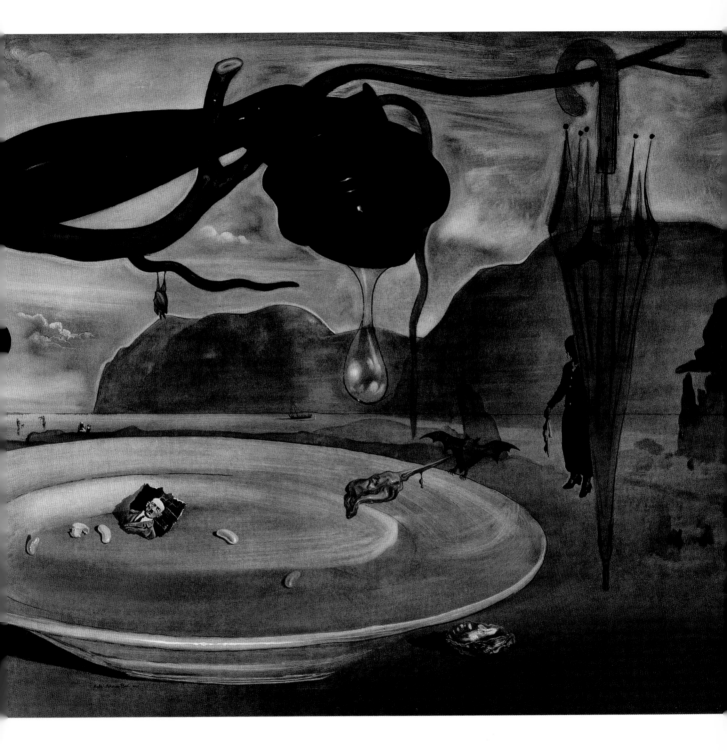

THE FACE OF WAR (1940)

Boymans-Van Beuningen Museum, Rotterdam. Courtesy of AiSA

*T*HE *Face of War* was painted in 1940, using oil on canvas, while Dalí and Gala were living in the US during the Second World War. At the time that Dalí painted *The Face of War*, the USA had not yet joined the war, although they would the following year. Like the 1938 painting *Spain*, *The Face of War* is an emotional portrayal of the harrowing effects of war.

Within the eyes' sockets and the open mouth of the face, there is a recurring image of skulls within skulls within skulls, symbolizing

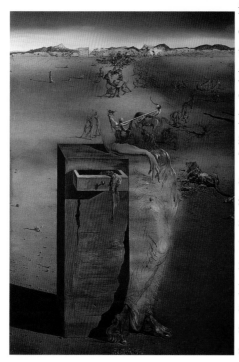

Spain (1938)
Edward James Foundation. Courtesy of Topham. (See p. 128)

infinite death. *The Face of War* is quite a conventional painting, in that there are no double images or personal symbols which appear in other of Dalí's works during this period. However, the painting is a good example of Dalí's technique. The face and the landscape it appears over are extremely smooth; the marks from the brush are minimal. Dalí would work on this technique of eliminating as much of the brushmarks as possible for hours, painting over and over till he had achieved the smooth effect he required. This smoothness on the face contrasts with the almost *trompe l'oeil* effect of the craggy rocks in the top, right-hand corner.

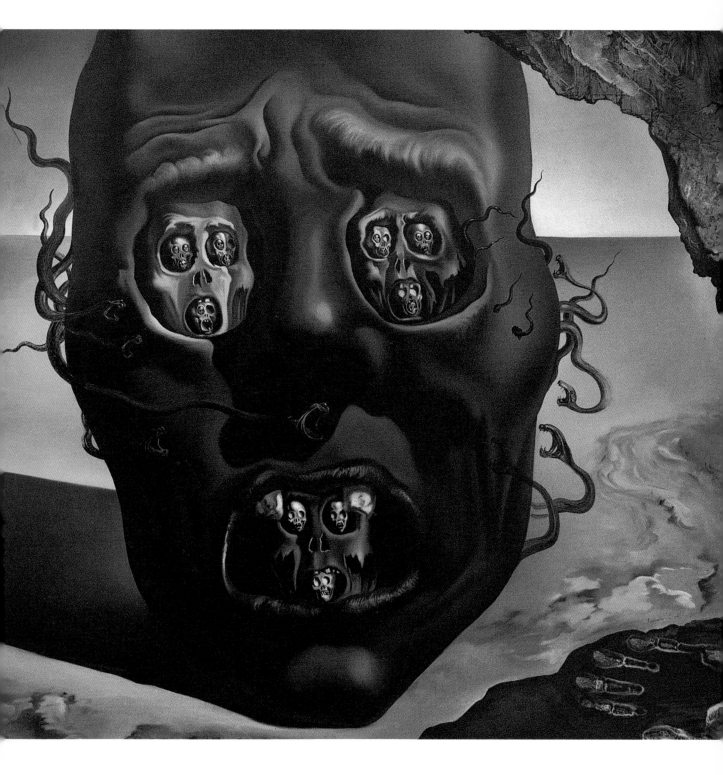

FAMILY OF MARSUPIAL CENTAURS (1940)

Courtesy of Christie's Images

DALÍ believed that *Family of Marsupial Centaurs* evinced his return to a Classical style, with a more precise technique and greater balance. He attributed the painting to Dr. Otto Rank, a psychoanalyst who theorized that neurosis could be traced back to birth trauma. Believing that he had pre-birth memories, Dalí was greatly interested in Dr. Rank's work.

The female centaurs have openings in their stomachs out of which human babies wait to be pulled free. In *The Secret Life*, Dalí wrote that he envied the centaurs because "the children can come out of, and go back into, the maternal uterine paradise."

The seascape here is the same as the one seen in *Dream Caused by the Flight of a Bee* (1944). It is based around Cadaqués, so even though Dalí was living in the US, he was painting the landscape of his homeland.

The configuration of a horse's rear is a shape that Dalí used in many paintings, often as a visual illusion. He saw a similarity of form between the horse's rear and a bunch of grapes, and to emphasize this he gives one centaur grapes to hold up.

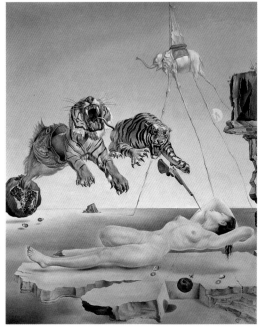

Dream Caused by the Flight of a Bee (1944)
Courtesy of Giraudon. (See p. 156)

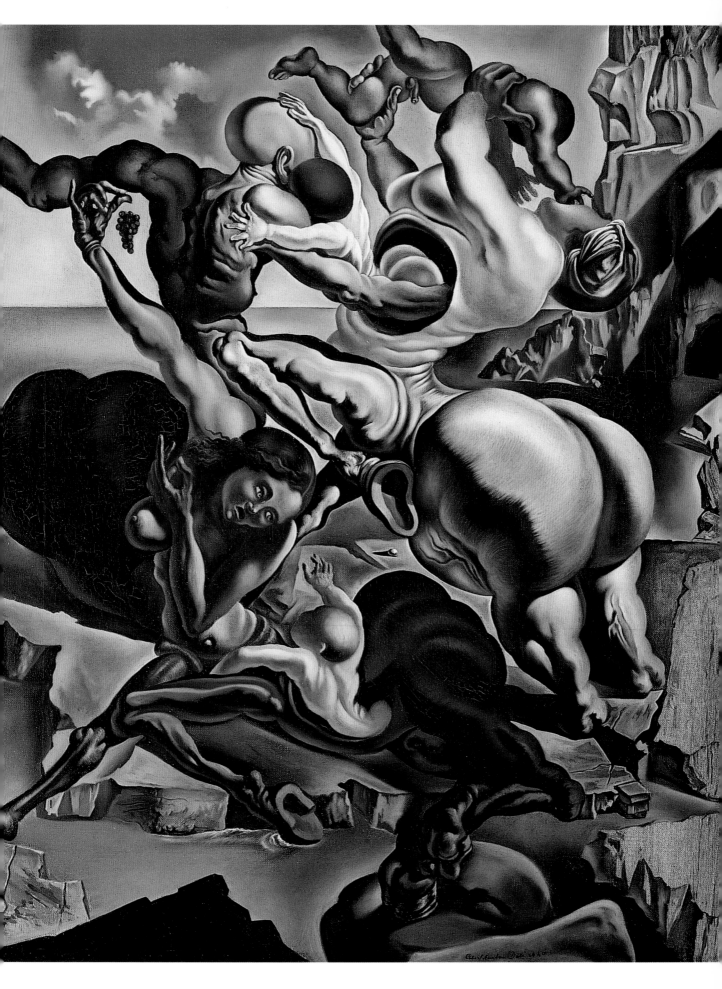

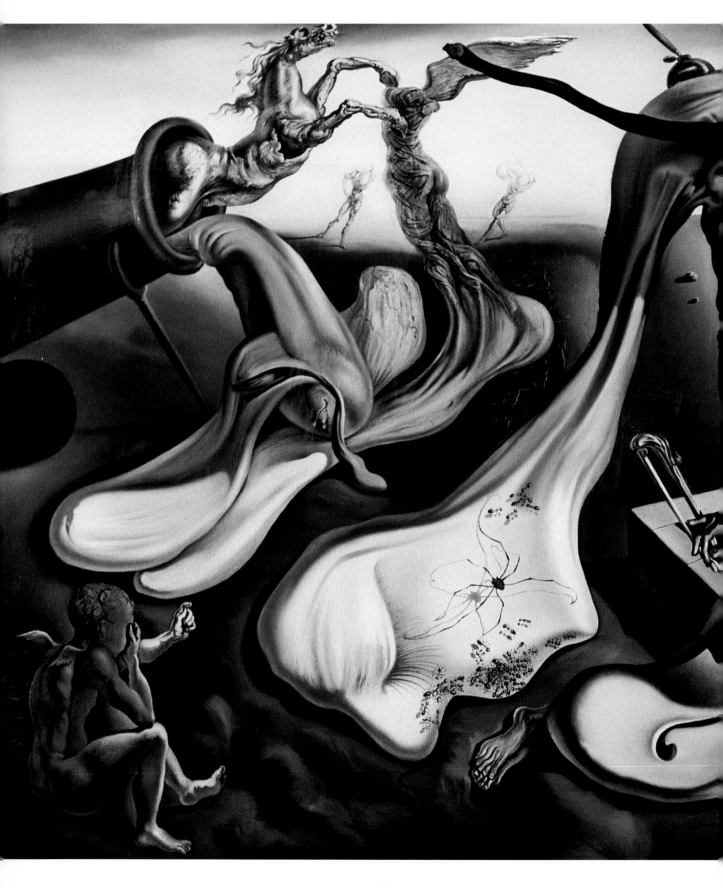

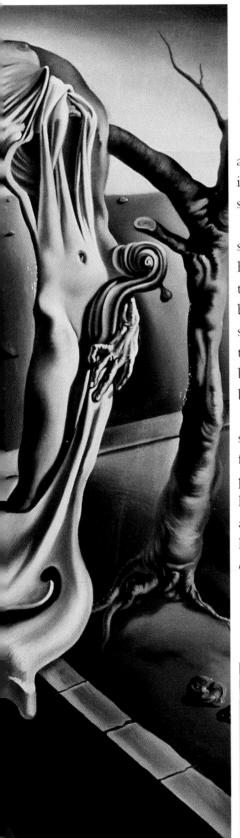

DADDY LONGLEGS OF THE EVENING
...HOPE! (1940)

Courtesy of Topham

PAINTED in 1940, using oil on canvas, *Daddy Longlegs of the Evening ...Hope!* is one of many of Dalí's works to incorporate a self-portrait. It also has the frequently occurring image of bodies stretched and twisted, as can be seen in *The Dance*.

Dalí's interpretation of *Daddy Longlegs* was a sexual one. He has again depicted himself as a "soft' head; exhausted and flushed. There are ants as well as the daddy longlegs on the face, signifying decay. The body that is joined to Dalí's head is in a near-liquid state, hanging limply over a dead tree, with skin so twisted that it has been ripped to expose the ribs beneath. The body is female; a fact Dalí emphasizes by the two inkwells that mimic the breasts.

The cannon on the left can be read as phallic, shooting out an ejaculation of murky, ghoulish figures. A crutch holds the cannon up; Dalí regularly painted phallic symbols in such a manner, hinting at his self-proclaimed impotence. In the right corner is a cherub, traditionally seen as the angel of love. He hides his eyes from the scene and so represents Dalí's dislike of the physical nature of love.

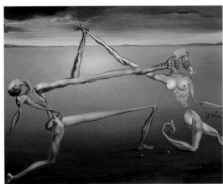

The Dance (1956)
Courtesy of Christie's Images. (See p. 202)

TRISTAN AND ISOLDE (1941)
Courtesy of Christie's Images

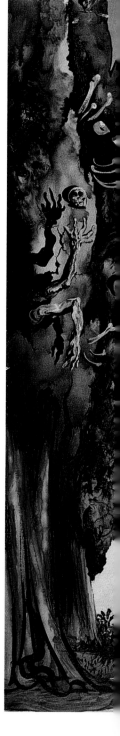

*T*RISTAN was a knight of the Round Table, who fell in love with Isolde, the future wife of his uncle, after they had both mistakenly taken a love potion. The tale is a tragic one with Tristan dying of despair and Isolde subsequently committing suicide. Wagner wrote an opera on Tristan and Isolde, which Dalí greatly admired. In 1944, he worked on the costumes, sets and scripts for three Surrealist ballets—one of which was *Mad Tristan*, based upon the tale of Tristan and Isolde. This drawing was completed in 1941 so pre-dates Dalí's ballet, but shows that the interest in Tristan and Isolde had been in his mind for some time.

This painting shares the same structure as the *Composition of the Leg* (1944). Both works are based on a flat landscape with segmenting lines drawn to a central point in the background to help give the illusion of distance. These lines separate the picture into sections that are filled with various forms that surround the one central image, which with *Tristan and Isolde* is the cypress tree. The cypress tree has a foreboding, black hole in the center into which a stepladder made from human bones leads.

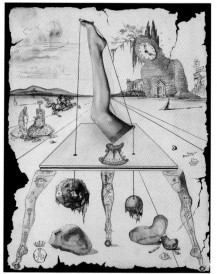

Composition of the Leg (1944)
Courtesy of Christie's Images. (See p. 154)

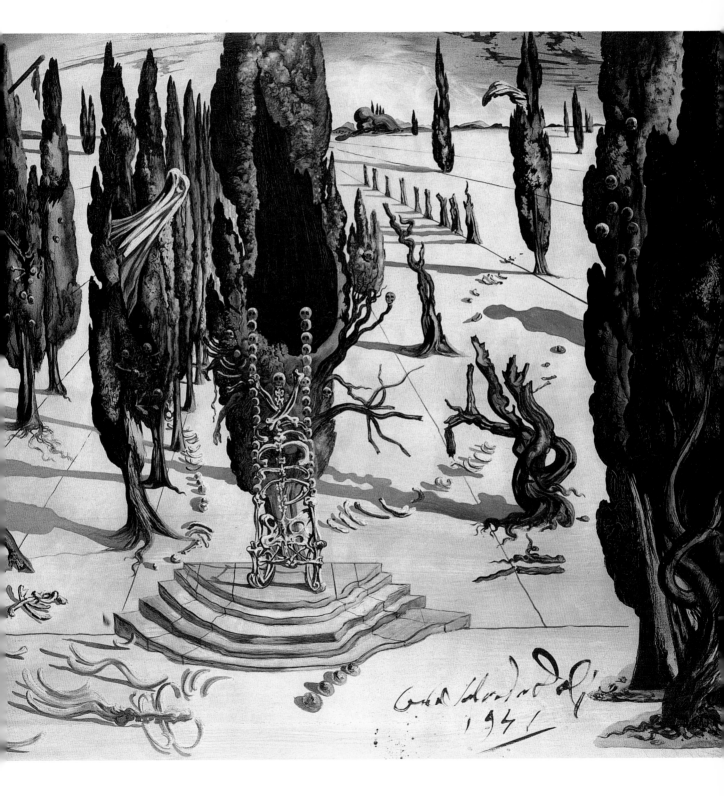

MATERNITÉ AUX OISEAUX (1942)

Courtesy of Christie's Images

MATERNITÉ *aux Oiseaux* (motherhood of birds) was painted in 1942, using watercolor on paper. This is one of Dalí's many interpretations of the Virgin Mary. Here he has chosen to paint her in probably the most common scene, with her holding the infant Jesus. Throughout history, artists have painted the Virgin Mary as they imagined her, the success of their paintings was dependent on how close their image of her was to the public's imagination. In later years Dalí was to use Gala's face or a face after

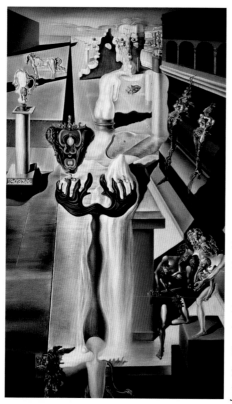

Raphael (as seen in *Raphaelesque Head Exploding*). In *Maternité aux Oiseaux*, Dalí has chosen to use a double image to form Mary's face.

By 1942 Dalí was gradually moving away from Surrealism toward his "nuclear-mystic" period, but he still employed visual illusions and double images such as those seen in the 1929 painting, *The Invisible Man*. The double images in *Maternité aux Oiseaux* are much simpler than those used for *The Invisible Man*. Mary's face is formed by the group of birds, while part of her body is loosely formed by the sea, with only her foot and the hand holding baby Jesus painted realistically.

The Invisible Man (1929–32)
Courtesy of AiSA. (See p. 58)

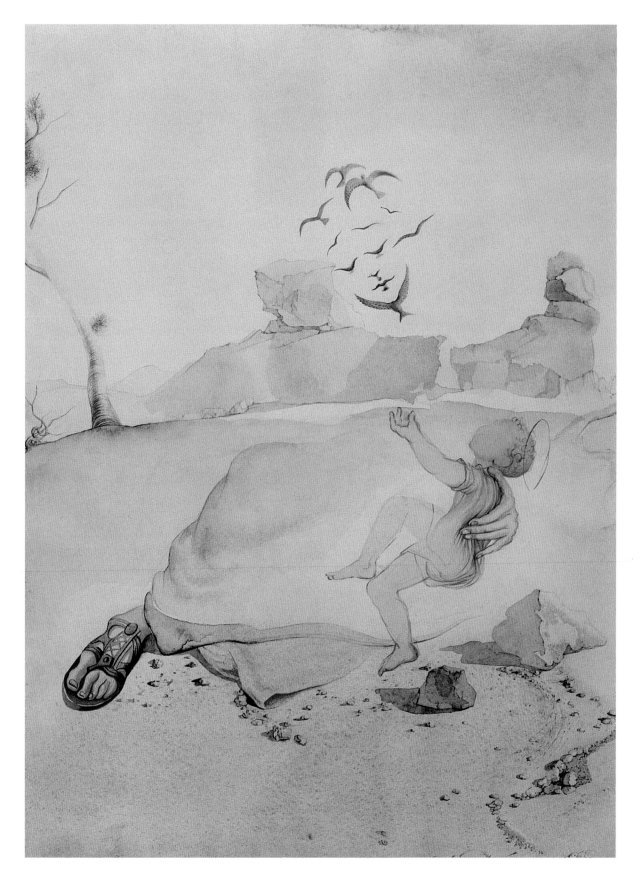

ST. GEORGES TUANT LE DRAGON (c. 1942)

Courtesy of Christie's Images

THIS painting is dedicated to the Marquis de Cuevas, who was a patron of Dalí's for many years. The marquis was married to a Rockerfeller millionairess, so had plenty of available funds to back Dalí's projects. *St. Georges Tuant le Dragon* is painted in oil on ivory. This rather expensive form of canvas could be the reason for the diminutive size of the work, measuring only 3 x 4 in (7.5 x 10 cm).

The frame is made from gold encrusted with seed pearls, and the corners are decorated with baguette-cut diamonds. Dalí regularly used precious jewels and metals in his work. He also liked to find unusual frames for his paintings, such as the gilt frame of *Messenger in a Palladian Landscape*.

A naked St. Georges is gripping on to the haunches of his horse while he is thrusting his lance into the open mouth of the dragon. The horse is lying on top of the dragon so that only the head of the beast can be seen. Around the horse's neck is the dragon's tail, its claws digging into the side of the horse. The horse looks fierce, taking on some of the dragon's features as it grimaces in pain.

Messenger in a Palladian Landscape (c. 1936)
Courtesy of Christie's Images. (See p. 112)

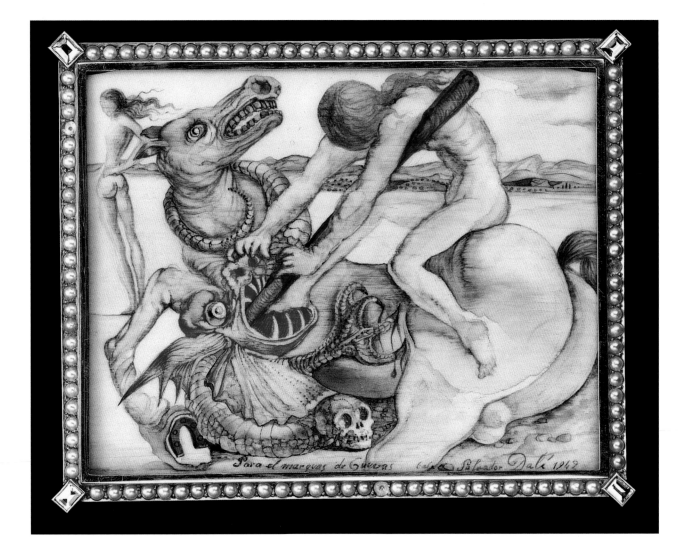

LE MENDICANT (1943)

Courtesy of Christie's Images

*L*E *Mendicant*, or the beggar, was executed in 1943, while Dalí was living in the US. The influence of his travels in Italy during the late Thirties can be seen here; Dalí had studied the great Masters, and in this drawing his emulation of their use of structure and harmonious form is discernable.

Le Mendicant is a pen and ink study on cartridge paper. On the left, the foreground is minutely detailed with no paper left showing at all. The features of the man and child (another version of the father and son that Dalí was so often to include in the background of his paintings) are clear, the viewer can see the man's hooked nose and bloody sleeves as he reaches out for aid.

The rest of the drawing is more insubstantial. This difference in style means that the foreground figures act as a frame for the drawing and, with their arms outstretched, bring the viewer's attention to the central figures of the two struggling men and the rearing horse. Dalí had been creating this image of the man and horse for some time; it can also be seen in the drawing *Messenger in a Palladian Landscape* (1936).

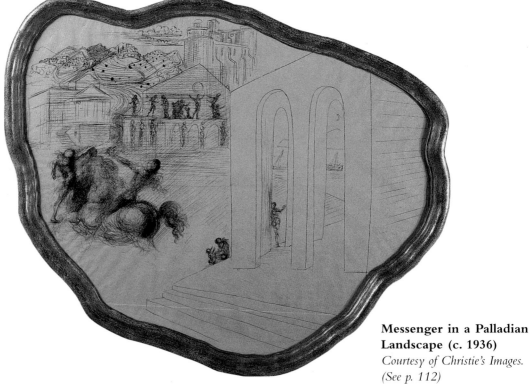

Messenger in a Palladian Landscape (c. 1936)
Courtesy of Christie's Images.
(See p. 112)

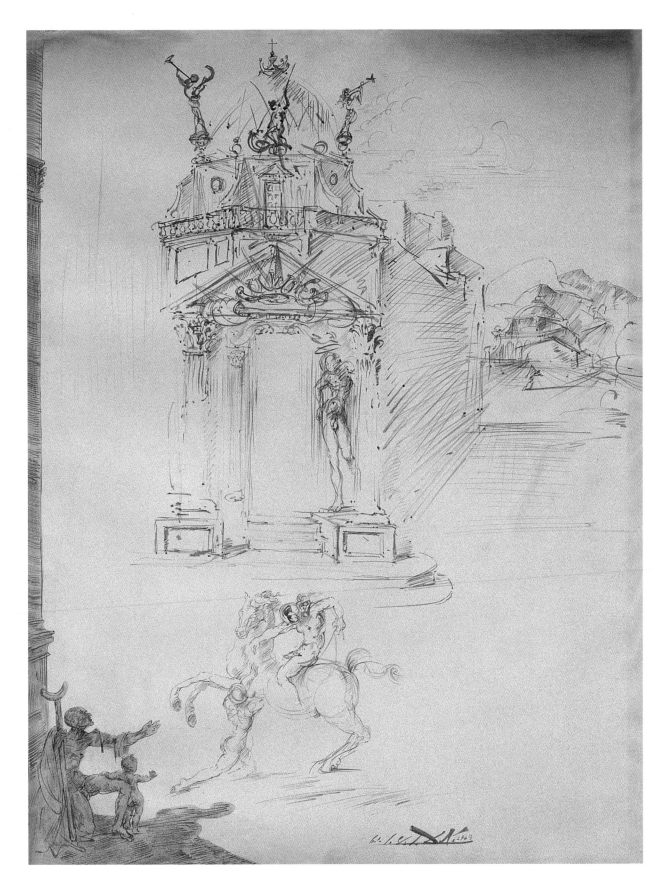

COMPOSITION OF THE LEG (C. 1944)
Courtesy of Christie's Images

ANDRÉ Breton, the leader of the Surrealists, gave Dalí the unsavory nickname of Avida Dollars, an anagram of his name meaning "greed for money," because of what he and other Surrealists saw as Dalí's disregard for art in favor of profit. This drawing, from about 1944, was part of a commission to design an advertisement for a hosiery company. Dalí went against the Surrealists' ethics by painting portraits for money; advertisements were an even further digression, and by the Forties, Dalí's links with the Surrealist group were at an end.

This drawing is in a mixture of mediums such as ink and collage; the central leg is a photograph placed upon the paper. In his commercial work, Dalí would include familiar images from his paintings of the time. In *Composition of the Leg*, there are many Dalínian images—the ant in the foreground or the crumbling clock tower with the cypress trees on top—or the man and child in the distance. This drawing takes two images from *Le Mendicant* (1943) which was executed the year before: behind the clock tower are the same ruins and the figure on horseback to the left of the collaged leg also appears in *Le Mendicant*.

Le Mendicant (1943)
Courtesy of Christie's Images. (See p. 152)

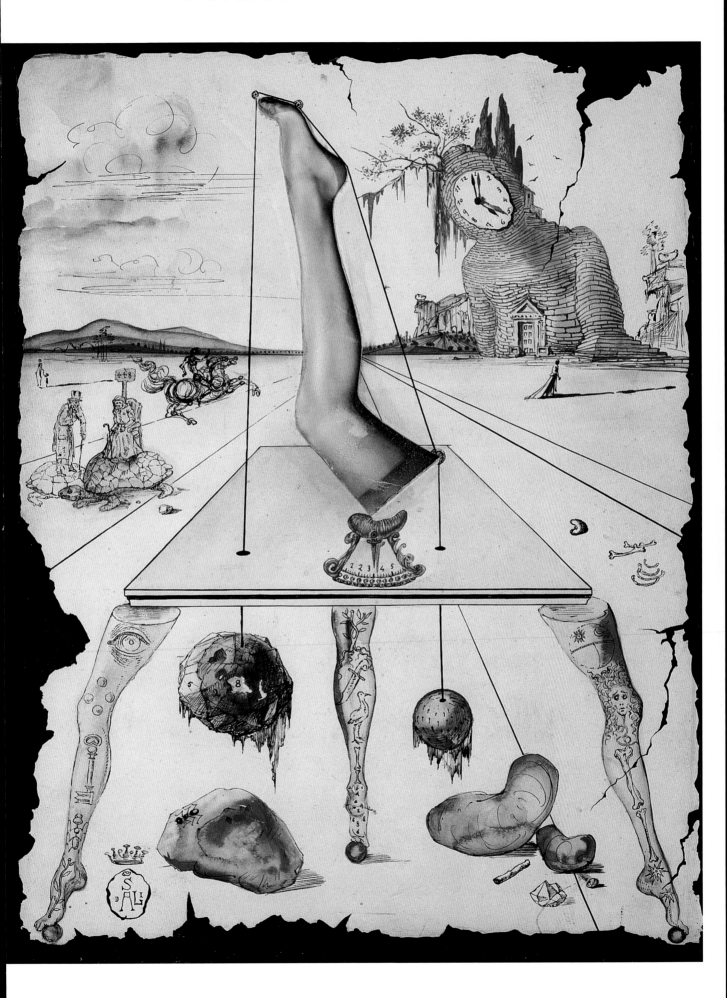

DREAM CAUSED BY THE FLIGHT OF A BEE AROUND A POMEGRANATE, A SECOND BEFORE WAKING UP (1944)

Courtesy of Giraudon

*D*REAM *Caused by the Flight of a Bee* was painted, using oil on canvas, in 1944, while Dalí and Gala were living in America. The full title explains the subject and content of the painting, which was taken from a dream that Gala reported to Dalí. He announced that this painting was the first illustration of Freud's discovery, that external stimuli could be the cause of a dream.

The catalyst for the dream, which is the pomegranate, hangs in the air with the bee flying toward it. Behind the pomegranate Gala's dream unfolds over a sea of brilliant blue. A naked Gala lies asleep as she hovers over a stone; an allusion to the common floating feeling that can occur in dreams.

To the left of Gala is a huge pomegranate that spills seeds on to the sea below. Out of the pomegranate an angry, pink fish is emerging with a wide open mouth. A snarling tiger leaps out of the fish. From this tiger another emerges, its tail in the mouth of the previous one. The tigers are rushing toward Gala, their claws at the ready, but it is the bayonet, mirroring the sting of the bee, that will wake her.

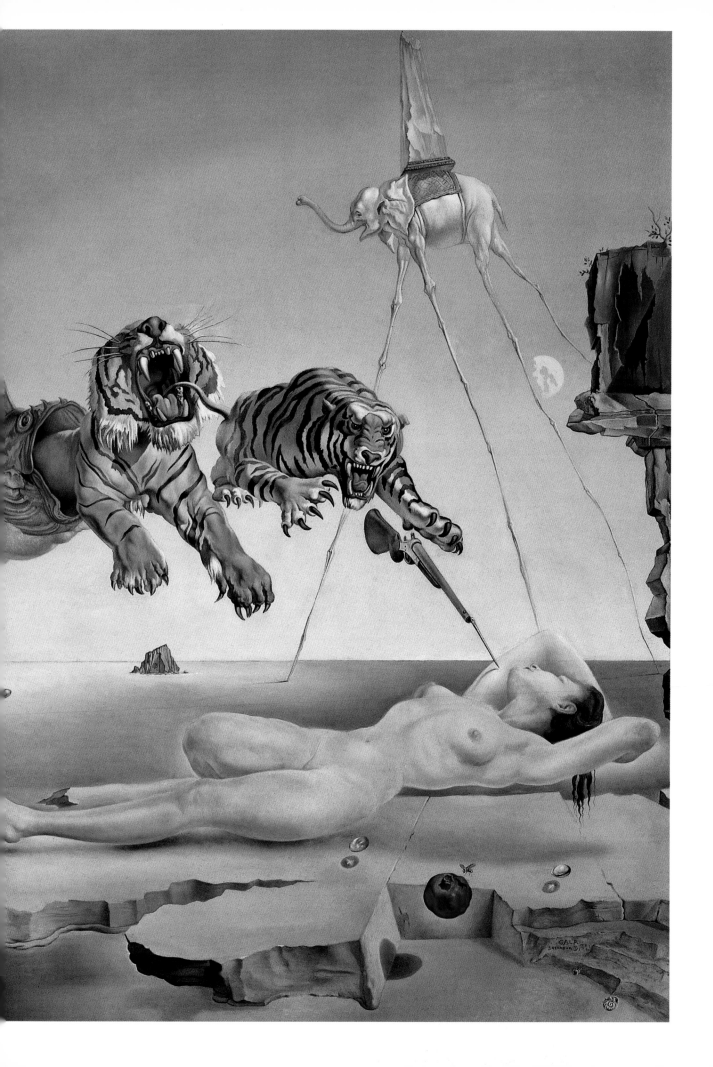

STUDY FOR THE DIVINE COMEDY (published 1945)
Courtesy of AiSA

DALÍ was asked by the Italian government to produce 200 watercolor illustrations for an edition of Dante's *The Divine Comedy*, the thirteenth-century Italian poet's most celebrated work. The story follows the journey of one man through purgatory and hell, using Virgil as his guide and eventually finding Paradise. Instead of signing this drawing, which is a study for the book, Dalí has engraved his name and the date on the rock, thereby making his presence an integral part of the picture.

The dominating image of the drawing is a huge clock tower, which appears in other works such as *Composition of the Leg* (c. 1944). A visual pun is created by the use of the "face" of the clock. Dalí has used an inanimate object and given it the human characteristics suggested to him by the objects' configuration. Dalí used this technique in earlier paintings such as *The Great Masturbator* (1929) where a rock formation from Cabo Creus became the huge self-portrait. The clock tower seems despondent, with sloping shoulders and a vertical crack culminating in the tree growing like a weed at the top of its downturned head.

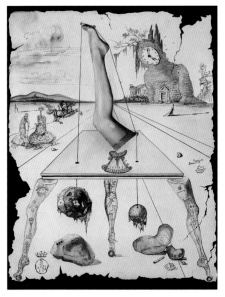

Composition of the Leg (c. 1944)
Courtesy of Christie's Images. (See p. 154)

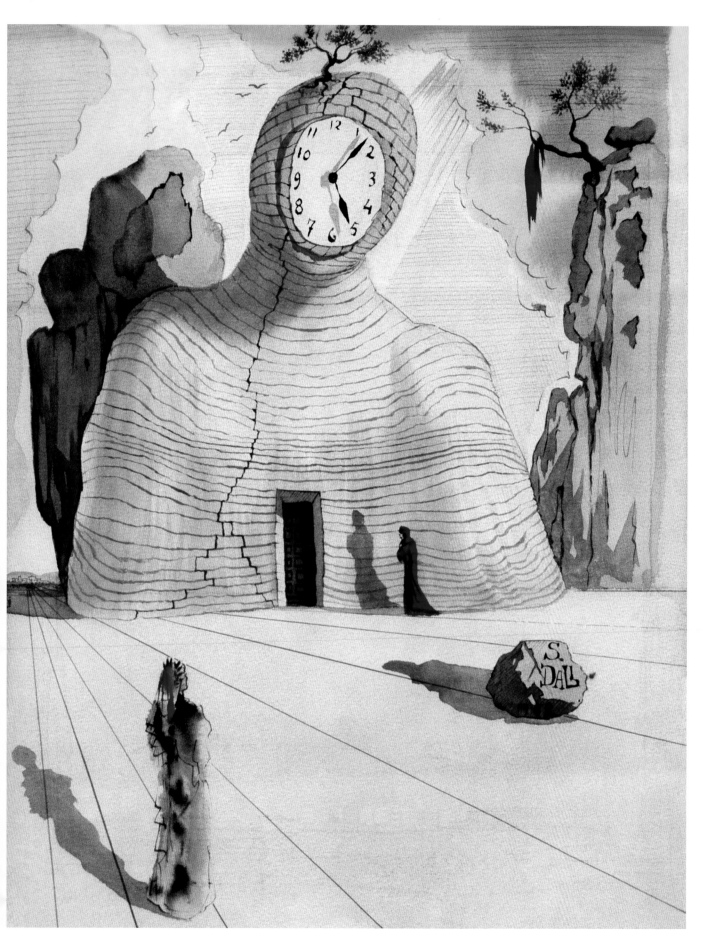

MY WIFE, NAKED, LOOKING AT HER OWN BODY, WHICH IS TRANSFORMED INTO STEPS, THREE VERTEBRAE OF A COLUMN, SKY, AND ARCHITECTURE (1945)

Private Collection. Courtesy of Giraudon

MY Wife, Naked, Looking at her own Body was painted in 1945, using oil on panel. It is one of several portraits of Gala where she is viewed from the rear. Dalí said that he had instantly realized Gala was the incarnation of his childhood love, the woman he waited for, upon seeing her back, which he believed had the ideal form. In his autobiography *The Secret Life of Salvador Dalí*, he wrote that Gala's image was "comparable to the serene perfection of the Renaissance' and that she was "as well painted as a Raphael."

On the wall to the right of Gala is a Grecian stone head, which emphasizes the Classical style of the painting. Apart from the Surrealist architectural Gala, this painting could be regarded as Classical.

Gala looks ahead to see her own body, as the title explains, transforming into architecture. The ends of her hair are formed from stonework reminiscent of that seen on the self-portrait, *The Great Masturbator* (1929). The column that would be Gala's backbone is metallic, creating a visual commentary on the strength and tenacity of his wife. Inside the architectural Gala is the tiny figure of a man, appearing lost inside a huge cage.

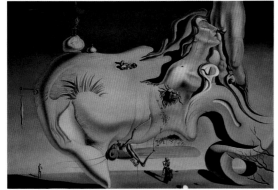

The Great Masturbator (1929)
Private Collection. Courtesy of AiSA. (See p. 48)

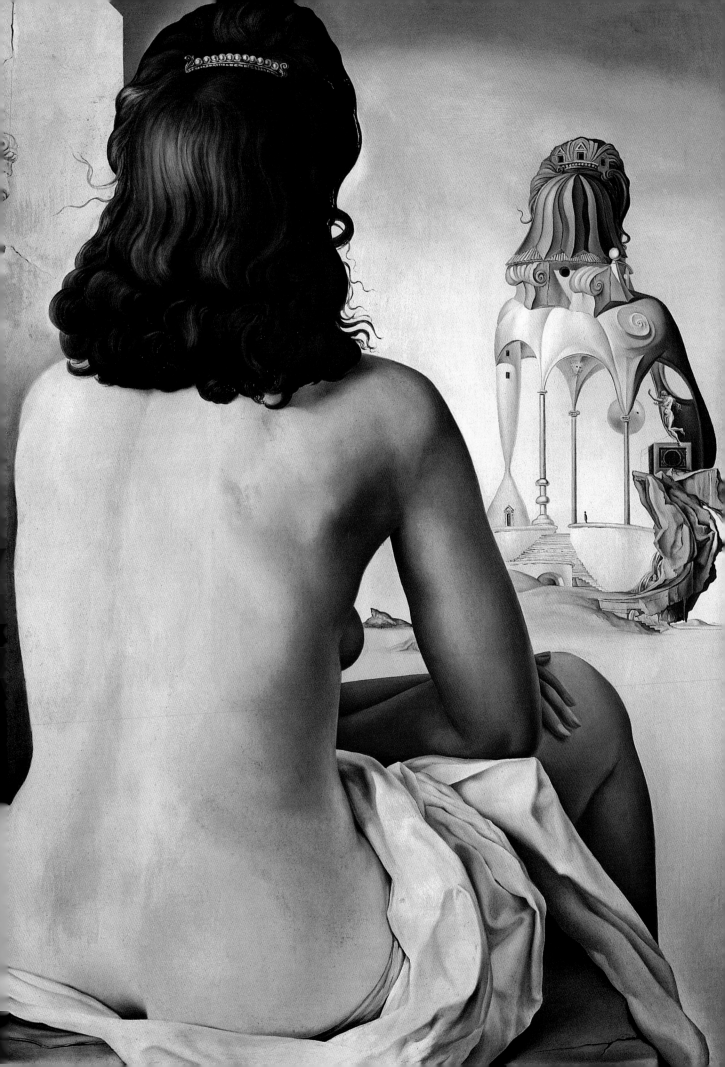

PORTRAIT OF MRS. JACK WARNER (1945)

Courtesy of Christie's Images

DALÍ painted this portrait in 1945, using oil on canvas. The sitter is Ann, wife of Jack Warner, who was the head of Warner Brothers Studios. Dalí was living in California at the time and he and Gala gained many rich and fashionable friends, becoming a part of the social élite.

Dalí's portraits were very chic during the Forties—he had clients who included the wealthy and the famous, such as Helena Rubenstein. Jack Warner was so impressed with the portrait of his wife that he asked Dalí to paint him also; it took him five years to finish the portrait. On the final completion, Warner said that the portrait was a great one of his dog and hung it in his kennels to prove his point.

Ann Warner appears severe in this painting; her skin tone is almost sickly with a gray overtone. The background of the portrait is a characteristically flat, desolate land with ruins clustered together and a few tiny figures. To the right, behind Ann, the land appears greener, almost lush by comparison. In the sky dense clouds form strange shapes, an image Dalí also used in *Le Spectre et le Fantôme* of 1934.

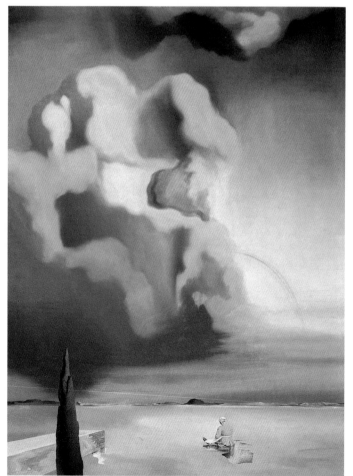

Le Spectre et le Fantôme (1934)
Courtesy of Christie's Images.
(See p. 102)

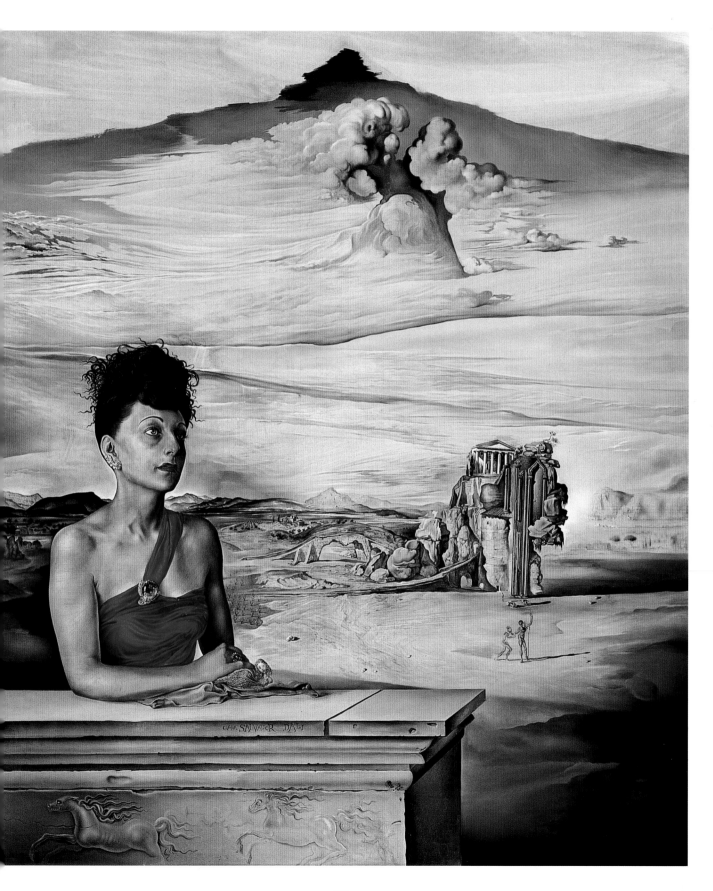

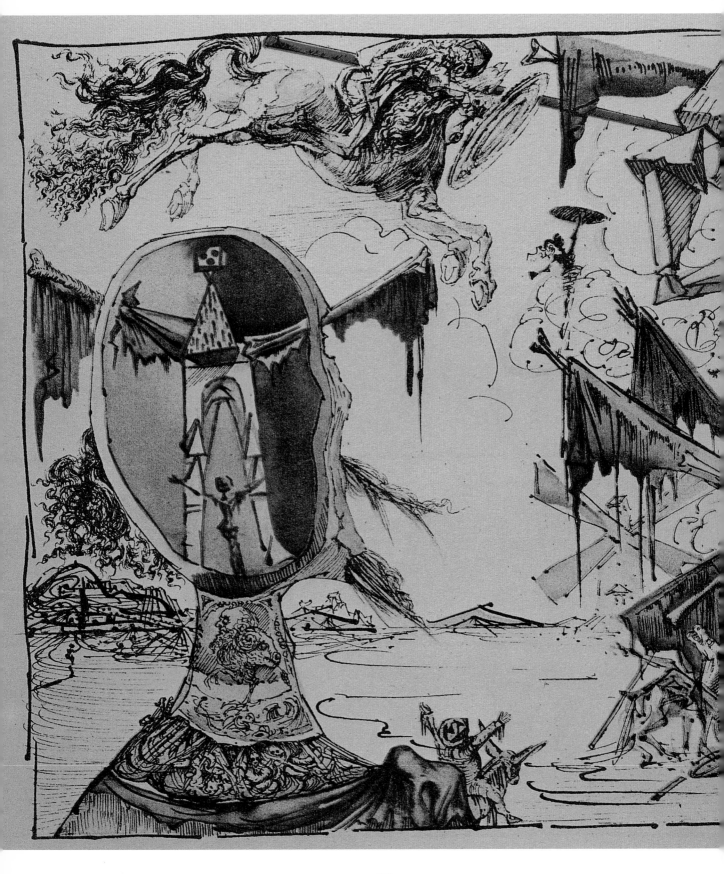

DON QUIXOTE (1946)

Courtesy of Topham

*D*ON *Quixote* was written by Miguel de Cervantes Saaredra. It is the classic tale of a Spanish man who read many adventure stories, changed his name to Don Quixote of La Mancha and took to the roads to seek adventures of his own. In his quest to become a knight renowned for his valor and courage, Don Quixote saw adventures and dangers where there are none. This drawing is from the 1946 edition of the book that Dalí illustrated. In the same year he also illustrated *The Autobiography of Benvenuto Cellini*.

This drawing depicts the most famous of Don Quixote's adventures, Don Quixote and the Windmills. The character charges through the air at the top of the picture, his lance at the ready to attack the "giants." The giants are, as his squire Sancho tells him, just windmills, but Don Quixote insists that they are giants waving their arms at him. In the foreground, on the left, is a giant head with the back open for the viewer to see inside—a reference to Sancho's words that Don Quixote must have windmills inside his head to see giants where there are in fact only windmills.

BENVENUTO CELLINI AND JUPITER (1946)
Courtesy of Christie's Images

BENVENUTO Cellini was an Italian goldsmith, metalworker and sculptor of the sixteenth century. Dalí illustrated a 1946 edition of his autobiography. The artist was interested in Italian Classical art and architecture, greatly inspired by visits to the country. He painted *Rome* in 1949.

Benvenuto Cellini and Jupiter illustrates the story of Cellini, who while working for the King of France, unveils his new sculpture of Jupiter, (the supreme God in Roman mythology). Cellini had made his Jupiter entirely from silver, in one hand he held a thunderbolt, in the other the world. Dalí's Jupiter fills most of the picture; he seems to be moving, with one foot held out behind him as if he is about to trample on Cellini in the foreground.

Once the figure of Jupiter was completed, Cellini positioned the piece in a dark hallway at the king's palace. He made a servant stand behind the sculpture with a white torch so that the silver would shine in the dark. Behind Jupiter were several more traditional bronze sculptures by Bologna, which can also be seen in Dalí's illustration. The king was delighted with the Jupiter, but others were critical of Cellini for his modernity in using silver.

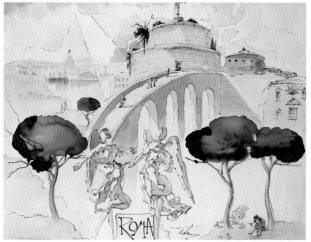

Rome (1949)
Courtesy of Christie's Images. (See p. 178)

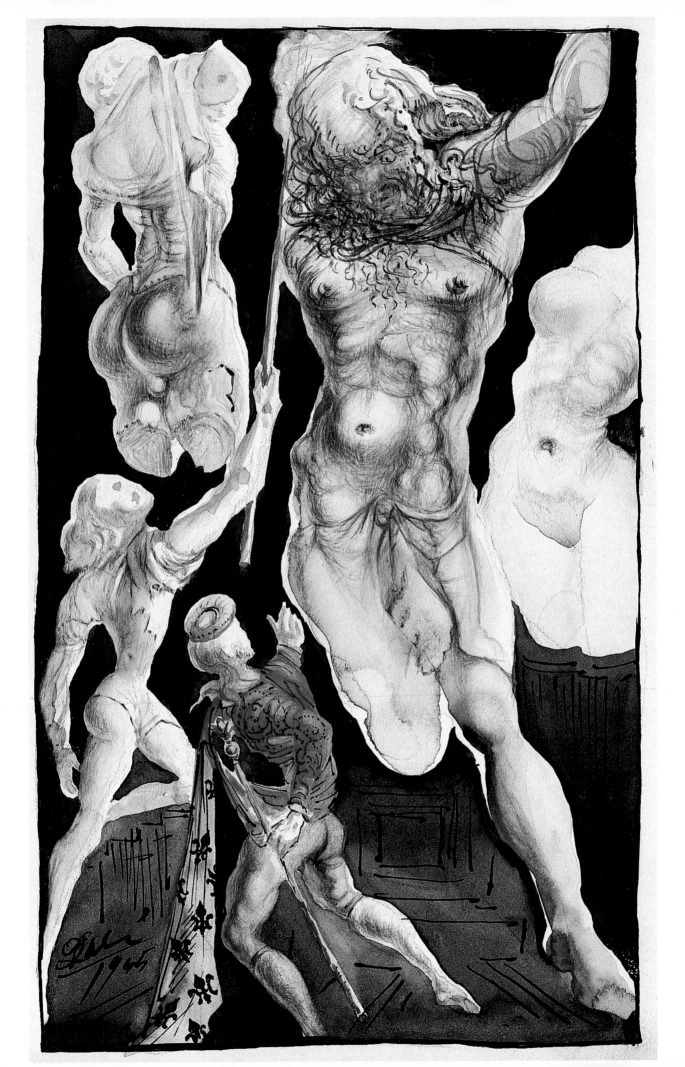

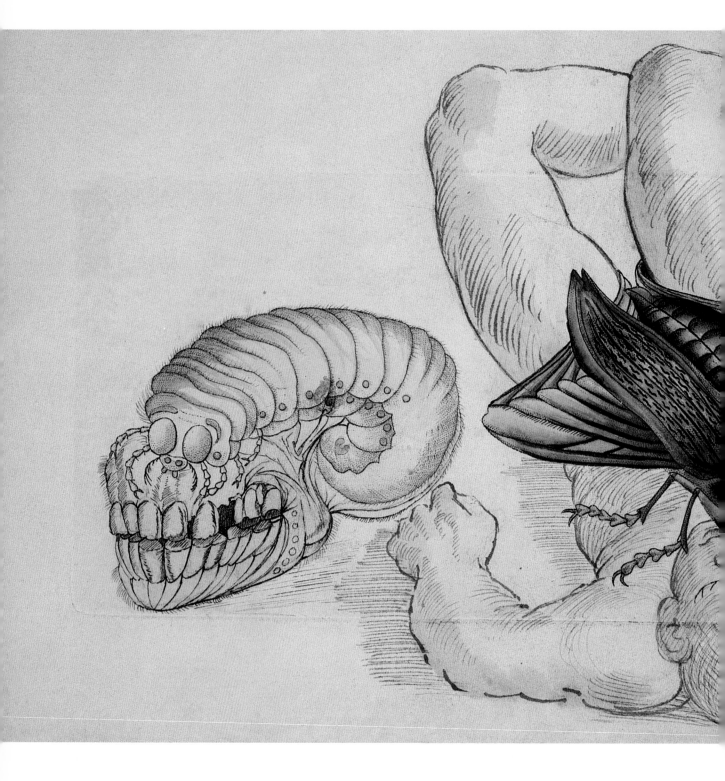

MÉTAMORPHOSE (1946)

Courtesy of Christie's Images

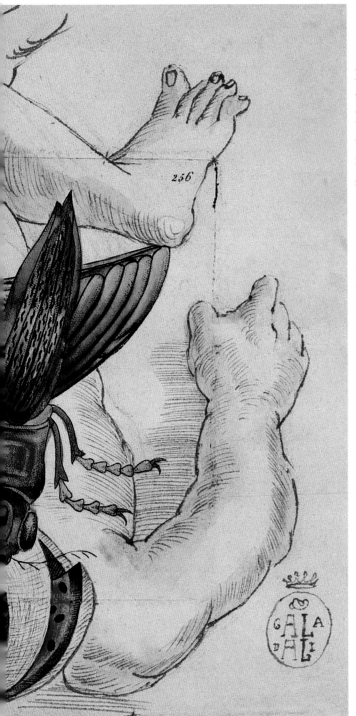

DALÍ's inspiration for this drawing seems to be the 1912 Franz Kafka tale *Metamorphosis*, where the hero is transformed into a huge bug. *Métamorphose* was executed around 1946; although not signed, it has a collector's stamp in the right corner.

The picture combines two of Dalí's most favored subjects, transformation and insects. Some insects, such as the grasshopper, were symbols of fear for Dalí but on the whole he had a keen interest in them and so was able to reproduce them skillfully.

The use of watercolor is restricted to areas that Dalí wanted to emphasize; the insect and the man's open skull. The insect bites into the head to reveal the inside is a watermelon. At a first glance, the object to the left of the man is a skull, on closer inspection the top of the skull is formed by a larvae attached to it. Dalí often painted skulls or transformed heads. In St. *Georges Tuant le Dragon* (c. 1942), a skull appears at the bottom of the painting to emphasize that death is occurring. In *Métamorphose* the skull could represent a death or an evolution.

MADONNA (1946)
Courtesy of Christie's Images

THIS portrayal of the Madonna was painted in 1946, using watercolor on canvas. The canvas is small at 10.5 x 10 in (25.5 x 24.2 cm) and Dalí has only used half of it. The work is indistinct, a rough sketch, but by 1946 anything with his signature on it would sell. Under the strict supervision of Gala, who was highly motivated by greed, Dalí often rushed off a painting or a sketch to be sold quickly and profitably.

The Madonna here is suggestive of a Renaissance Madonna, with her serene air, her closed eyes and the tilt of her head. Her vague half-smile is reminiscent of Leonardo da Vinci's *Mona Lisa*. With these influences, the sketch does hint at the direction that Dalí was taking with his art; the subject is Classical and the style, in its imitation of the great Renaissance masters, is Classical also.

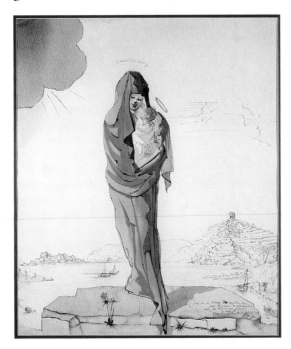

The Madonna became a popular subject for Dalí in the early Fifties, during his "nuclear-mystical" period. The face in *Madonna* is similar to the one in *Jour de la Vierge* painted in 1947, but both of these can be seen as practise runs for *Raphaelesque Head Exploding*.

Jour de la Vierge (1947)
Courtesy of Christie's Images. (See p. 177)

INTRA-ATOMIC BALANCE OF A SWAN'S FEATHER (1947)

Private Collection. Courtesy of AiSA

*I*NTRA-ATOMIC *Balance of a Swan's Feather* was painted in 1947, using oil on canvas. Like the painting *Dematerialization Near the Nose of Nero*, also painted in 1947, it marks Dalí's interest in the emerging field of nuclear science and physics. This new interest was combined with his reawakened religious beliefs to produce what he termed "nuclear mysticism." The atomic bombings of Japan at the end of the Second World War had catalysed his conversion to this "nuclear mysticism." Since then, Dalí had been subscribing to scientific journals to ensure that he was aware of new developments within the scientific community. He wrote that since the atomic bombing of Hiroshima, "the atom was my favorite food for thought."

Intra-Atomic Balance of a Swan's Feather is Dalí's interpretation of the splitting of the particles within atoms, and the forces of attraction and repulsion. In the painting, ten objects, some related some not, appear frozen, suspended in the air in front of a stone background. The swan's feather of the title floats down the painting, while above is the swans' head and to the left, its foot. The central image of the hand is painted realistically, the fingers reaching toward an inkwell beneath it.

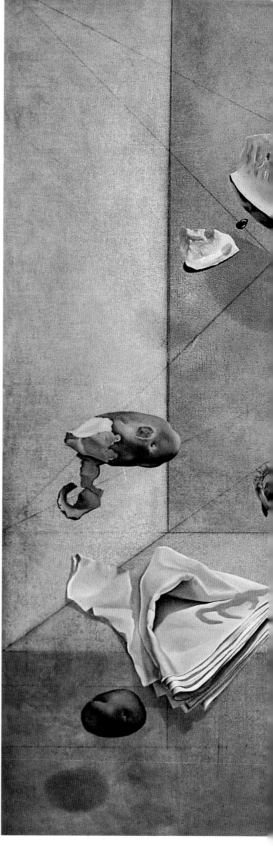

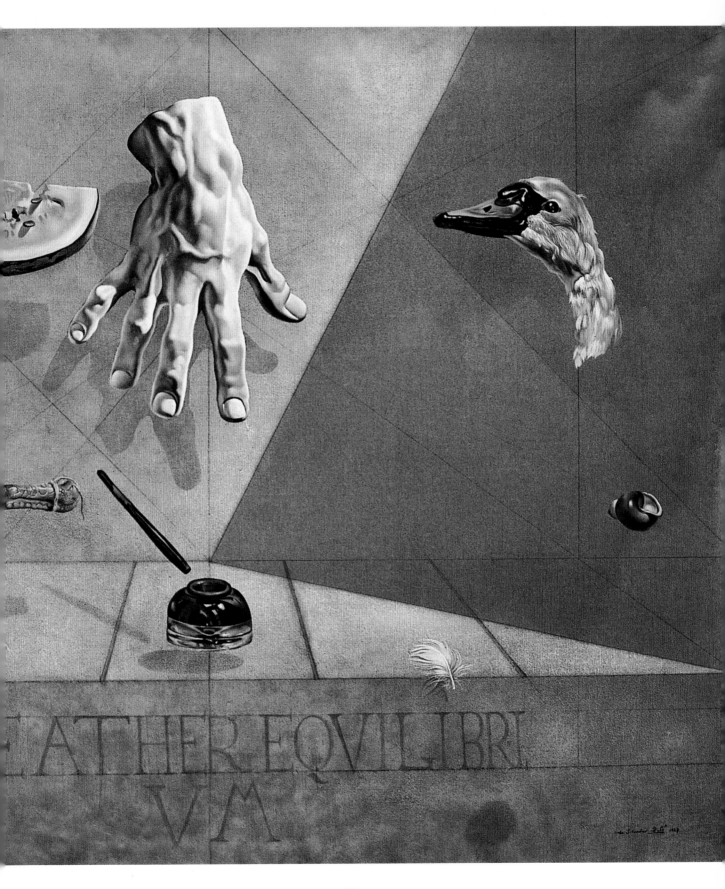

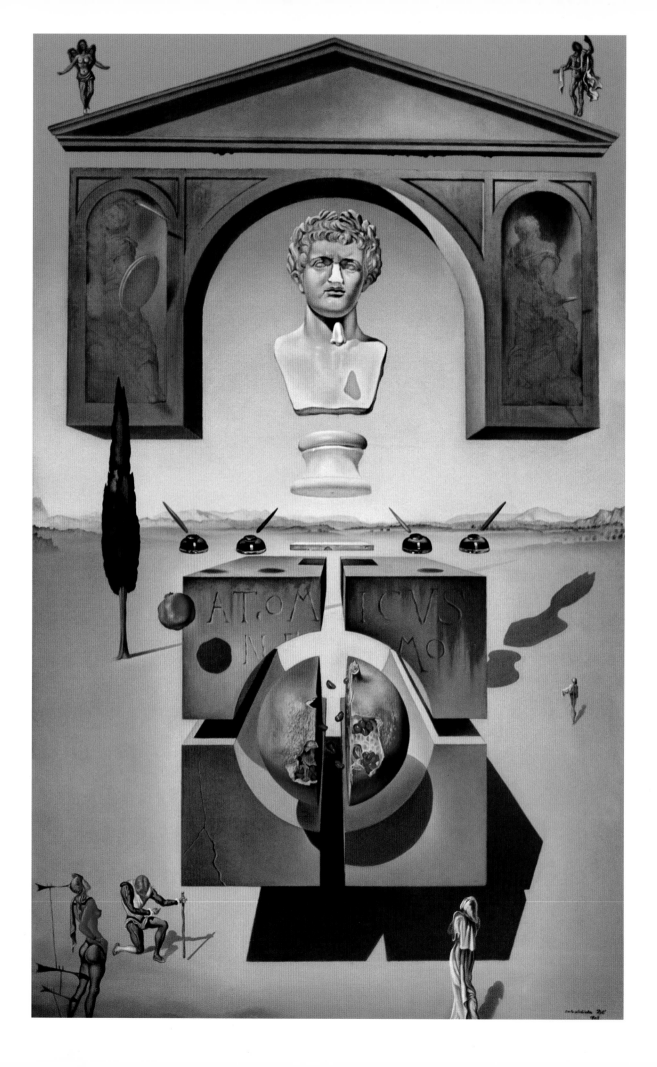

DEMATERIALIZATION NEAR THE NOSE OF NERO (1947)
Courtesy of AiSA

*D*EMATERIALIZATION *Near the Nose of Nero* was painted in 1947, using oil on canvas. The painting, while a good example of Dalí's "nuclear mystical" period, also evinces a more Classical style. With typical irony, Dalí wrote that "the two worst things that can happen to an ex-Surrealist today are, firstly, to become a mystic and secondly, to know how to draw. Both these forms of vigour have lately befallen me at one and the same time".

Against an Ampordán plain, a huge pomegranate has been spliced, like an atom, into two parts. Seeds spill out from the pomegranate, floating in the air between the two halves. A bust of Nero hovers above the dissected cube that houses the pomegranate. The bust itself has split into four parts, (or alternatively, the four parts are coming together to form a whole). Dalí's use of a Classical theme such as Nero is emphasized by the Classical architecture that hangs over Nero's head. However, it is not just the content that marks this painting's Classical style; the brushwork is meticulous, the depiction realistic and the balance within it also evokes the Classical style, while being at the same time Dalí's interpretation of atomic force.

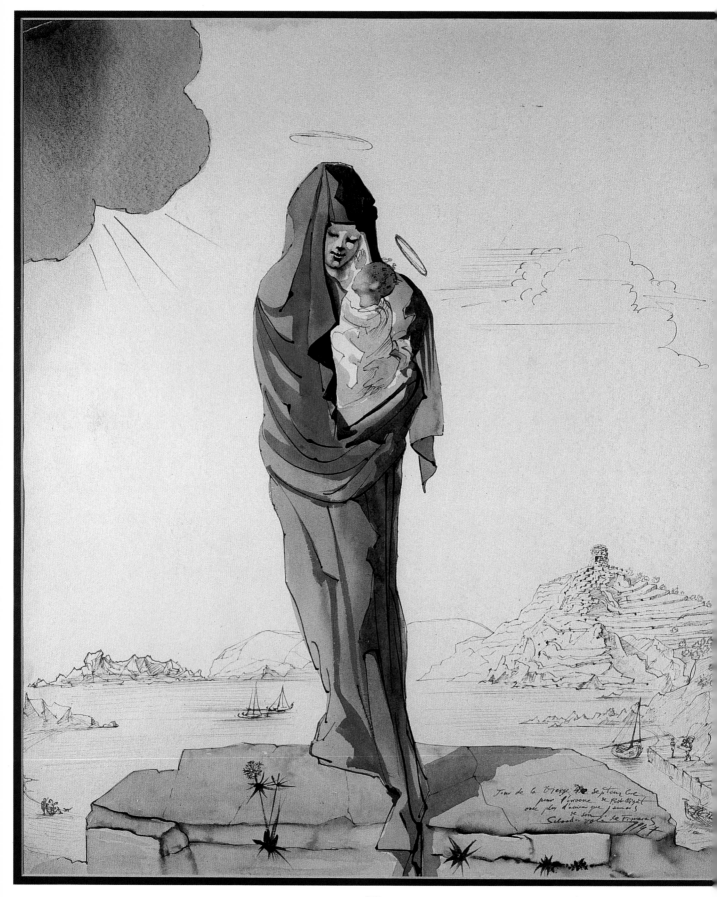

JOUR DE LA VIERGE (1947)

Courtesy of Christie's Images

*J*OUR *de la Vierge* (Day of the Virgin) was painted in 1947, while Dalí and Gala were still living in the USA. Although the Second World War had been over for two years, they did not return to Spain or France until the following year. Under the dedication, Dalí has signed the painting as Salvador Dalí of Figueras.

In keeping with his religious subjects of the Forties and Fifties, this painting is of the Virgin Mary, this time in a traditional pose and holding baby Jesus in her arms. The Virgin Mary's face has also been painted in a traditional manner, with a calm, peaceful expression on her face, her eyes closed, smiling down at the baby Jesus. The traditional techniques and pose employed in *Jour de la Vierge* contrast with the later painting of *The Sistine Madonna* (1958).

The background of the painting is drawn in brown ink, a medium that Dalí often used. The landscape is that of Port Lligat, Dalí's home for many years. The Virgin Mary is painted in watercolor, her face, which reflects the colors of the stones that she stands upon, contrasts with the vivid blue of her dress, while this is mirrored in the one childlike cloud above her.

The Sistine Madonna (1958)
Courtesy of AiSA. (See p. 208)

ROME (1949)

Courtesy of Christie's Images

*R*OME was painted in 1949, using watercolor, gouache, pen and ink on board. It is from the same series as *Naples*, and is part of a commission for Mr. and Mrs. Lasker of New York. As with the other painting, Dalí has restricted his use of color in order to create emphasis where it is applied. In *Rome*, Dalí has used the strong color of the trees to create a frame for the stone angels that appear in the center of the foreground. The different greens used for the color of the trees have been allowed to bleed into each other, a technique that Dalí also used for another work in this series, *Lago di Garda* (1949).

The angels in the foreground remind us of the religious aspect of the city, the papal home. Characteristically for Dalí, they have no facial features. In the distance, sitting under a tree is the same medieval jester that appears in the foreground of the painting of *Naples* (1949) although he has swapped his mandolin for a trumpet, the instrument of the angels. The religious aspect of Rome is further alluded to by the celestial light that shines over the city.

Naples (1949)
Courtesy of Christie's Images. (See p. 182)

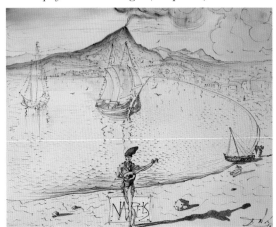

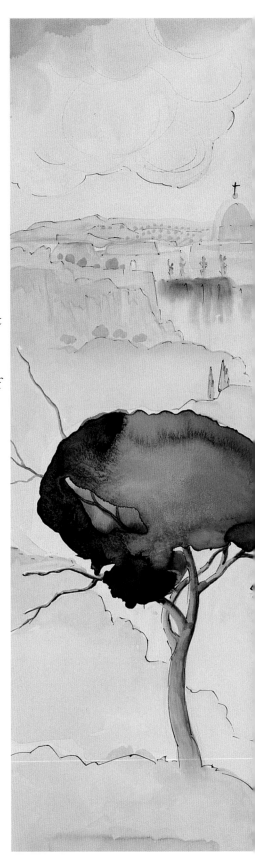

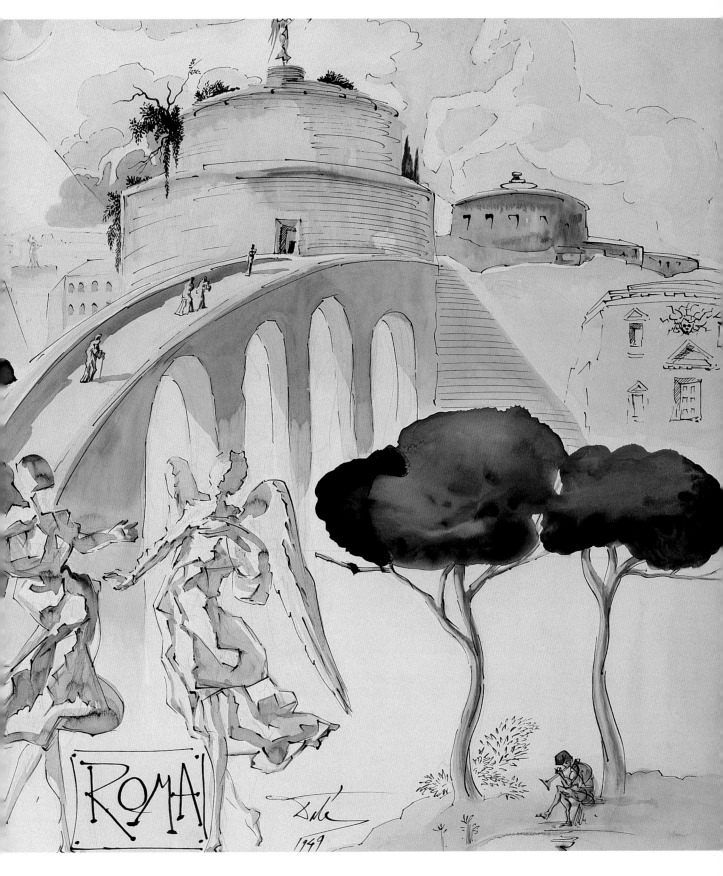

LAGO DI GARDA (1949)

Courtesy of Christie's Images

*L*AGO *di Garda* features the largest lake in Italy, which is popular for tourism and water sports. The painting has an unusually peaceful air; the lake has few ripples on it and the reflection of the sailing boat can be clearly seen.

This 1949 painting was executed in pen, ink, gouache, and watercolor on board. Dalí has used the ink as outline before using watercolor to complete the images. For the flowers in the foreground, he has allowed the colors to merge and spread, creating a haze of blue and yellow, then delineating their shapes by adding the leaves or the pen marks. Dalí's use of detail for the figure in red and the tower on the hill make a marked contrast with the blurry effect of the watercolor, as if the landscape is merely a dream that these two solid images have appeared in.

The woman in the foreground wears a Dalínian costume; a parasol is attached to her head, her dress is held up by ties to her arms and of course, she holds a crutch. The dress shows similarities to the costume Dalí designed for *The Woman of the Future* (1953).

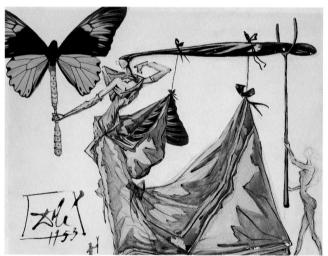

Design for the costume for *The Woman of the Future* (1953)
Courtesy of Christie's Images. (See p. 191)

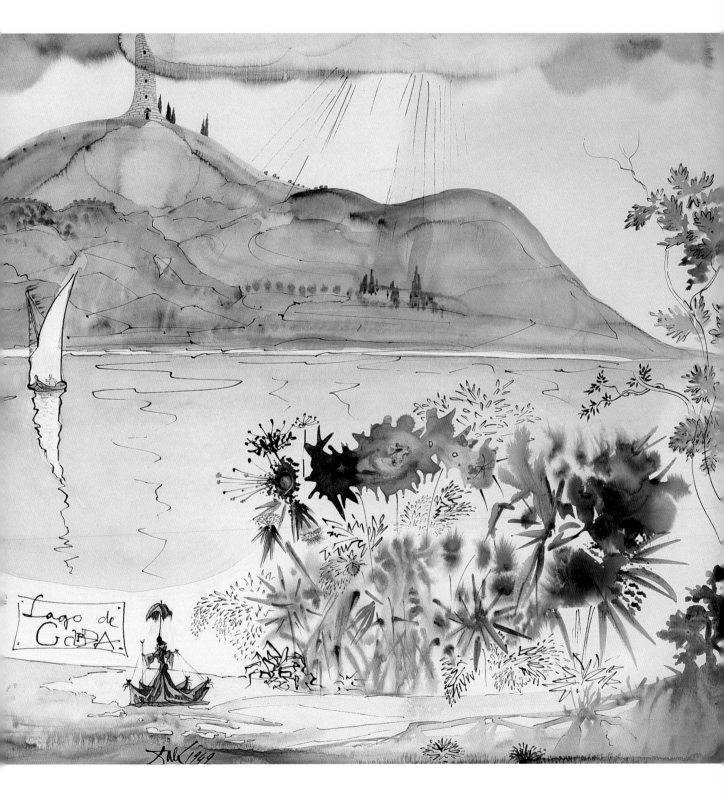

NAPLES (1949)
Courtesy of Christie's Images

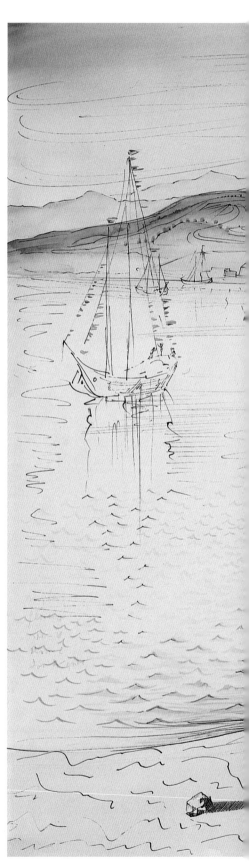

*N*APLES is one of a series of watercolor and ink paintings that Dalí made of Italian scenery during 1949. He had returned to Europe in 1948 after living in the USA for nearly ten years. The color in the painting has been restricted to the areas of emphasis, such as the figure in the foreground and the volcano. To increase this emphasis, these two images are aligned.

In the foreground, playing a mandolin, is a medieval court jester; Dalí was accused of behaving like a jester with his constant publicity stunts and the hat is similar to one that he took to wearing in later years. This medieval figure acts as a sign to the viewer that Dalí's depiction of Naples is of the city many centuries ago. There are only a few sketchy houses along the seashore, sailing boats move toward the shore and in the background a volcano is erupting.

The tiny figures behind the jester, the fisherman with his net, the figure sitting with legs stretched out in front of it, and the small boat, all appear in the background of another lakeside scene in *Roman Cavalier in Spain* (1954).

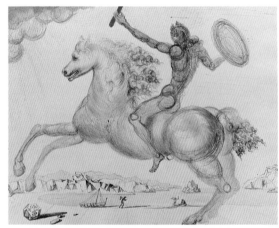

Roman Cavalier in Spain (1954)
Courtesy of Giraudon. (See p. 192)

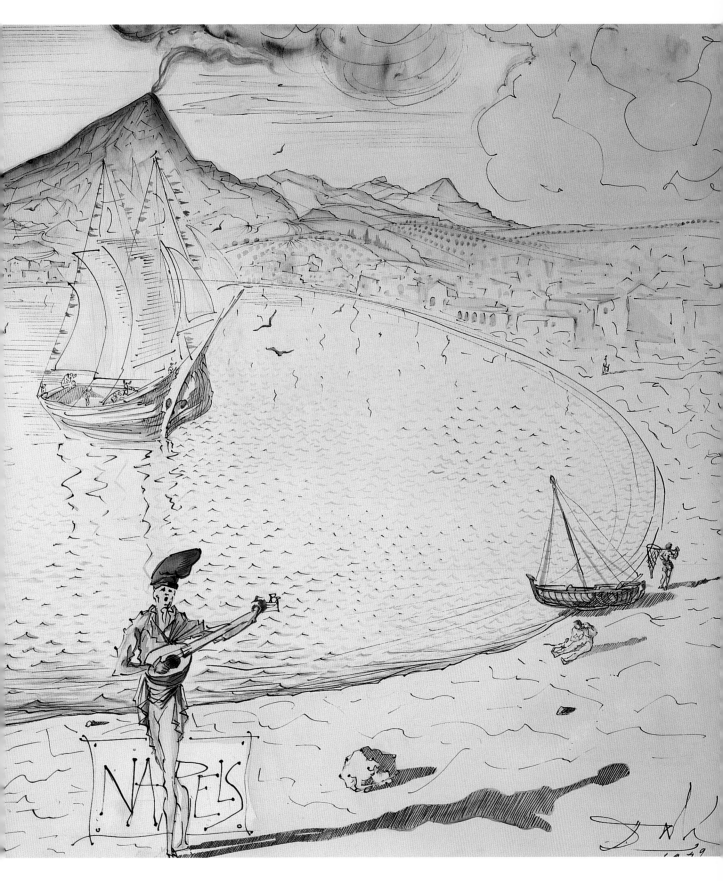

ETUDES D'ANGES (c. 1940–50)

Courtesy of Christie's Images

FROM the Forties, Dalí was becoming increasingly religious. He wrote in the epilogue to his autobiography *The Secret Life of Salvador Dalí*, "heaven is what I have been seeking all along and through the density of confused and demoniac flesh of my life— heaven!' He had always been enchanted by the idea of angels, the ethereal emissaries of God who are the go-betweens for our world and heaven. Dalí has painted many versions of angels, seeing them in different forms. He saw his spindly-legged elephants as a kind of angel, as with their great height they were halfway to heaven while still connected to the earth, much like angels.

Etudes d'Anges (literally study of angels), is drawn in ball-point pen on the headed stationery of Del Monte Lodge at Pebble Beach, California. The Dalís stayed at this hotel during the summers while they were living in the US between the years 1940 and 1950. Although *Etudes d'Anges* is essentially a brief sketch, it was possibly a study for a work that Dalí was composing at the time.

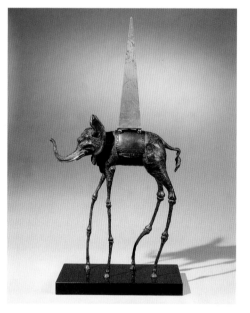

Elephant Spatial (1980)
Courtesy of Christie's Images. (See p. 242)

PEBBLE BEACH
DEL MONTE } CALIFORNIA
CARMEL 500

DEL MONTE
LODGE

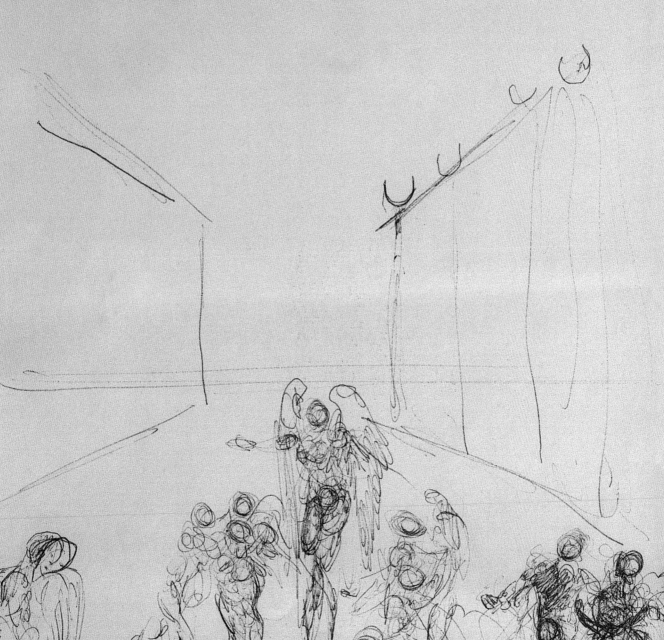

RAPHAELESQUE HEAD EXPLODING (1951)
Courtesy of AiSA

*R*APHAELESQUE *Head Exploding* was painted in 1951, using oil on canvas. The painting successfully combines Dalí's ideas and obsessions of the early Fifties. It is a further exploration of his "nuclear mysticism," as it encompasses both the religious (the Madonna) and the scientific (the atomic explosion) themes.

The painting is one of Dalí's most captivating and accomplished double images: though fragmented, the face of the Madonna appears clearly, as does the interior of the Pantheon. The Madonna is a copy of a painting by Raphael, hence the title of the piece. The Pantheon at Rome forms the inside of the Madonna's head. There is a golden light within the painting that appears to descend from heaven to emphasize the religious aspect of the work as well as the structure of the Pantheon.

As well as religion, science, and Raphael, this painting shows another of Dalí's obsessions: the shape of the rhinoceros horn. Some of the particles of the exploding head are the same shape as a rhinoceros horn. Dalí believed that this form could be seen everywhere, in everything: a cauliflower or a sunflower, and here in particles of the exploding head of the Madonna.

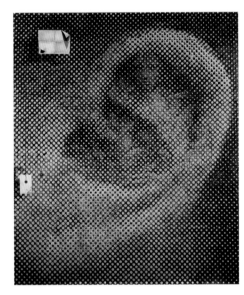

The Sistine Madonna (1958)
Courtesy of AiSA. (See p. 208)

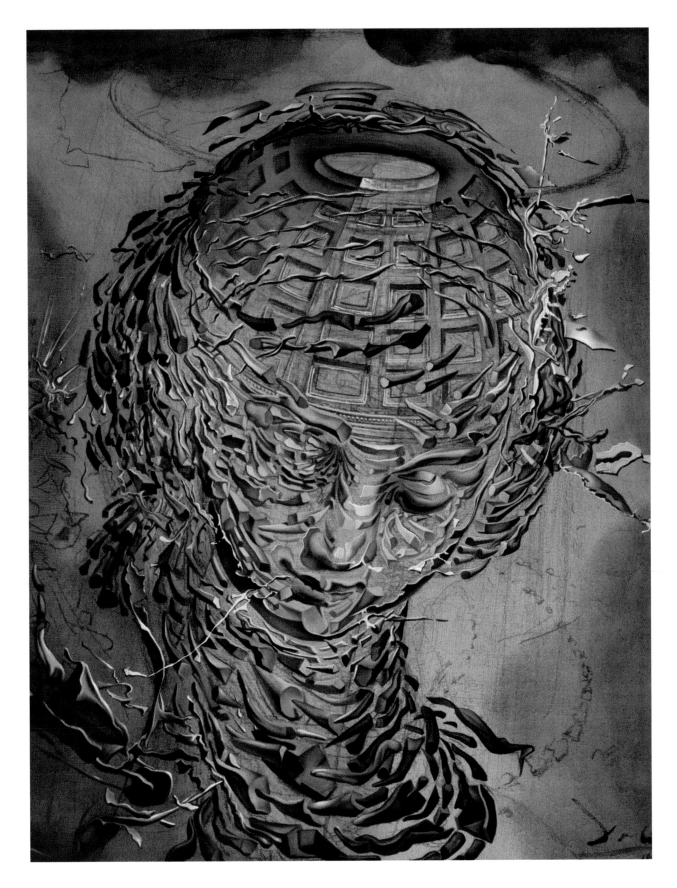

LAPIS-LAZULI CORPUSCULAR ASSUMPTION (1952)
Courtesy of Christie's Images

*P*AINTED in 1952, using oil on canvas, *Lapis-lazuli Corpuscular Assumption* repeats several of the images seen in *Raphaelesque Head Exploding* (1951). The outline of the Pantheon can be seen, the top of which acts as a halo to Gala's head. Like the Madonna, Gala is exploding, her body delineated by the rhinoceros horns that swirl about the painting.

Above an altar is the figure of the crucified Christ. The model for Christ was a boy from Cadaqués called Juan whom the Dalís were very close to, treating him like an adopted son. The boy's body forms a triangle, a shape repeated by Gala's arms and head above. Dalí had a glass floor put in his studio so that he could look up or down on his models in order to recreate this perspective.

Dalí saw this painting as an interpretation of the philosopher Nietzsche's idea of natural strength, although here we have Gala as a "superwoman," ascending to heaven through her own innate force. In a later explanation of the work, Dalí wrote that Gala was rising to heaven with the aid of "anti-matter Angels." The painting can be interpreted as Gala's body either disintegrating or integrating.

Raphaelesque Head Exploding (1951)
Courtesy of AiSA. (See p. 186)

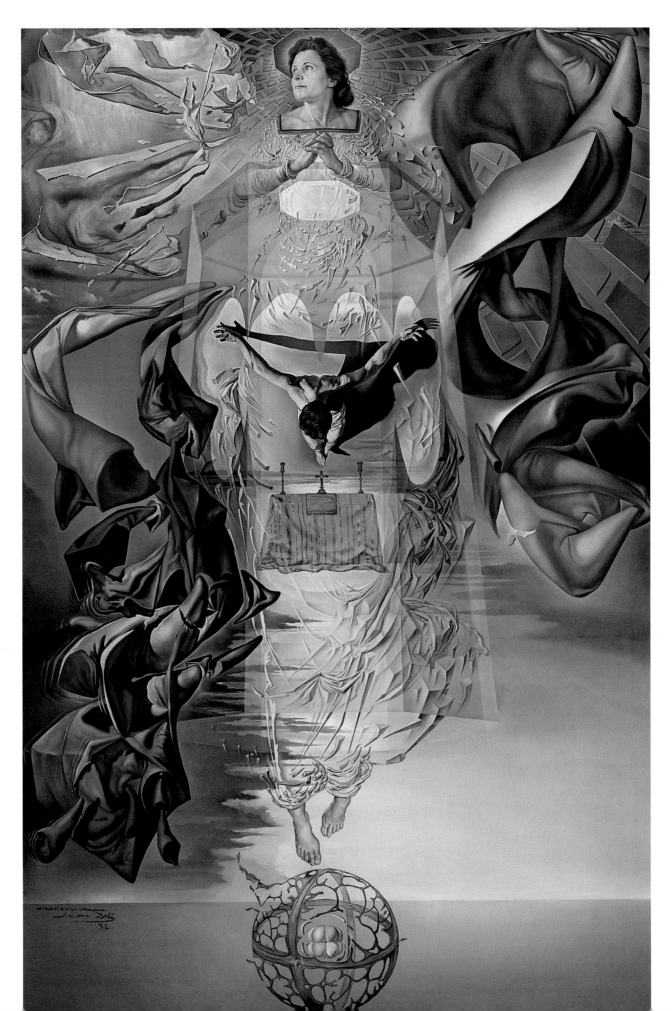

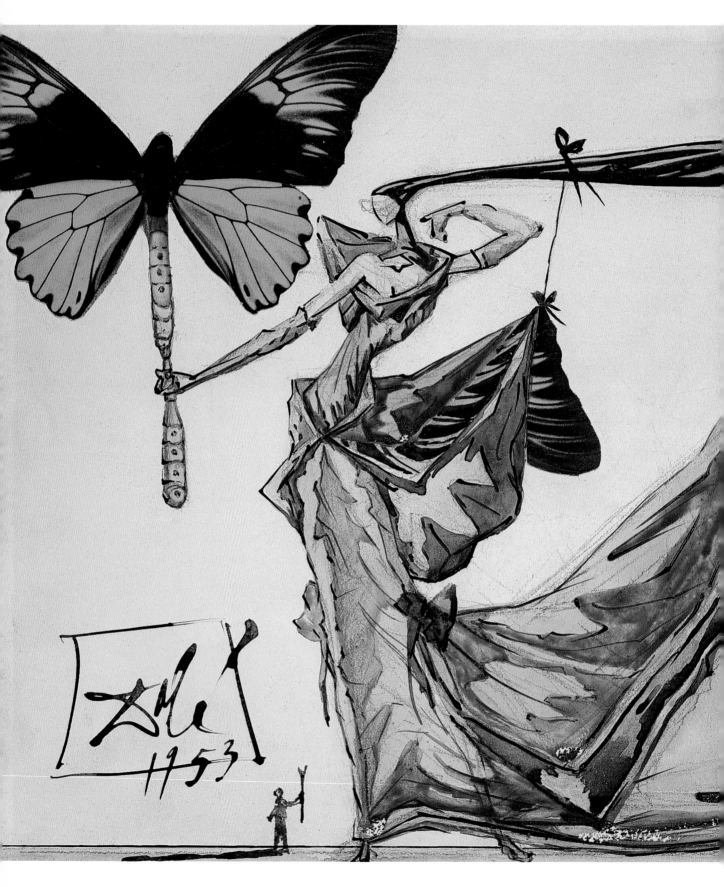

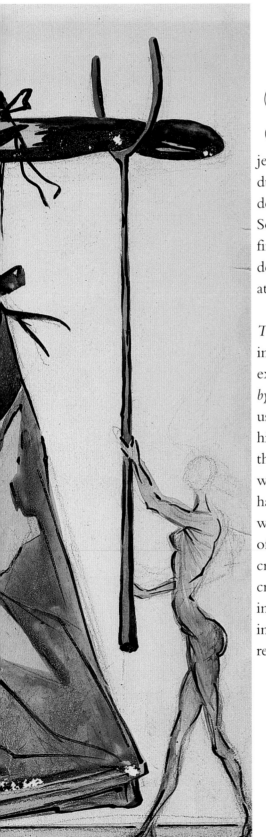

DESIGN FOR THE COSTUME FOR *THE WOMAN OF THE FUTURE* (1953)

Courtesy of Christie's Images

*T*HROUGHOUT his life, Dalí had a keen interest in design, especially of clothes but also of objects, stage sets, jewelry and inventions. In the early Thirties, during a period of extreme hardship, he made designs that Gala tried, unsuccessfully, to sell. Some of these were for inventions such as fingernails with mirrors on them but he also designed clothes, such as a dress with padding to attain the "ideal' female shape.

Dalí made the design for the costume for *The Woman of the Future* in 1953. The by-now infamous Dalínian images of the crutch and the extended body parts (seen in *Hairdresser Depressed by the Persistent Good Weather* (1934)) are both used in the design, although their appearance in his paintings had greatly declined. The crutch, this time held by a servant of the statuesque woman, props up the woman's hugely extended hair. Dalí once designed a jeweled nose crutch, which he described as "an absolutely useless kind of object to appeal to the snobbism of certain criminally elegant women." The use of the crutch in this design seems to have the same inference. The woman holds up a huge butterfly into which she is vainly seeking her own reflection.

ROMAN CAVALIER IN SPAIN (1954)
Courtesy of Giraudon

THE figure of the Roman, with laurel leaves in his hair, sits naked upon his horse. In one hand is a shield, in the other a weapon. He is leaning up on his horse and the horse is rearing, as if they are about to attack. The Roman and his horse are sketched in ink and a light color has been added to give them substance. The light use of color means that the crude outline of the two forms shows through clearly and Dalí's draftsman techniques can be observed. The rear of the horse and the arms of the Roman are formed by circles and ovals that build up the body shape when placed together. Dalí used a similar technique for the figures of St.

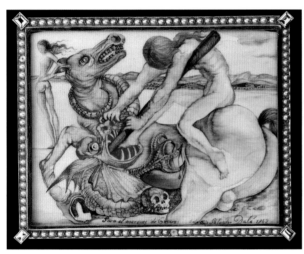

St. Georges Tuant le Dragon (c. 1942)
Courtesy of Christie's Images. (See p. 150)

George and his horse *St. George Tuant le Dragon* (c. 1942).

The horse and rider were a repetitive image in Dalí's work, they often appear in the background as minor details to a painting. In *Roman Cavalier in Spain*, the background is a rocky Spanish bay. The rocks have been left in the same basic form as the Roman and his horse; so that their triangular structure is plain to see.

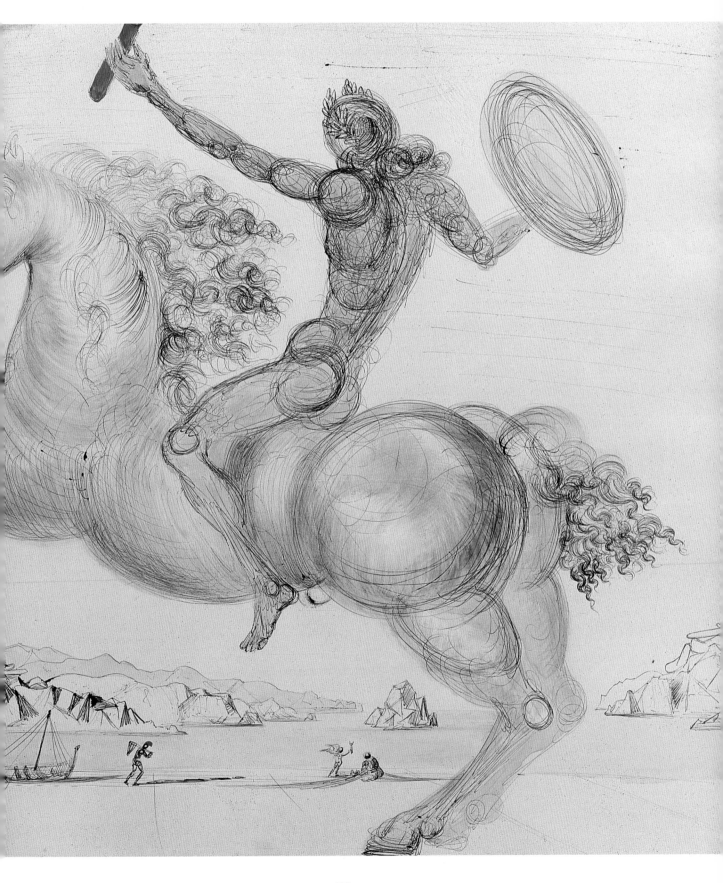

LE PAPILLON AU ROCHER (1954)

Courtesy of Christie's Images

*L*E *Papillon au Rocher*—the butterfly at the stone—was painted in 1954, using a variety of mediums: watercolor, collage and black ink on paper. Dalí often employed several techniques in one work to create contrast, texture and emphasis. With a very small picture such as *Le Papillon au Rocher*, which measures only 14 x 23 in (35 x 27 cm), the collage gives a startling effect.

At the top of the picture poised over the rock is the butterfly. The shadow on the rock gives the impression that it is about to land. The butterfly is a real one, possibly from Dalí's own collection of mounted butterflies. Dalí has used very little color in the picture, the background is left empty of color and, with the exception of a figure holding a crutch, of form. This lack of color ensures that the emphasis on the butterfly is amplified.

Dalí was fascinated with insects, especially those that transformed themselves from one form to another, an interest that he made use of in *Métamorphose*. The picture is a simple one and with the dedication at the bottom "Pour Madame Lambert Hommage," it is probably unfinished.

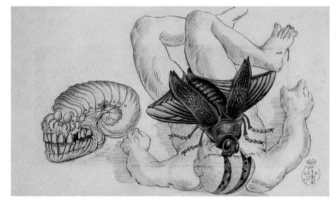

Métamorphose (1946)
Courtesy of Christie's Images. (See p. 169)

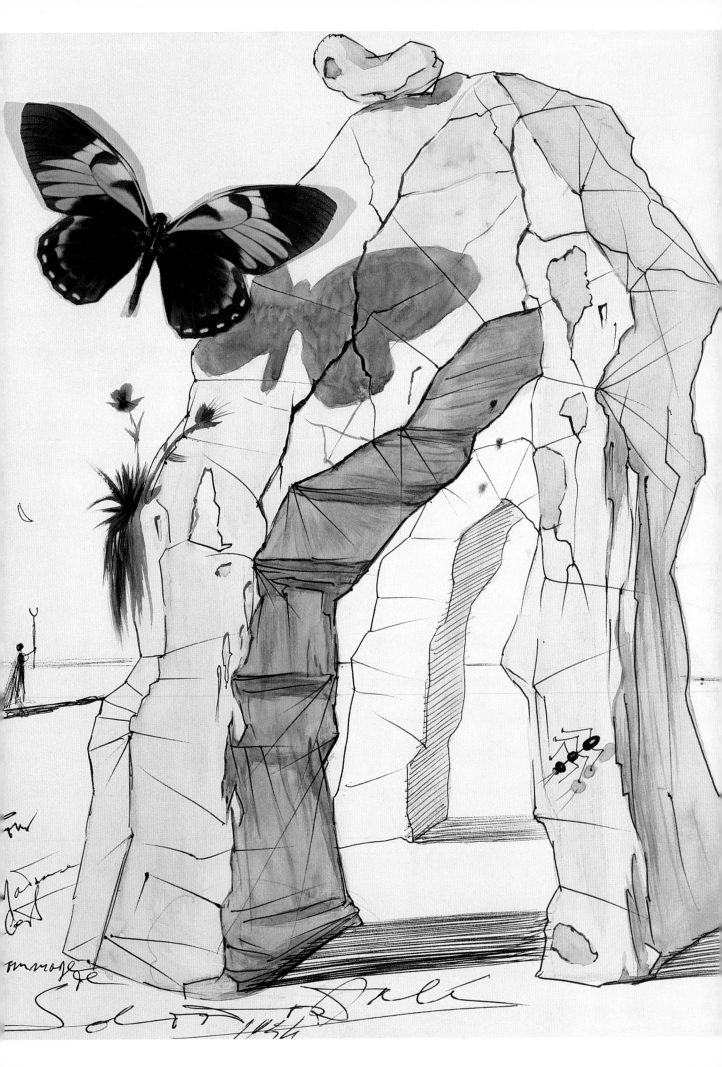

PORTRAIT OF GALA WITH THE RHINOCEROTIC SYMPTOMS (1954)

Courtesy of AiSA

*P*ORTRAIT *of Gala with the Rhinocerotic Symptoms* was painted using oil on canvas in 1954. It is another exploration of Dalí's theory of the recurring form of the rhinoceros horn, as seen in the 1951 painting *Raphaelesque Head Exploding.* This theory came from Dalí's study of the 1665 painting called *The Lacemaker* by the Jan Vermeer. In 1955, Dalí gave a lecture at the Sorbonne where he put forward his view that *The Lacemaker* was composed from the repetition of the rhinoceros horn pattern. Dalí saw the rhinoceros horn as "the delirium sign," saying there was no better example "in nature of logarithmic spirals than those of the curve of the rhinoceros horn."

In this portrait of Gala, her disembodied face appears over a Spanish bay. The two intense blues of the sky and the sea contrast with the vivid red border that delineates her bust. The curves and lines of her neck and chest are formed by rhinoceros horns that swirl beneath her head. To the left of Gala, one of the cliffs along the coast has also fallen prey to Dalí's obsession with the rhinoceros horn. The cliff has disintegrated, but the horns still delineate an overall shape.

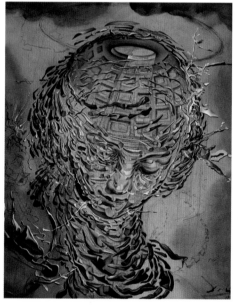

Raphaelesque Head Exploding (1951)
Courtesy of AiSA. (See p. 186)

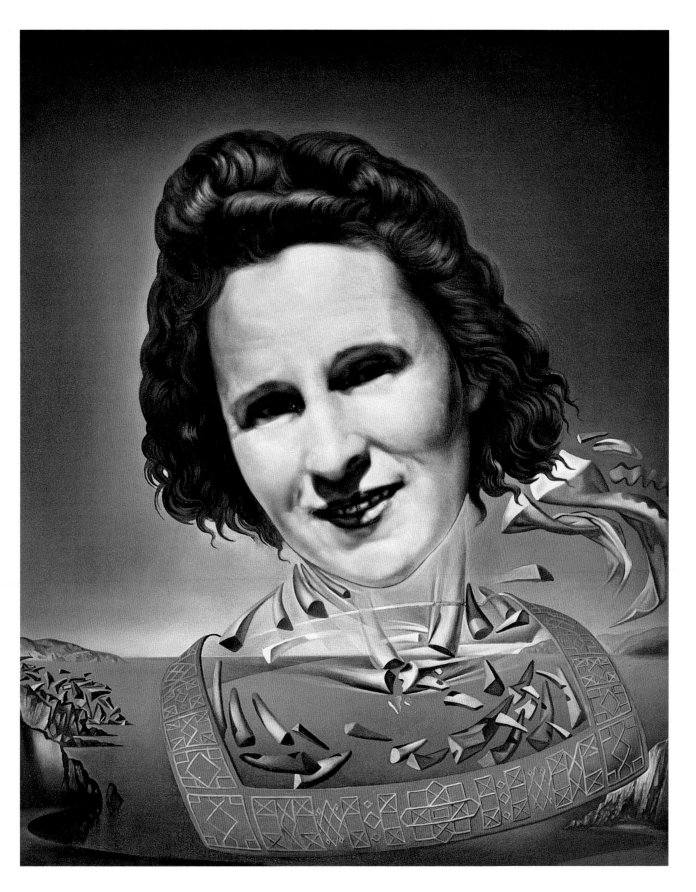

THE SACRAMENT OF THE LAST SUPPER (1955)

National Gallery of Art, Washington, D.C.. Courtesy of AiSA

*T*HE *Sacrament of the Last Supper* was painted using oil on canvas, in 1955. An art collector called Chester Dale commissioned the painting. Whilst he was enormously pleased with the painting, some critics viewed it as a mediocre rendering of a much-used subject. The subject is Christ's Last Supper, which has been painted by many artists over the centuries. Amongst these renditions is a version by one of Dalí's favorite artists, Leonardo da Vinci.

Like the Leonardo version, Dalí's *The Sacrament of Last Supper* shows Christ sitting centrally at a table with the disciples around him and in the background, windows look on to a landscape, in Dalí's case it is that of a bay near his home of Port Lligat. The figure of Christ is transparent, and above him the arms and chest of a man appear in the sky, suggesting that he is already ascending to heaven.

An aspect of the painting that caused controversy was the fact that Christ was given

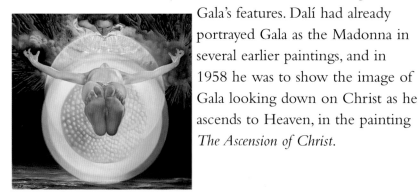

Gala's features. Dalí had already portrayed Gala as the Madonna in several earlier paintings, and in 1958 he was to show the image of Gala looking down on Christ as he ascends to Heaven, in the painting *The Ascension of Christ*.

The Ascension of Christ (1958)
Courtesy of Christie's Images. (See p. 205)

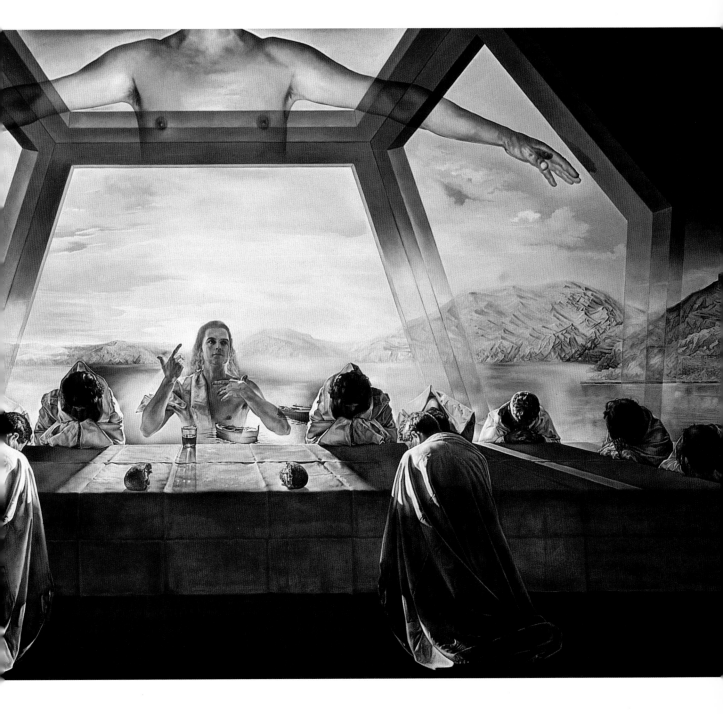

VASE DE FLEURS (1956)
Courtesy of Christie's Images

*V*ASE *de Fleurs* was painted using the mediums of watercolor, pen and black ink on board, in 1956. Dalí signed the painting in the small rock on the left, making the letters appear as if chiselled out of the stone. The watercolor flowers are similar to those of the *Lago di Garda* (1949), in which the flowers of the foreground seem blurred as if they have been left to bleed into each other. The colors seem to merge and run across the paper. The flowers in *Vase de Fleurs* are not realistic, they appear to have been dropped on to the paper.

The flowing structure of the flowers contrasts with the intricate decorations on the vase, especially with the woman's face on the right.

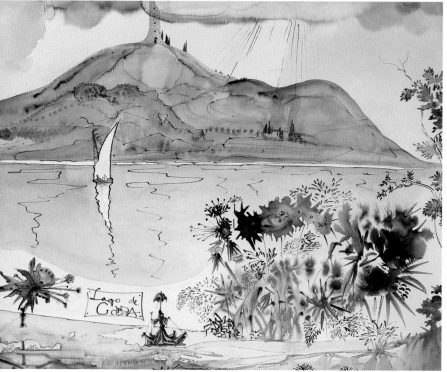

Dalí had used the image of a woman's face combined with a jug in a series of paintings in 1929, which included *The Great Masturbator*. Lilies were also painted to echo a sexual scene that is shown above them. The lily can be seen as symbolically sexual in *Vase de Fleurs*, with open, dark red petals combined with the image of the woman as a receptacle.

Lago di Garda (1949)
Courtesy of Christie's Images. (See p. 180)

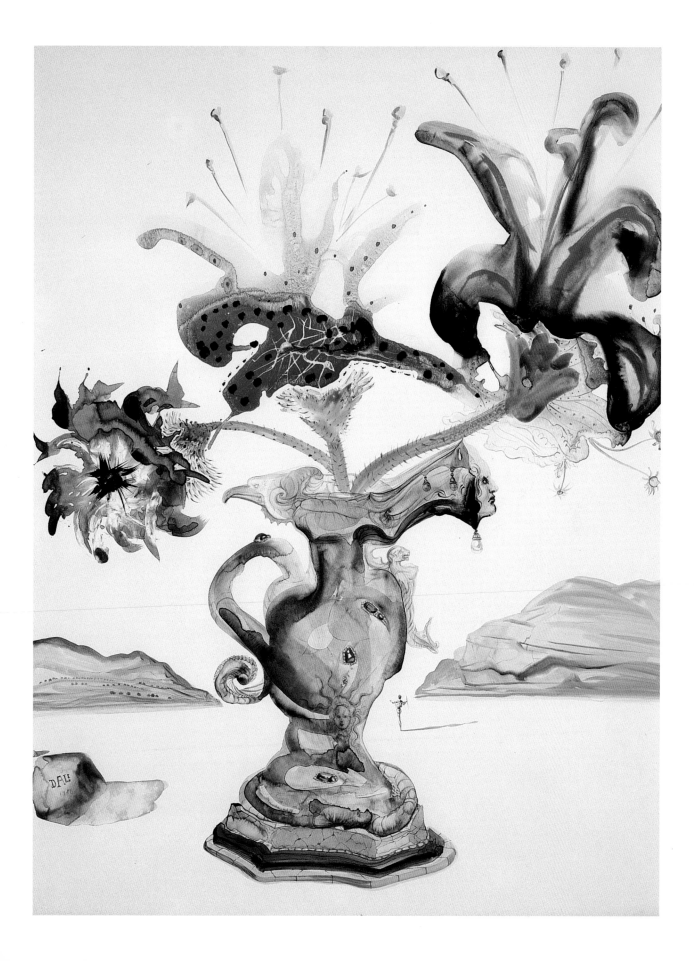

THE DANCE (THE SEVEN ARTS, ROCK "N" ROLL) (1956)

Courtesy of Christie's Images

*T*HIS painting is one of a series of seven that Dalí painted in 1956, using oil on canvas. The paintings were for his friend Billy Rose, to replace a 1944 series Dalí had painted for him called *The Seven Lively Arts*, which were destroyed in a fire at Billy's home. *The Dance* is a visual interpretation of rock and roll. In the previous series, this picture had been called *Boogie-Woogie* after the current dance and music scene of that name.

1956 was the year in which Dalí launched his own perfume, which was also called Rock "n" Roll. Dalí explained the allure of Rock "n" Roll saying "I love anything that is dionysic, violent and aphrodisiac." In *The Dance* he has represented all three of these qualities. The naked figures are deformed, with their bodies twisted out of shape through the energy of their dance. They are pulling each other apart; the hand of the man is squeezing the neck of the woman, another hand (he has three) stretches her arm. The picture is a further exploration of the sexual cannibalism theme portrayed in *Autumnal Cannibalism* (1936); the idea of love being devouring.

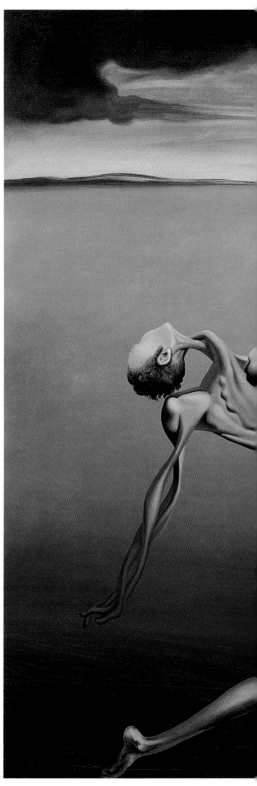

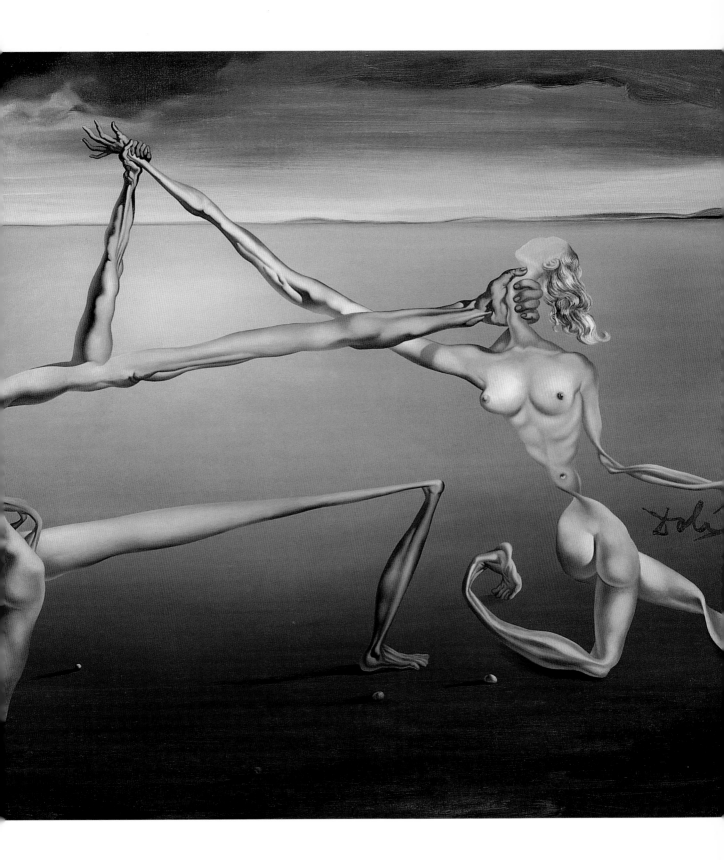

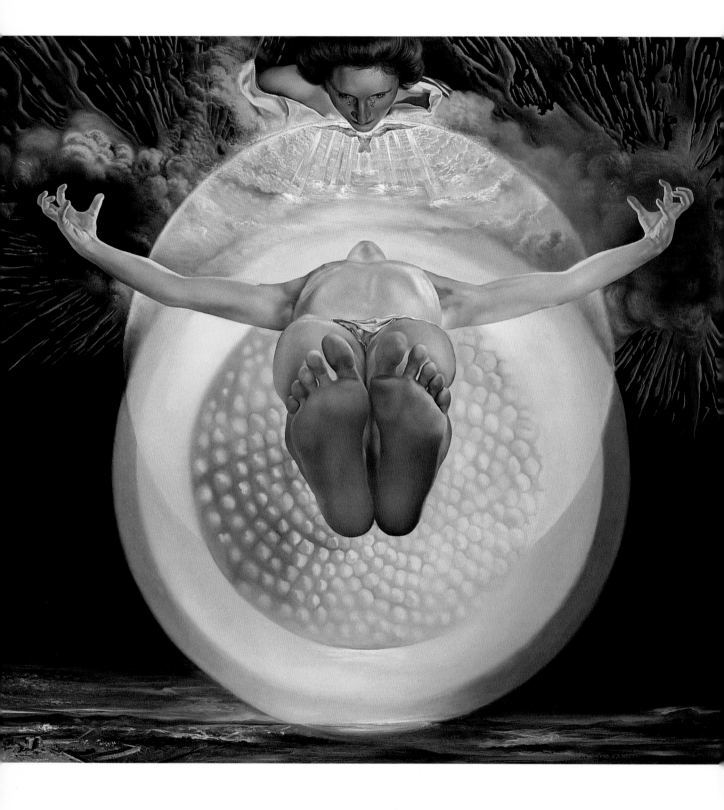

THE ASCENSION OF CHRIST (1958)

Courtesy of Christie's Images

*D*ALÍ said that his inspiration for *The Ascension of Christ* came from a "cosmic dream' that he had in 1950, some eight years before the painting was completed. In the dream, which was in vivid color, he saw the nucleus of an atom, which we see in the background of the painting; Dalí later realized that this nucleus was the true representation of the unifying spirit of Christ.

The feet of Christ point out at the viewer, drawing the eye inwards along his body to the center of the atom behind him. The atom has the same interior structure as the head of a sunflower. As with most of Dalí's other paintings of Christ, his face is not visible. Above the Christ is Gala, her eyes wet with tears.

The figure of the Christ, from his feet in the foreground to his outstretched arms, forms a triangle. Dalí had used the same geometry for his *Lapis-lazuli Corpuscular Assumption*. He used a triangular

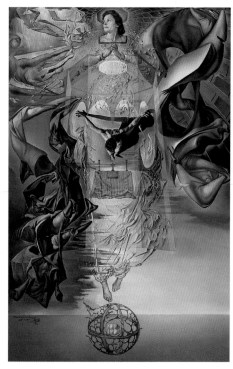

structure first in the 1951 painting *Christ of St. John of the Cross*. The inspiration for this form came from a drawing by Spanish mystic St. John of the Cross, where Christ is depicted as if seen from above.

Lapis-lazuli Corpuscular Assumption (1952)
Courtesy of Christie's Images. (See p. 188)

THE ROSE (1958)

Courtesy of Christie's Images

THE *Rose* was painted in 1958, using oil on canvas. Roses appear in many of Dalí's works; in the Thirties he made several paintings of women whose heads were formed by roses. Dalí uses the rose as a female sexual symbol. *The Invisible Man* (1929–32) includes two partially naked women with huge roses appearing where their wombs should be. In 1930, Dalí used this image again but in a more definitive way, depicting a nude woman with bleeding roses coming from her womb. To Dalí then, the rose represented menstruation and the internal reproductive organs of women.

The Rose shares a similar structure with the *Portrait of Gala with the Rhinocerotic Symptoms* (1954). Both paintings have the familiar intensely blue sky as a backdrop to a dominating central image that

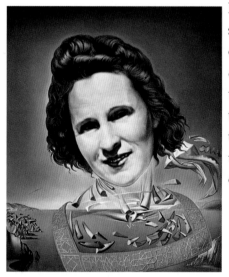

hovers over a Spanish landscape. The paintings also share the same vivid red color of the rose, which contrasts so effectively with the blue sky; in *Portrait of Gala with the Rhinocerotic Symptoms*, the red is used for the border beneath her head. In *The Rose*, there is a tiny drop of water on one of the petals of the flower, as realistic as a photograph. Dalí often used this effect of *trompe l'oeil* to highlight a small detail of a painting.

**Portrait of Gala with the
Rhinocerotic Symptoms (1954)**
Courtesy of AiSA. (See p. 196)

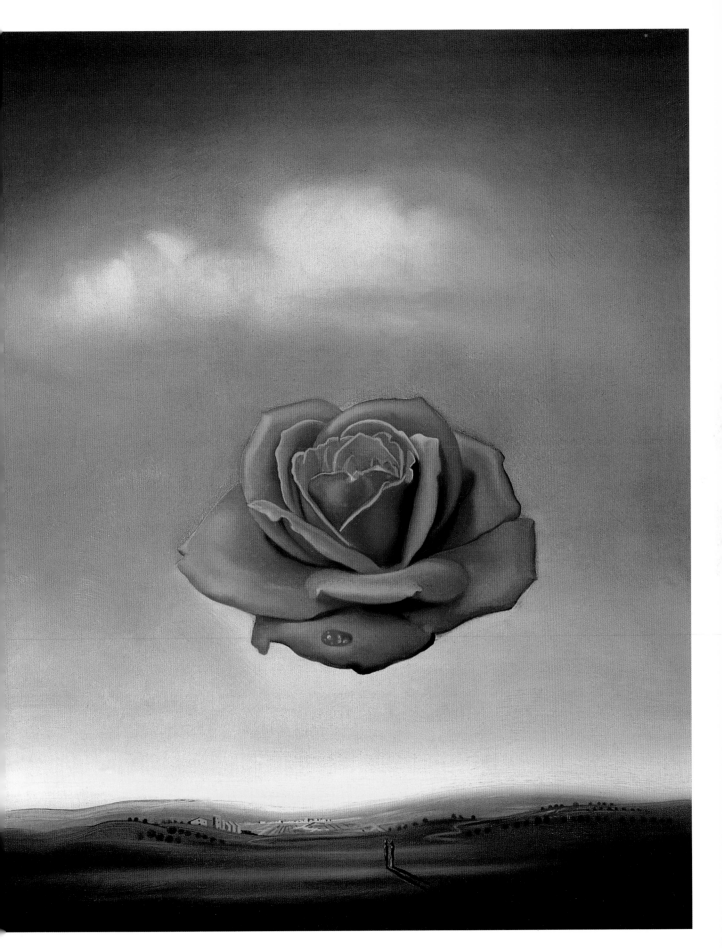

THE SISTINE MADONNA (1958)

Courtesy of AiSA

*T*HE *Sistine Madonna* is one of Dalí's many representations of the Virgin Mary, although she appears here in the most obscure setting. The painting was completed in 1958, using oil on canvas. Like the later painting, *The Portrait of my Dead Brother* (1963), it uses a matrix of dots to create the images. The technique that Dalí used for the matrix was taken from an industrial printing system. This work shows Dalí was well ahead of his time as, with the use of optical illusion and the playful subject, *The Sistine Madonna* would fit well into the Op and Pop Art scene that emerged in the Sixties.

The dot matrix forms two images: one being the huge ear, the smaller image being the Madonna. The ear is a reproduction of Pope John XXIII's ear, which was taken from a photograph in a newspaper. The face of the Madonna is a copy of *The Sistine Madonna* by Raphael, one of the Renaissance painters that Dalí

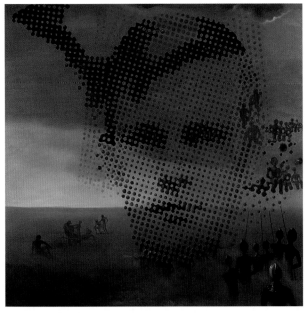

Portrait of My Dead Brother (1963)
Courtesy of Giraudon. (See p. 213)

most admired. He enjoyed the idea that this painting can be seen in different ways, depending on the viewer's perspective: if the viewer is at a close distance the painting seems abstract, if further away one of the separate images will come into focus.

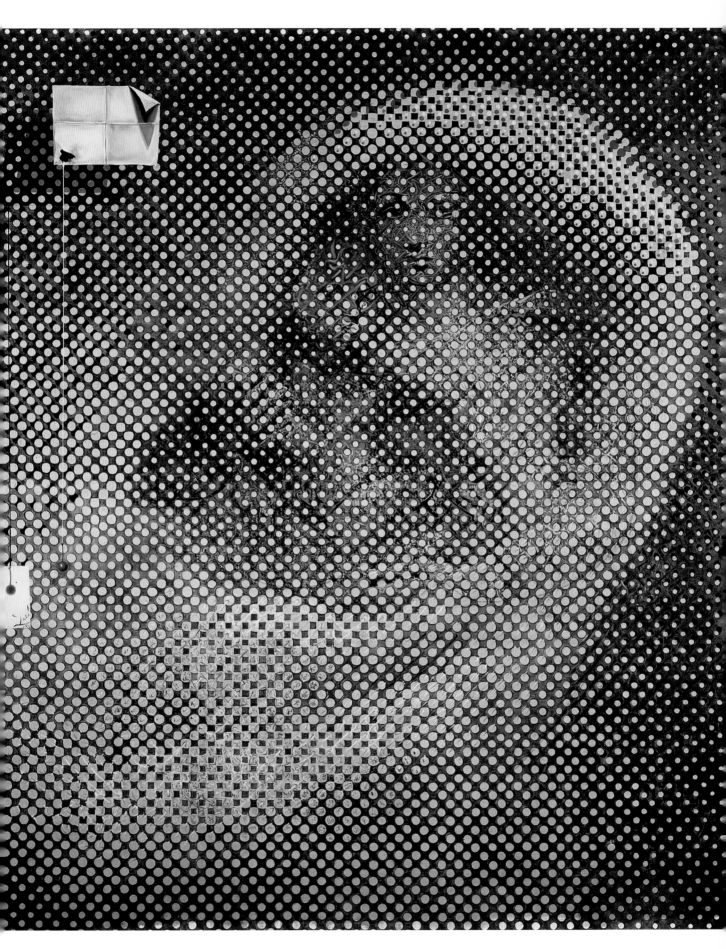

St. George and the Dragon (1962)

Courtesy of Christie's Images

ALÍ painted an earlier version of the story of St. George and the Dragon in 1942, in which the dragon and St. George battle in the foreground of the painting. This version was painted in 1962, using oil on canvas. Unlike the 1942 version, the brushwork in the painting is quite brusque—almost as if it were rushed. Dalí often undertook work purely for monetary rewards, as his fame was such that any work with his signature on it would sell. This painting could easily have been a background to one of Dalí's portraits, such as *They Were There* (1931).

St. George is dressed in a red tunic in the style of a Spanish cavalier, rather than the clothes of a medieval Englishman. The landscape also, though greener than Dalí's customary bleak deserts, is still typically Spanish in feel. This impression is aided by the appearance of the clump of buildings that can be seen in the central background. The buildings with their slopes and the color of burnt sienna have a definite Mediterranean feel to them. Dalí has not included the dragon in this painting, although the dark figure in the foreground forebodes death with its grim, almost spectral appearance.

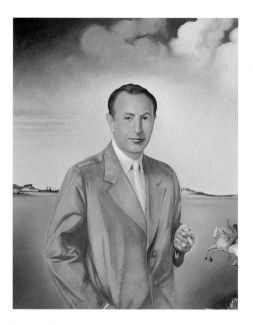

They Were There (1931)
Courtesy of Christie's Images. (See p. 65)

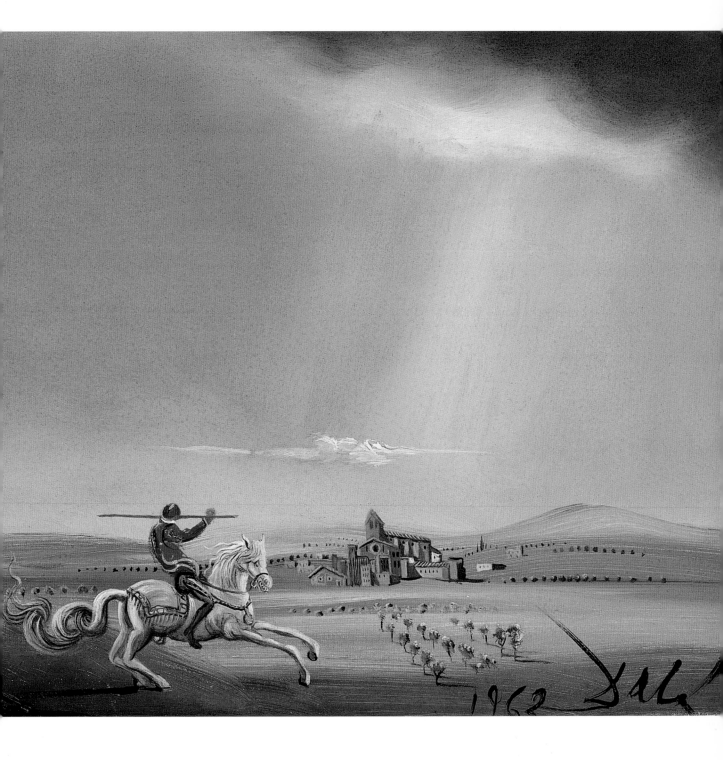

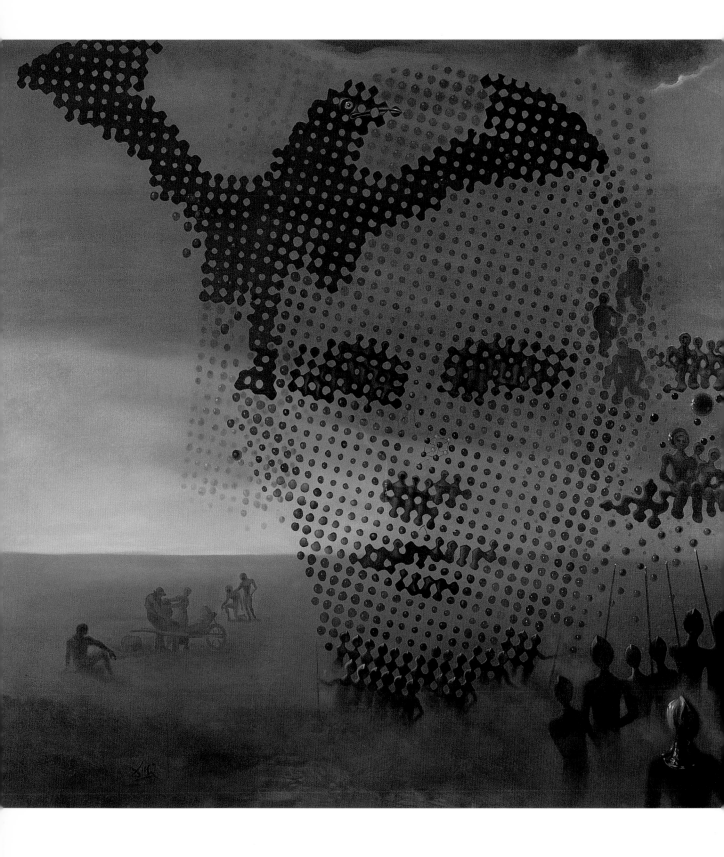

PORTRAIT OF MY DEAD BROTHER (1963)
Courtesy of Giraudon

DALÍ'S brother, also named Salvador, died at the age of two, a year before his birth. He looked very like his dead brother and said that his "forced identification with a dead person meant that my true image of my own body was of a decaying, rotting, soft, wormy corpse" This is the only painting Dalí did of his brother, although the boy is older than his real brother was before he died. Dalí felt that he was exorcizing the spirit of his brother with this painting.

The face of the boy is created by a dot matrix, a technique that was widely used in the Pop Art period of the Sixties. This technique emphasizes the ghost-like quality of the boy, he is insubstantial, yet his presence fills the landscape. The boy's hair also forms part of the wings of a crow; a bird often viewed as a harbinger of death. Beneath the boy is a miniature depiction of Millet's *The Angelus*. Dalí believed that through an X-ray of *The Angelus*, it would be proved that the basket over which the couple are praying was initially the coffin for a child.

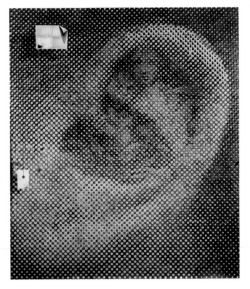

The Sistine Madonna (1958)
Courtesy of AiSA. *(See p. 209)*

LES OEILLETS AUX CLEFS (1967)

Courtesy of Christie's Images

*L*ES *Oeillets aux Clefs* (the pink carnations of keys) was painted using various mediums on paper. It is dated and signed 1967, and was verified as a genuine Dalí by Robert Descharnes. *Les Oeillets aux Clefs* fuses two common objects to create one Surrealist image. As with the Surrealist *Lobster Telephone*, Dalí has used living objects, the carnations, and combined them with an inanimate object, the keys. Like the telephone in *Lobster Telephone*, the inanimate objects are every day items, which would not normally attract much attention.

Dalí has included keys as a minor detail in other works, such as in the *Composition of the Leg*, where the key is part of a pattern on a woman's leg. Heavily influenced by Freud's theories, Dalí saw the key as a phallic symbol; given that flowers are generally seen as female in gender, this painting can be seen as a sexual metaphor. Out of one golden key is growing this strange plant. The three stems from the flowers are attached to the golden key and have themselves become keys, their handles locking on to the bottom key as if it were their root.

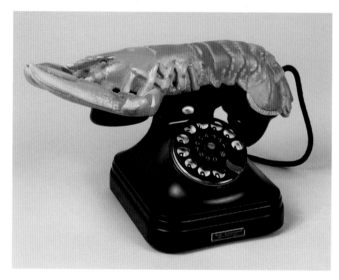

Lobster Telephone (1936)
Courtesy of Christie's Images. (See p. 110)

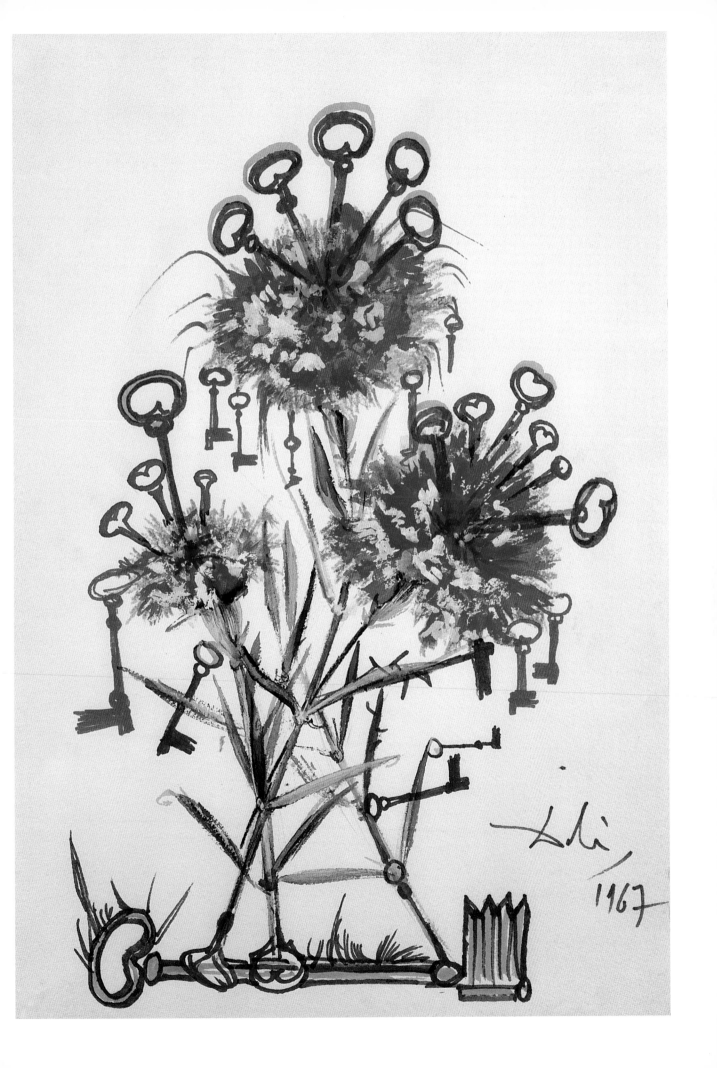

LE VOYAGEUR (1967)
Courtesy of Christie's Images

*L*E *Voyageur* was drawn using soft pencil on paper, in 1967. A little watercolor has been used at the top of the painting, giving the drawing an unfinished appearance. Dalí's sexual fears and erotic images filled his paintings; he once said that "everything born of my brush is erotic." Dalí described himself as "autoerotic'; he did not like to take part in the act of penetrative sex, although he enjoyed watching. During the Sixties he held erotic parties, which were basically orgies with the rooms filled with people having sex. Dalí also used to persuade his models to perform sexual acts for him to watch and sometimes draw.

The central woman in *Le Voyageur* is masturbating, her hand blurred in movement. She looks toward another naked woman who lies next to her. Behind the women, a bald man is watching them. He has a drawer instead of eyes. The drawer is a Dalínian symbol for orifices, especially sexual ones; it can be seen in *The Woman in Flames* (c. 1937). From between his open lips the man's tongue sticks out, drops of drool hang beneath it. Although his hands and arms are not seen, it seems that he is masturbating.

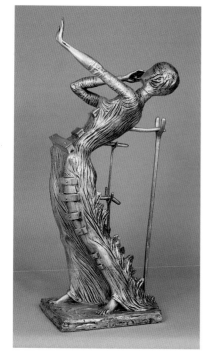

The Woman in Flames (c. 1937)
Courtesy of Christie's Images.
(See p. 116)

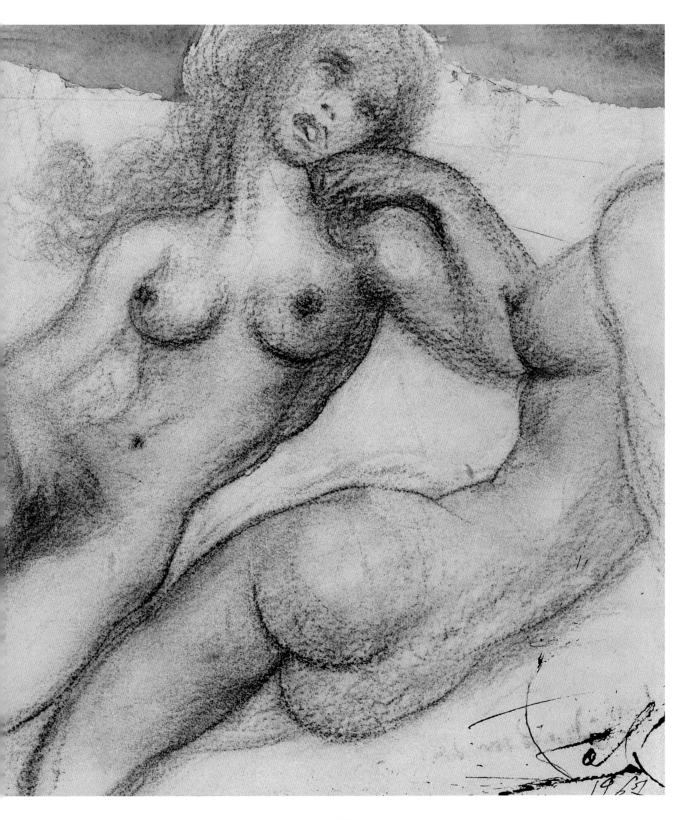

TUNA FISHING (1966–67)
Courtesy of AiSA

*T*UNA *Fishing* was painted in 1966–67 and is seen by many as one of Dalí's last masterpieces. The canvas is huge, over 9 ft 9 in x 13 ft 2 in (3 x 4 m),and is chaotically filled with the violent struggle between the men and the huge fish; a gleaming knife stabs into a fish and the azure-blue sea becomes red with blood. The subtitle of the painting was *Hommage to Meissonier*, who was a nineteenth-century French painter specializing in battle scenes.

Dalí often deliberately used images and styles that he had absorbed from the various artistic movements he explored. In the foreground, the young man in black and white is depicted in the popular style of the Sixties. The figure to the left is influenced by Classical sculpture.

Dalí explained this painting as being a representation of the finite nature of the universe and cosmos. The idea of this finite nature led Dalí to the idea that "the entire cosmos and the universe meet at a certain point— which, in this case, is the tuna catch. Hence the alarming energy in the painting! Because all those fish, all those tuna and all the people busy killing them, are personifications of the finite universe."

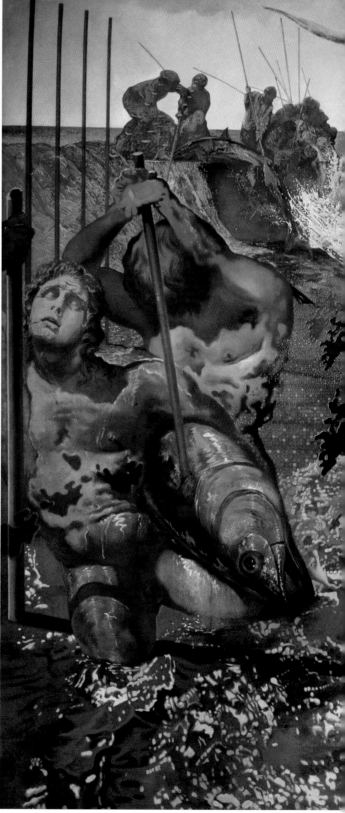

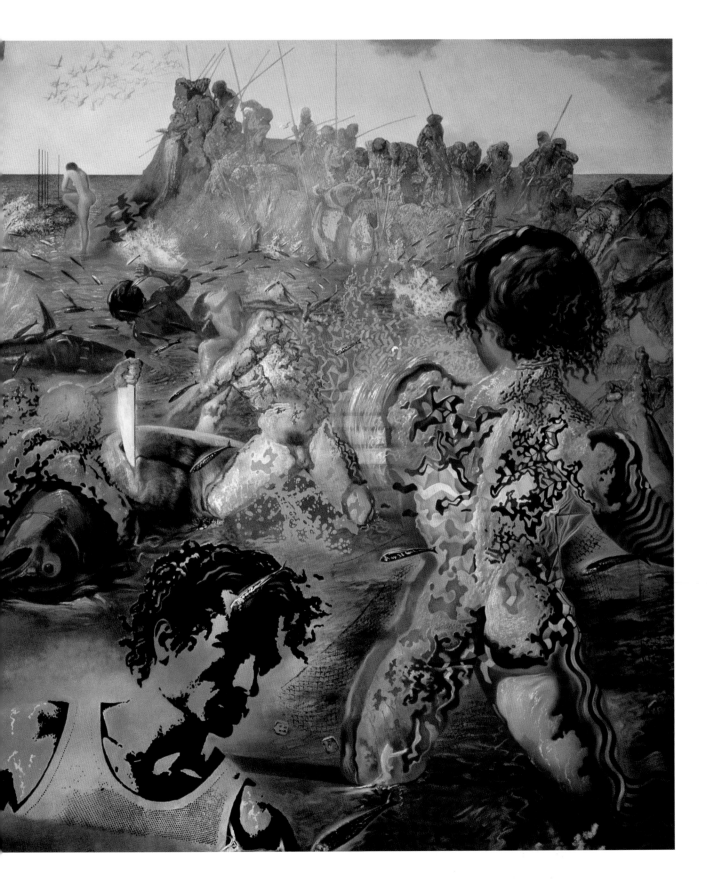

THE SEA OF TEARS (1969)

Courtesy of Christie's Images

FROM as early as 1926, Dalí painted book illustrations. *The Sea of Tears* is an illustration from a 1969 edition of *Alice in Wonderland*. With the emergence of psychedelia in the late Sixties, the tale of *Alice in Wonderland* found a new audience. Dalí also found a new popularity in the Sixties; his Surrealist mentality and hallucinogenic aspirations greatly appealed to a new drug-taking generation. Dalí's home became a Mecca, like Kathmandu, which many hippies would visit to see the great Master.

The Sea of Tears illustrates the story of Alice crying and, having grown to the size of a giant, her tears becoming a sea. Dalí uses just black ink for Alice who appears in miniature in the bottom foreground.

The tears have been given an appearance of solidity and reflection, to give the illusion of liquid. Dalí achieved this by painting them in dark colors graduating to light on the inside, leaving one small spot clear in the middle as if it were water reflecting light. This technique contrasts with the *trompe l'oeil* effect used for the drop of water in *The Rose* (1958), where the color of the rose can still be seen through the drop of water.

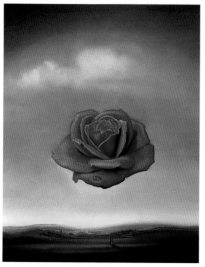

The Rose (1958)
Courtesy of Christie's Images. (See p. 206)

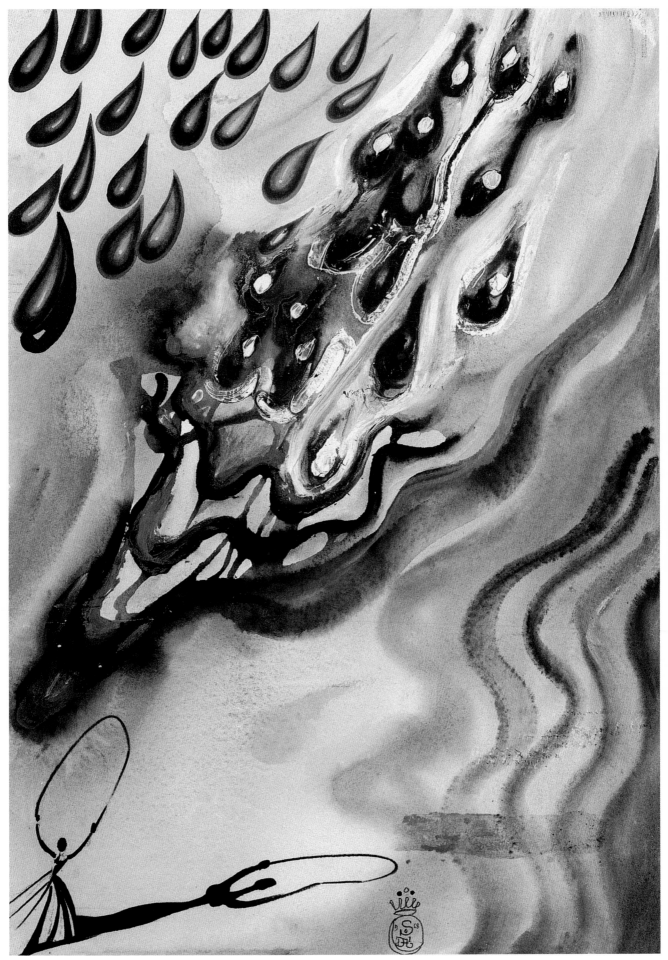

MAY (1949)

Courtesy of Christie's Images

HE personification of the month of May stands with her head facing the sun. A dark rain cloud partly covers the sun, so that rain as well as rays of light pour down. Next to May, hovering near her arm, is Cupid, Dalí here reminding the viewer of the cliché of love in the springtime. The drawing is mainly executed in pen, with touches of watercolor to add a warm skin tone to May and to darken the cloud above her.

Shoots of plants are emerging from May's hair and feet, representing the fecundity of the month. Also suggesting fecundity, are the mushrooms that she carries in a basket and that grow from her groin and along her hips. The mushroom's likeness for dank and moldy areas gives this particular image an unpleasant overtone, and is possibly Dalí referring to his dislike of sexual contact. Snails form the woman's breasts, the swirl of their cones insinuating her nipples.

Although executed much earlier, May shares the same tall, slim figure, high breasts, and tiny waist with the women in the later work, *Le Voyageur* (1967). This shapely figure can be seen in most of Dalí's women, Dalí's men also share this same lithe, almost athletic shape, like dancers.

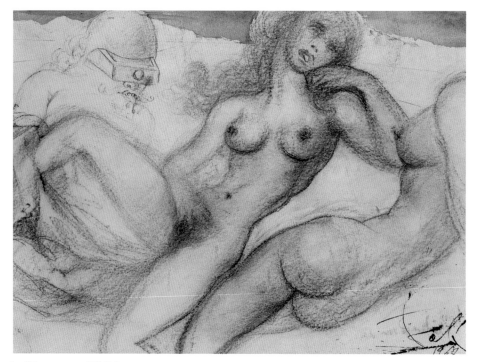

Le Voyageur (1967)
Courtesy of Christie's Images. (See p. 216)

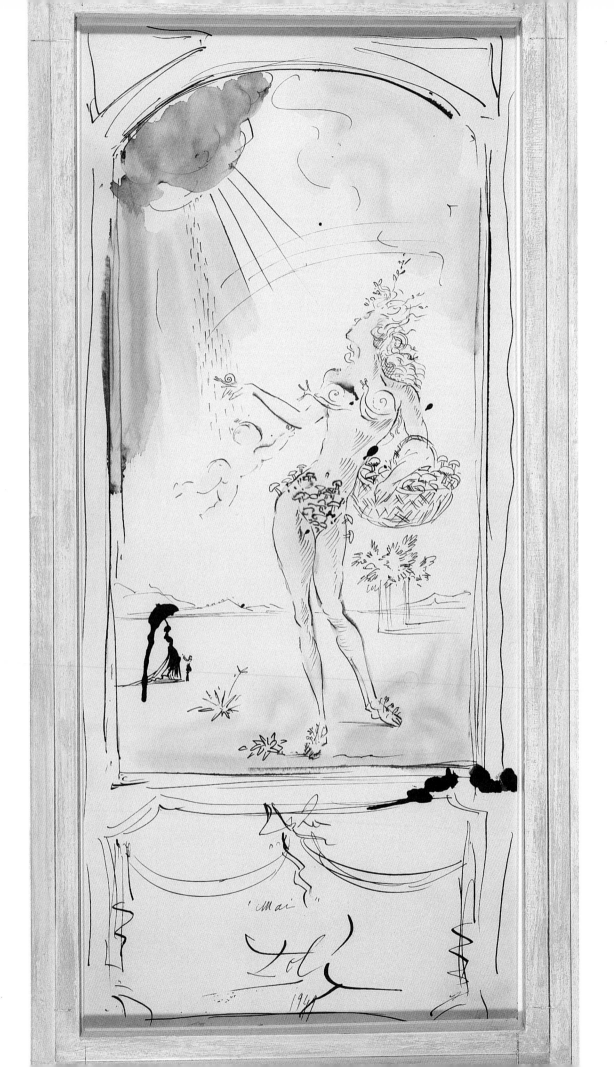

'Mai'

1947

LE CHAR D'OR (1971)

Courtesy of Christie's Images

*L*E Char d'Or—the golden chariot—was painted in 1971, using oil, pen and ink on paper. Dalí frequently painted horses as they were a form that intrigued him. In the Thirties he found a similarity of configuration between horses and women, when seen at a certain angle, which he exploited in the double image used in the background of his painting *The Invention of Monsters* (1937). The horse in *Le Char d'Or* is drawn simply, with the shape of the horse formed by several bold lines in oil. Underneath these bold lines can be seen the pen sketch of the horse.

Le Char d'Or shares a technique that Dalí called "bullitisme" (also called "tachisme') with *The Angel of Alchemy* (1974) where the paint is allowed to hit the canvas in an unplanned, unconscious way. In *Le Char d'Or,* this technique has been used in a way that harks back to Dalí's paranoia-critical method of the Thirties. The ink spatterings have been applied to the paper and after contemplation of the forms that they suggest, the outline of a horse, a chariot wheel, and a driver were added in primary colored oils, to contrast with the fine ink spatters.

The Angel of Alchemy (1974)
Courtesy of Christie's Images. (See p. 235)

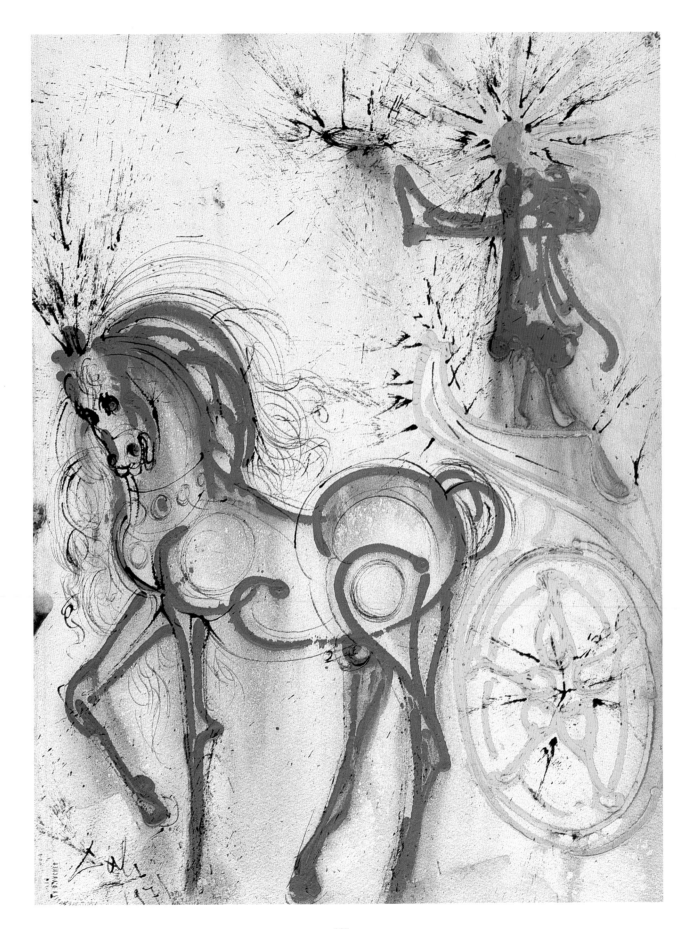

DOCTOR, DOCTOR (1971)

Courtesy of Christie's Images

DOCTOR, *Doctor* was painted in 1971, using watercolor, blue ink and oil on card. Robert Descharnes, an expert on Dalí as well as his friend of many years, has verified that this painting was indeed executed by Dalí. Such verification has become necessary following the discovery of thousands of fraudulent Dalí works over the past two decades. It has been claimed that Dalí signed thousands of sheets of blank paper that another artist could then use in order to pass off their own work as an original Dalí.

Like *Le Char d'Or* (1971) this painting gives off a simple, childlike image; the brushwork is elementary and minimal. The techniques used in these two pictures contrast with Dalí's usual technique of painting; he described his aim was to produce "instantaneous and hand-done color photography of the superfine, extravagant, extra plastic."

Doctor, Doctor suggests a deathbed scene. The patient lying in bed is lit up by the light that descends from the heavens. Through the open window, the familiar image of the rider and horse, seen in so many of Dalí's paintings from the Thirties onwards, can be seen hailing the patient, as if he were Dalí's symbolic Grim Reaper.

Le Char d'Or (1971)
Courtesy of Christie's Images. (See p. 224)

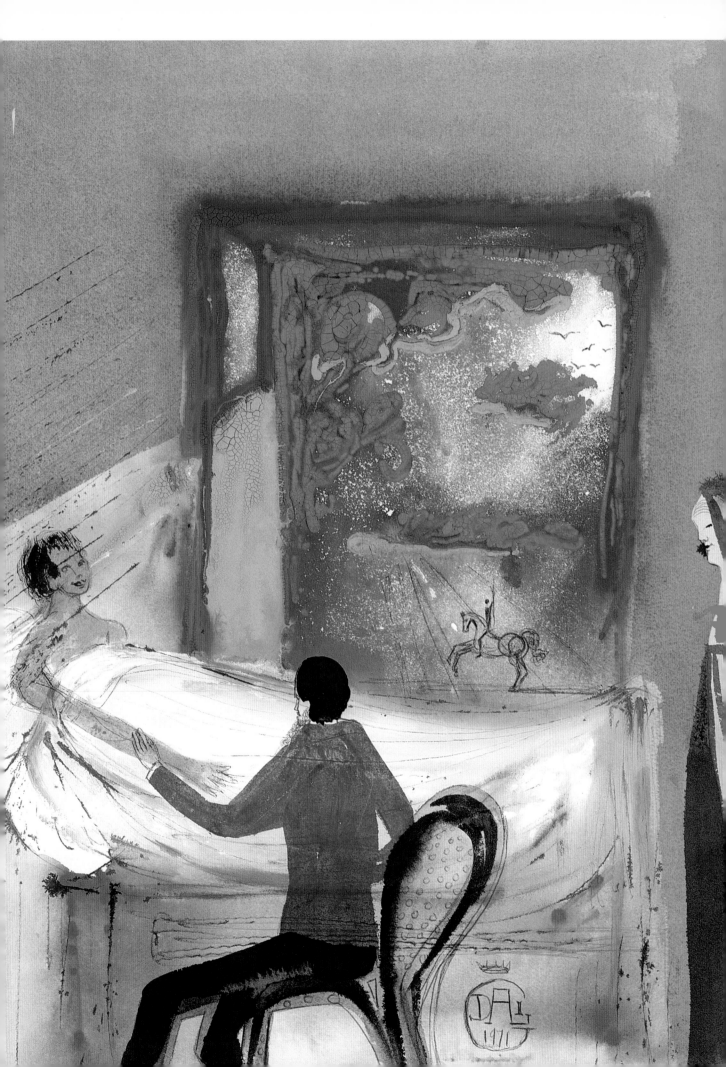

AUTOMNE, POMONA, FEMME DEBOUT (1973)

Courtesy of Christie's Images

*A*UTOMNE, *Pomona, Femme Debout* is signed with Dalí's monogram and dated 1973. The title translates as Autumn, Pomona, Woman Standing; Pomona being the Roman goddess of fruit and the word also meaning a greeny color that is predominately yellow. The woman's skin is alabaster-white, which is exaggerated when set against the murky, charcoal color of the background. Although her body has been given great detail, by contrast her face has an indistinct look, as if smudged. The face is also distinctly darker in color than the rest of her body.

The woman has a peaceful, almost mournful demeanor. Her eyes are closed and her head is downcast; she shares the regular features of Dalí's many portrayals of the Virgin Mary. The face is remarkably similar to the face in his sketch, *Madonna* (1946). The yellow that spreads around the woman's head seems like a halo which adds to the serene, almost religious tone of this painting.

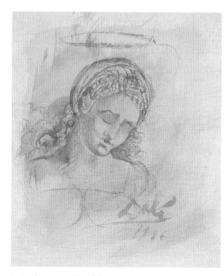

Dalí used a mixture of mediums for this painting: pastel, gouache, and watercolor. The result has given the work a discordant, meshed look, as if it is a collaboration of various images that are pooled to create one form.

Madonna (1946)
Courtesy of Christie's Images. (See p. 170)

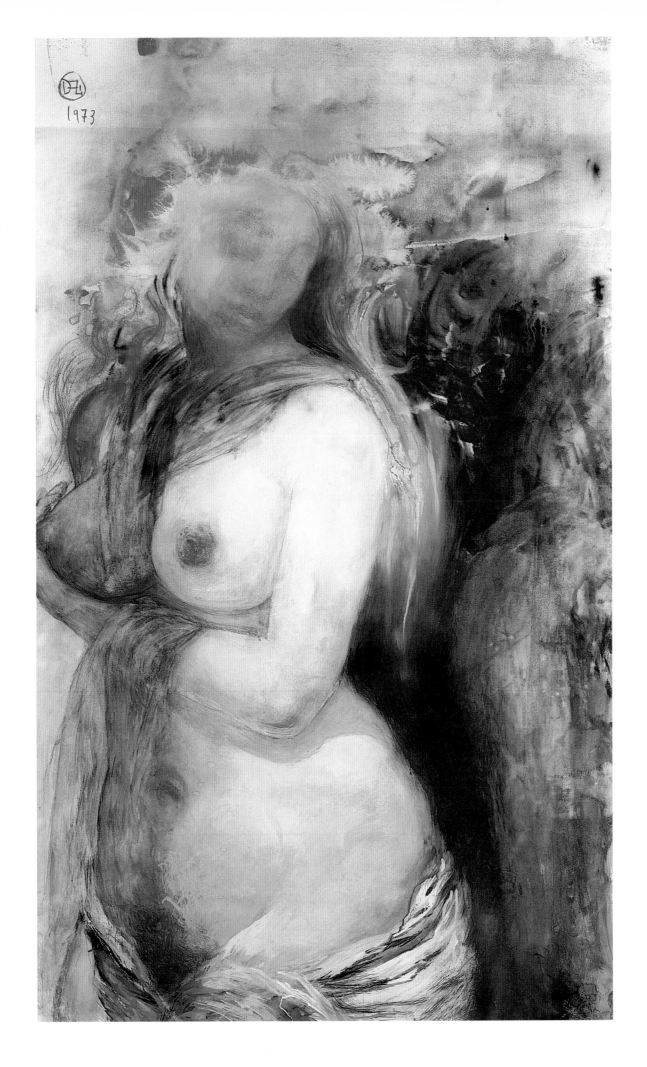

THE PRINCE OF SLEEP (1973–79)
Courtesy of AiSA

*T*HE *Prince of Sleep* is a portrait of King Juan Carlos of Spain, completed between 1973 and 1979. Dalí was a firm supporter of the Spanish Royal Family—he and Gala became friends with Juan Carlos when he was still prince. By the time of the portrait's completion, he had become king, following Franco's death in 1975.

The portrait takes the photographic image of Juan Carlos in his military costume and sets it against a peaceful blue seascape, where the clouds are filled with sunlight. The image is taken from an official photograph of the prince. On his chest is an open door which seems to come out of the painting; a shadow from it is cast on to the white border. Through the doorway, a yellow road leads off into a desert landscape. Against the blue sky, a panel of gold hangs held up by two birds. The panel is positioned over the prince's heart, effecting a pun on the phrase, "heart of gold." Dalí often used the image of bodies with holes cut through; here, as in *The Phoenix* (1974), the open space is filled with images.

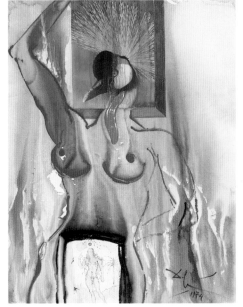

The Phoenix (1974)
Courtesy of Christie's Images. (See p. 233)

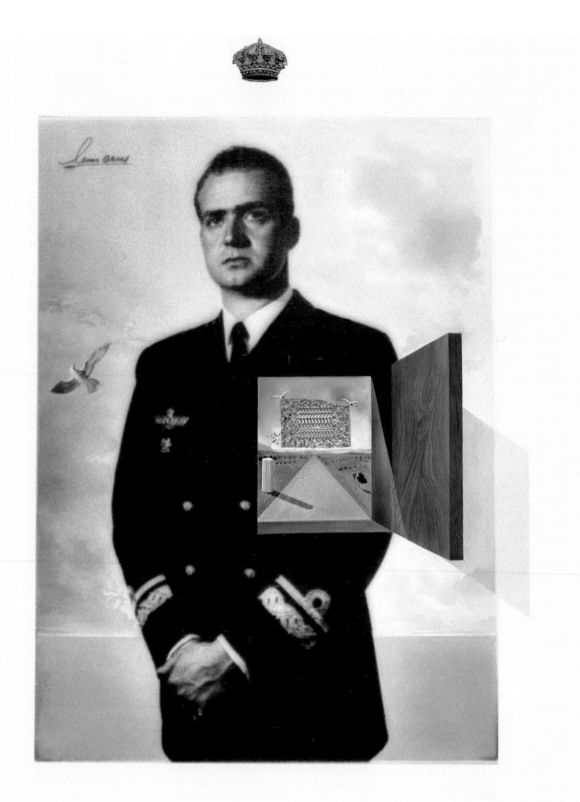

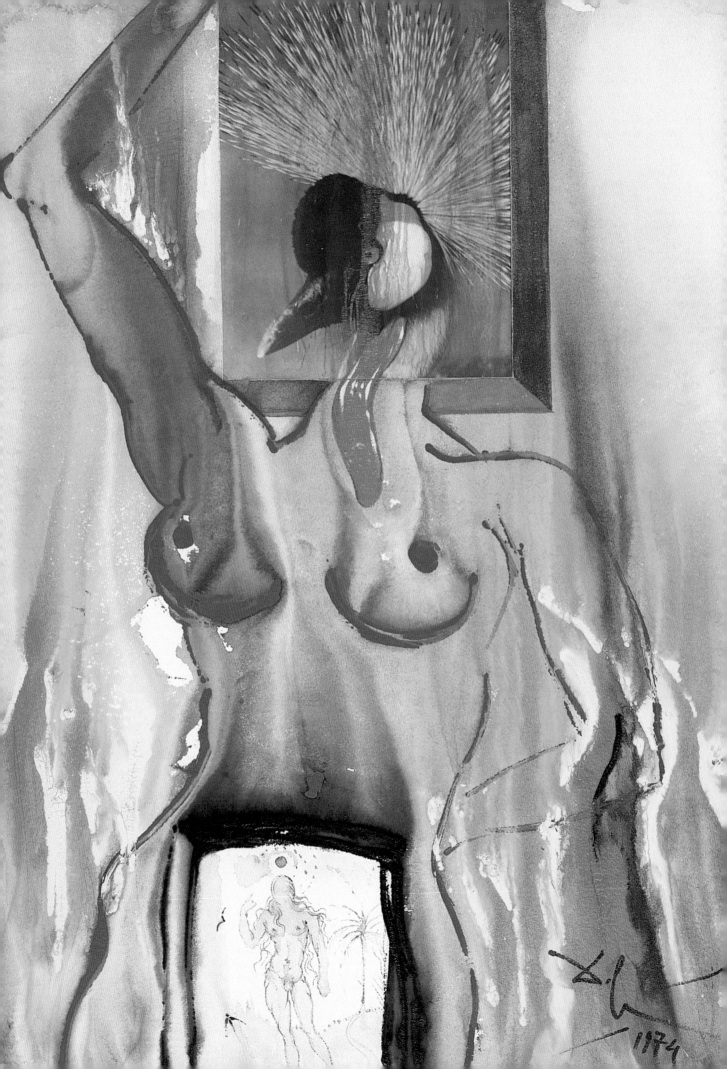

THE PHOENIX (1974)

Courtesy of Christie's Images

DALÍ painted *The Phoenix* in 1974 in a variety of mediums. The tale of the phoenix is one of transformation and resurrection, both themes that he was fascinated by. An earlier drawing called *Métamorphose* (also dealt with the theme of transformation). In *The Phoenix* the theme of transformation is accentuated by the opening on the woman's stomach that shows a naked young man inside her.

Dalí has painted the phoenix as if in flames. To create the impression of flames licking up at the body of the phoenix, the intense red and yellow paints were splashed on to the paper, which was then turned upside down so the paint was allowed to spill down the body of the phoenix. The phoenix has the body of a woman while the head is a picture of a real bird's head, set against a wooden frame. The neck of the bird is joined to the body of the woman beneath the end of this picture, to give the impression that the woman has put her head behind the frame. The red color on the bird's neck continues down the painting to become a tongue-like form that glistens against the woman's neck.

Métamorphose (1946)
Courtesy of Christie's Images. (See p. 169)

233

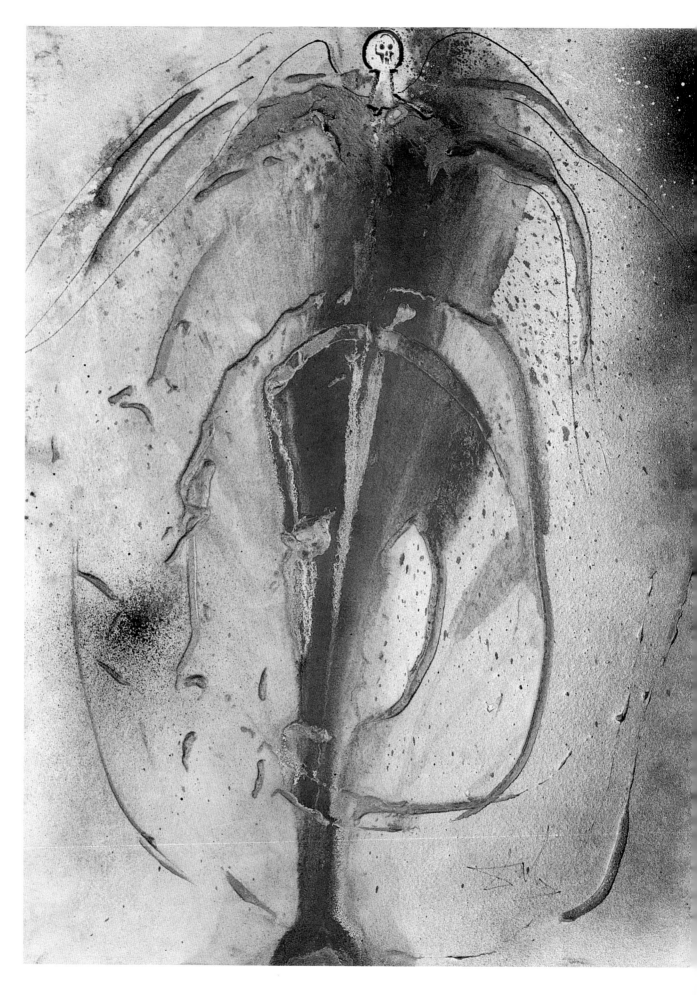

THE ANGEL OF ALCHEMY (1974)

Courtesy of Christie's Images

*T*HE *Angel of Alchemy* was painted using gouache and gold paint on paper, in 1974. The body of the angel is formed by a dark splash of paint, using the same technique as the painting *Le Char d'Or* (1971). Dalí claimed that he first used this technique of splashing paint while at the Madrid Academy of Arts. He boasted that he could win an award without putting his brush to the canvas, splashed paint at his canvas, and did indeed win the award.

The use of gold paint explains the title of the piece; alchemists were obsessed with the idea of making gold. The gold paint appears to be haphazardly splashed on to the paper, although in a circular motion.

In *The Angel of Alchemy*, the angel is only roughly implied in contrast to the more realistic depiction in the painting *Rome* (1949). A tiny head was added to the top of the body, and ink lines have been drawn into denote the angel's wings; these additions ensure that the viewer sees an angel. With a contradiction typical of Dalí, the head of the angel is actually a skull, normally the symbol of death and evil.

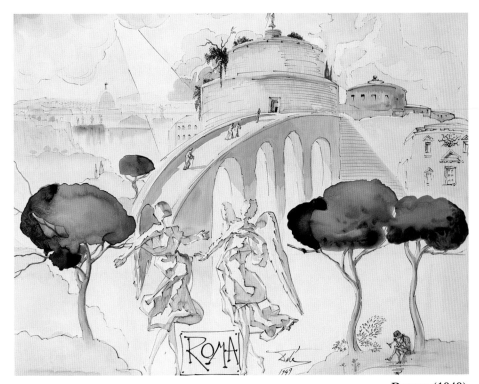

Rome (1949)
Courtesy of Christie's Images. (See p. 178)

THE CHAIR (1975)

Gala-Salvador Dalí Foundation. Courtesy of AiSA

DALÍ was constantly attempting to find new techniques that would allow him to express himself in unique, more visually arresting ways. In *Tuna Fishing* Dalí used photography projected on to his canvas to recreate images, such as the figure of the Hellenistic statue on the left, in perfect detail. In the Seventies, he began to experiment with holography and stereoscopy. Painted in 1975, *The Chair* is one of Dalí's most successful stereoscopic paintings. The idea of stereoscopy was to combine a left and right image so that a three-dimensional image is achieved. The images were combined by looking through a stereoscope. A special one was designed for *The Chair* as the works were 13 ft (9 m) tall.

The two paintings that make up *The Chair* are near identical pictures, differing only in their definition and light. When viewed together the images coalesce to form a solid looking chair that hangs in

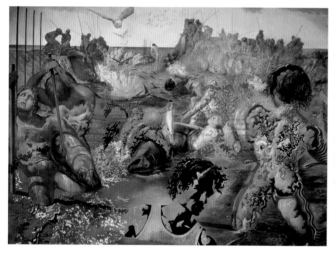

the air, while Dalí's hand appears in the foreground with intense detail, liver warts and all. Dalí wanted to achieve a sense of distance in the painting to emphasize the three-dimensional quality, so he placed the pedestals in decreasing size as if they were disappearing into the distance.

Tuna Fishing (1966–67)
Courtesy of AiSA. (See p. 218)

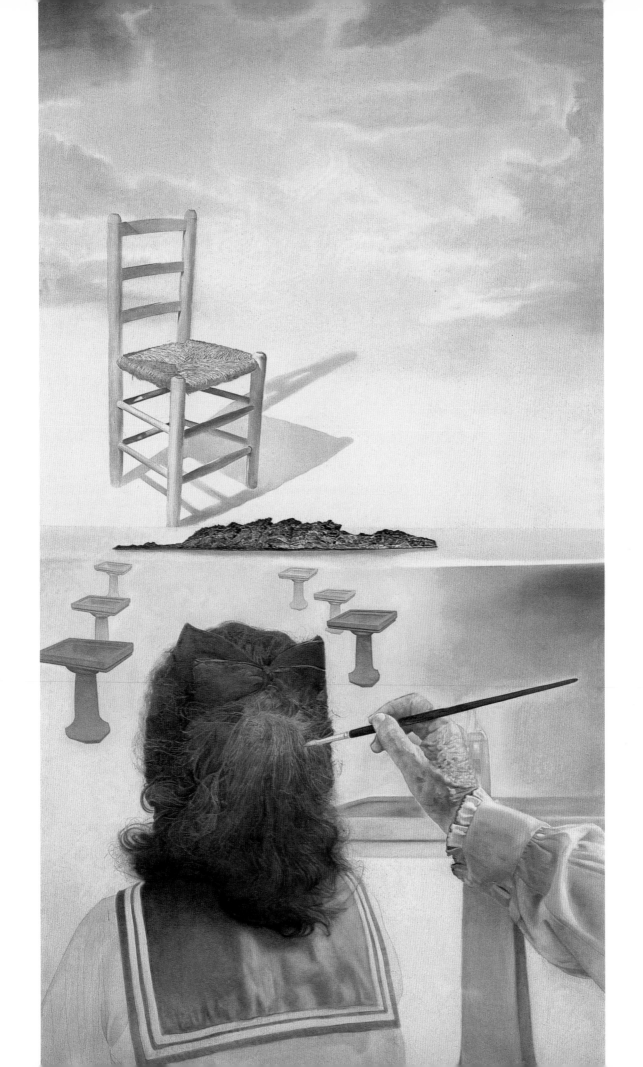

DAWN, NOON, SUNSET, AND TWILIGHT (1978)
Courtesy of AiSA

WHEN *Dawn, Noon, Sunset, and Twilight* was shown in an exhibition at the Guggenheim Museum in New York, it was accompanied by the this sound track: "What time is it? It is the hour of the Angelus. Well then, waiter bring me a harlequin!" The work was completed in 1978 and shows Dalí was still interested in stereoscopic painting. The painting of the woman and landscape is covered with colored dots. The shades of the colors vary to give the suggestion of the different light that can be seen at dawn or at noon. Color was becoming increasingly important to Dalí in his work; through the use of contrasting segments of color, distanced equally, he was attempting to create vibrations between the colors, thus enhancing the autonomy of the stereoscopic space within the piece.

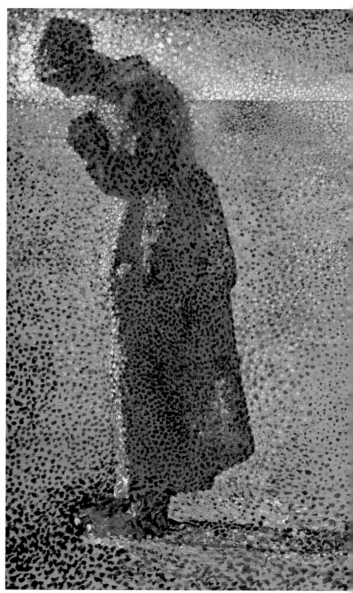

The repeated image of the woman is taken from Millet's *The Angelus*, a work that Dalí incorporated into paintings in the Thirties, one of which was *The Angelus of Gala*. The "Angelus" would often appear in the background of Dalí's paintings. Only the woman is seen, as if she has finally submerged the male that Dalí always saw her as the predator of.

✳ D A W N , N O O N , S U N S E T A N D T W I L I G H T ✳

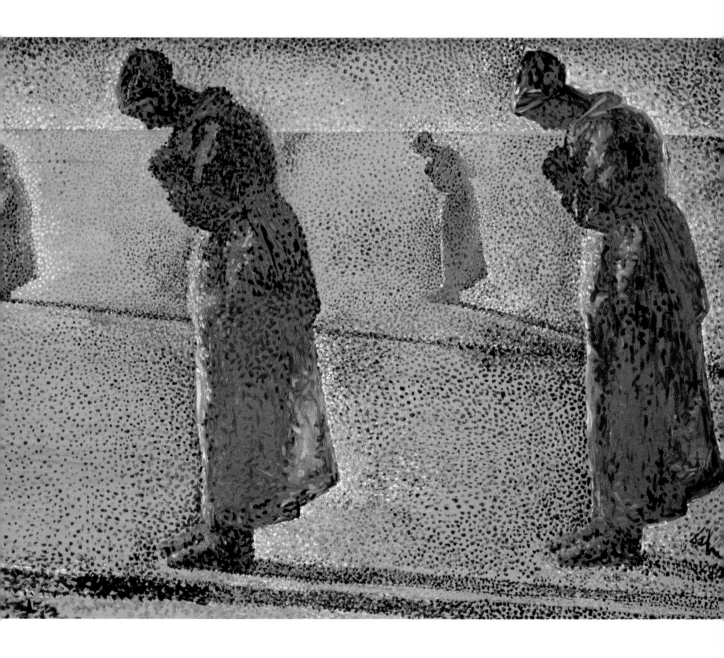

GALA BOUQUET (1979)
Courtesy of Christie's Images

*G*ALA *Bouquet* was painted, using watercolor and oil on card, in 1979. The oil has been used to create definition, particularly on the vase. It has also been used within the flowers, to give the form of the stems and to highlight a few flowers from within the mass of color. The watercolor looks as if it has been spilled on to the paper; it has been allowed to bleed heavily into the paper and to drip down to mix with the oil, creating a blurred, out of focus image. The colors have bled into each other to form new colors, giving an almost tie-dye effect to the painting. In the 1956 painting *Vase de Fleurs*, Dalí used the same subject as well as the same medium. Where the paintings differ is in the definition that Dalí has given to the flowers in the earlier painting that *Gala Bouquet* lacks.

Although this painting is supposedly a dedication to Gala, by 1979 Gala and Dalí were virtually living separate lives. If Dalí wished to visit Gala, he had to write to ask her permission first. She was in her eighties, he was 75 and also suffering from Parkinson's Disease.

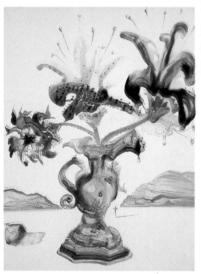

Vase de Fleurs (1956)
Courtesy of Christie's Images. (See p. 200)

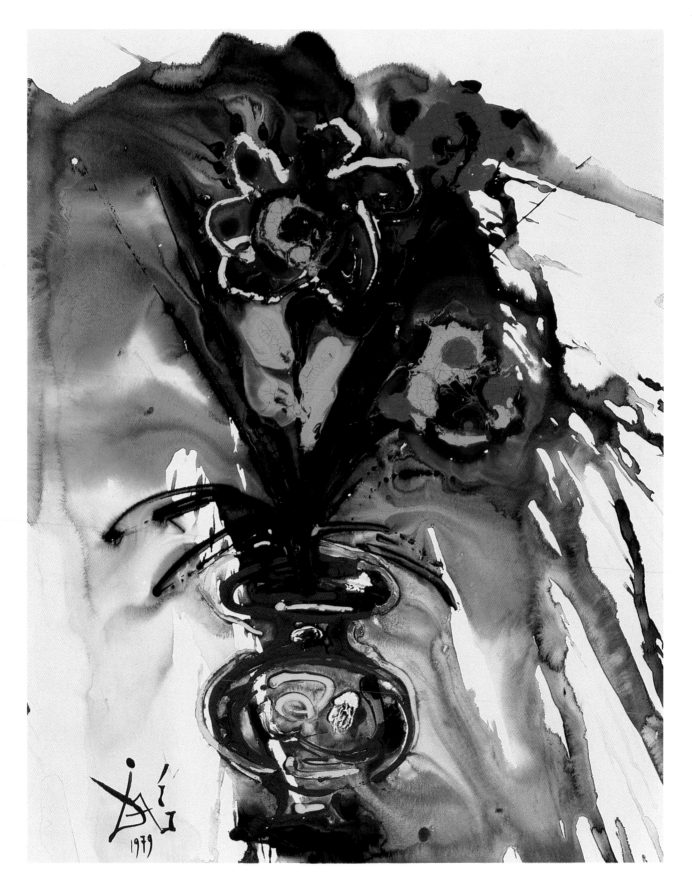

ELEPHANT SPATIAL (1980)
Courtesy of Christie's Images

ELEPHANT *Spatial* was cast in bronze in 1980. The same elephant with huge spindly legs, also bearing a pyramid on its back, can be seen in the background of the 1944 painting entitled *Dream Caused by the Flight of a Bee*. These elephants also featured heavily in the *The Temptation of St. Anthony* (1946), where several of them advance upon the cowering figure of St. Anthony, who appears in the foreground holding up a crucifix. *The Temptation of St. Anthony* would seem to indicate that these distorted elephants are to be interpreted as ungodly, or evil symbols; in fact Dalí saw them as existing in a mystical nether-region, halfway to the heavens but still attached to the earth.

Elephant Spatial has a green patina to make the bronze appear aged. The bronze on the tusk has been highly polished for emphasis. The base is made of marble and the pyramid on the top is made from plexiglas. *Elephant Spatial* was not the first statue of the elephant that Dalí made. In 1956, he made a piece called *The Space Elephant*, with the figure made with gold, rubies, diamonds, and emeralds.

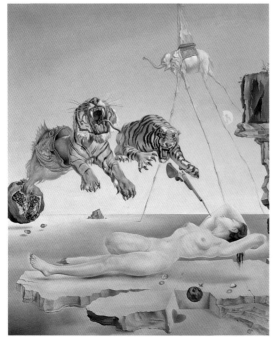

Dream Caused by the Flight of a Bee (1944)
Courtesy of Giraudon. (See p. 156)

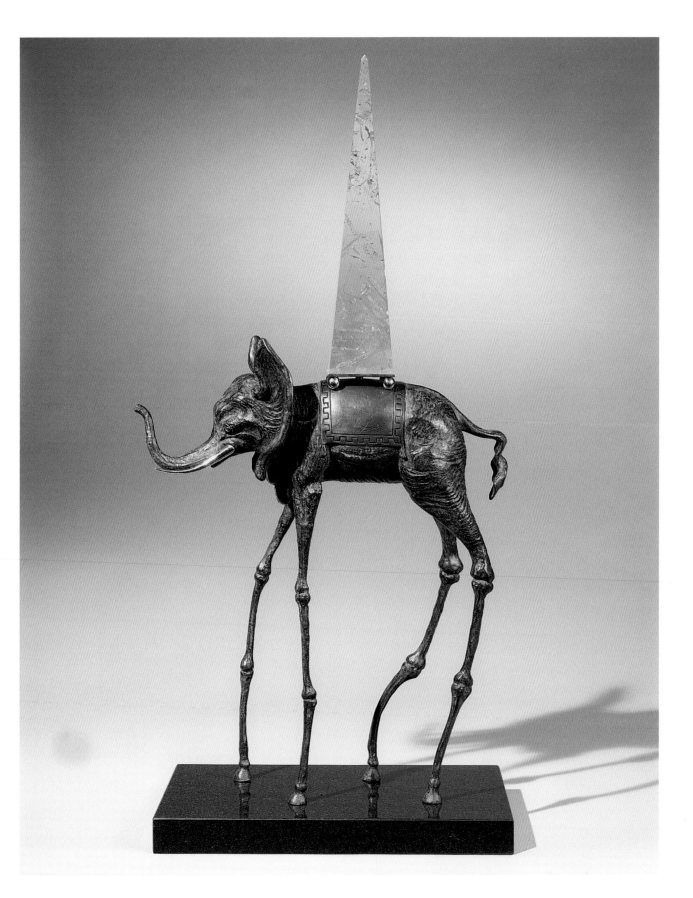

ALICE IN WONDERLAND (1984)
Courtesy of Christie's Images

*T*HE figure of *Alice in Wonderland* was conceived and cast in bronze in 1984 and measures over 36 in (91 cm) high. The bronze has a green and gold patina, which gives an illusion of age to metal. Dalí had illustrated an edition of *Alice in Wonderland* in 1969 and the form of this figure is the same one that he chose for the book illustrations.

Dalí often used this same image of a girl with a long flowing skirt, holding a skipping rope, during the Thirties. She appears in the background of several paintings such as *The Triangular Hour* (1933). The girl is usually portrayed as she is here, as if is in movement, with the rope held above her head to form a circle with her arms. The skipping rope is an image from Dalí's childhood; he liked to look at the blue sky through a frame, such as an insect's carcass or a skipping rope which was poised in mid air.

A crutch, now synonymous with Dalí, appears at the front of the piece. Here it is not supporting anything, but is included as a form of signature to identify the work as being Dalí's.

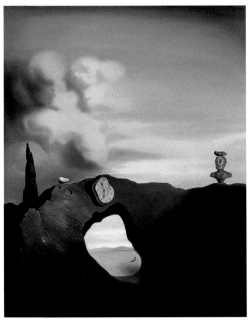

The Triangular Hour (1933)
Chatelard Collection, France. Courtesy of AiSA. (See p. 84)

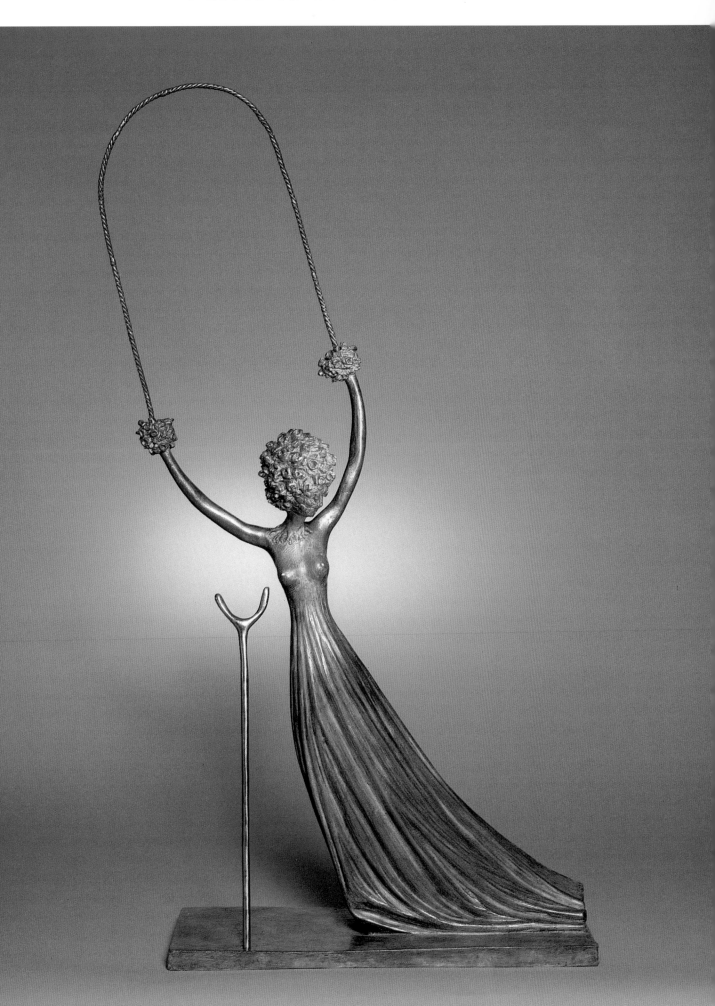

HOMMAGE À TERPSICHORD (LA DANSE) (undated)

Courtesy of Christie's Images

THE two figures stand with one hand outstretched, the other placed on their hip, as if they are frozen in a dance. Terpsichord was the muse of dancing, but the word also means "enjoying a dance" or "personifying the art of dancing." The figures face each other in a mutual pose, creating a mirror reflection of the other; forming a converse mirror, the bronze figure being the inverse of the gold one.

The figures contrast as well as mimic each other: the sleek bronze with the appearance of marble against the reflective harshness of the gold figure. The substance of the two figures is echoed in their form: the smoothness of the marble correlates to the fluid, linear form of that figure, while the golden figure, like metal, is angular, inhuman, with the appearance of an android.

The golden figure is androgynous, with the hint of breasts and womanly form but also a penis. Androgyny was an idea that appealed to Dalí's contradictory nature. An androgynous figure was included in his 1940 work *Daddy Longlegs of the Evening …Hope!* (1940). The tendrils growing from the figure's calves and head further denote this figure to be a Surrealist image.

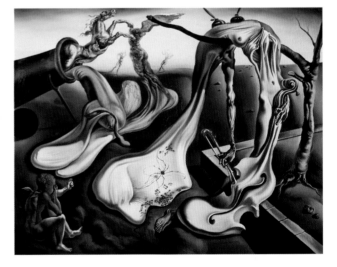

Daddy Longlegs of the Evening …Hope! (1940)
Courtesy of Topham. (See p. 145)

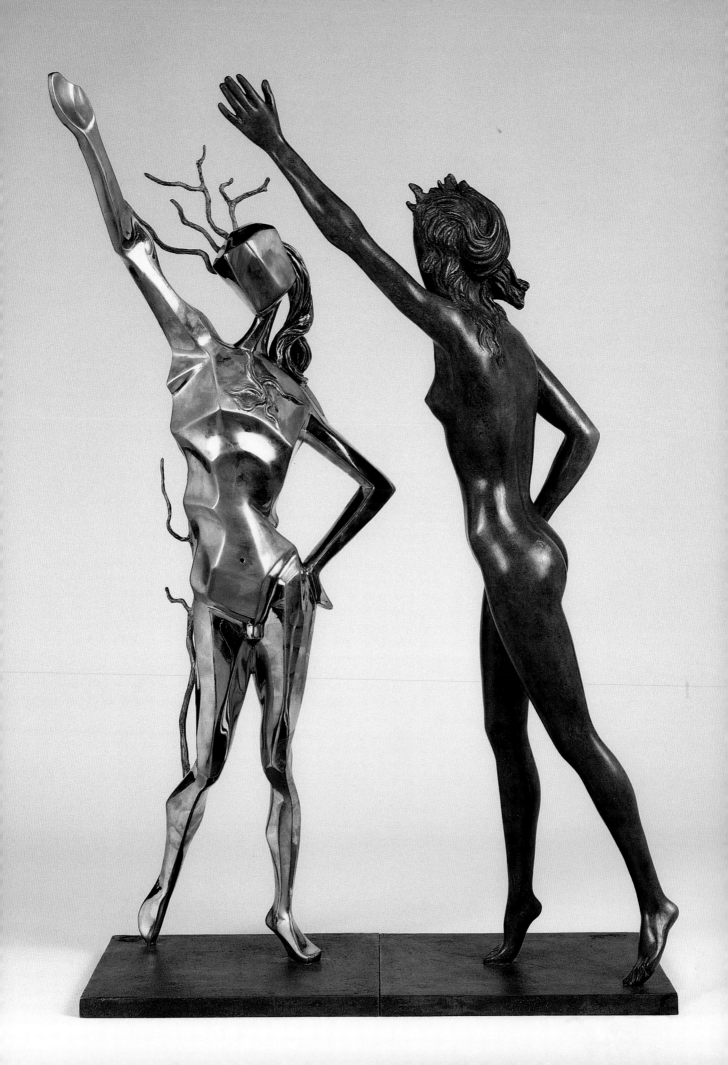

THE PROFILE OF TIME (c. 1984)

Courtesy of Christie's Images

*T*HE *Profile of Time* is one of several pieces that were conceived and cast in bronze during the Eighties. The pieces portray different images from Dalí's paintings or his illustration work, such as the figure of *Alice in Wonderland* (1984). *The Profile of Time* is a further exploration of the image of the "soft watch." The piece has had a green patina applied to the bronze to give an antique, aged appearance. Against the darkened brass, the polished brass that frames the soft watch stands out, instantly capturing the viewer's eye.

The soft watch seems melted on to the front of a tree. The branches of the tree have been severed, but unusually for Dalí, there are still leaves growing. The tree appears as if it is the body for the watch with the branches forming arms, held up in the air as if the watch is alarmed by something. Beneath the watch face, there are two figures, placed one on either side, they act as a visual reference to the cuckoo clock. An angel sits with his head in his hand as a naked woman stands on the other side of the watch; both figures are looking away from time.

The Persistence of Memory (1931)
M.O.M.A., New York. Courtesy of Topham. (See p. 70)

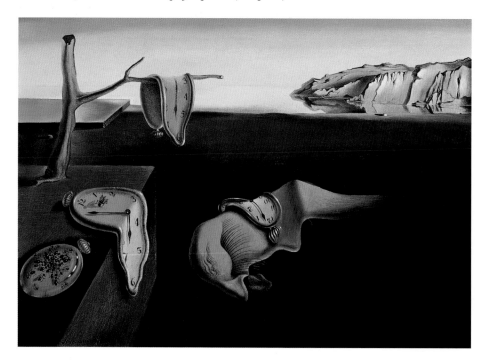

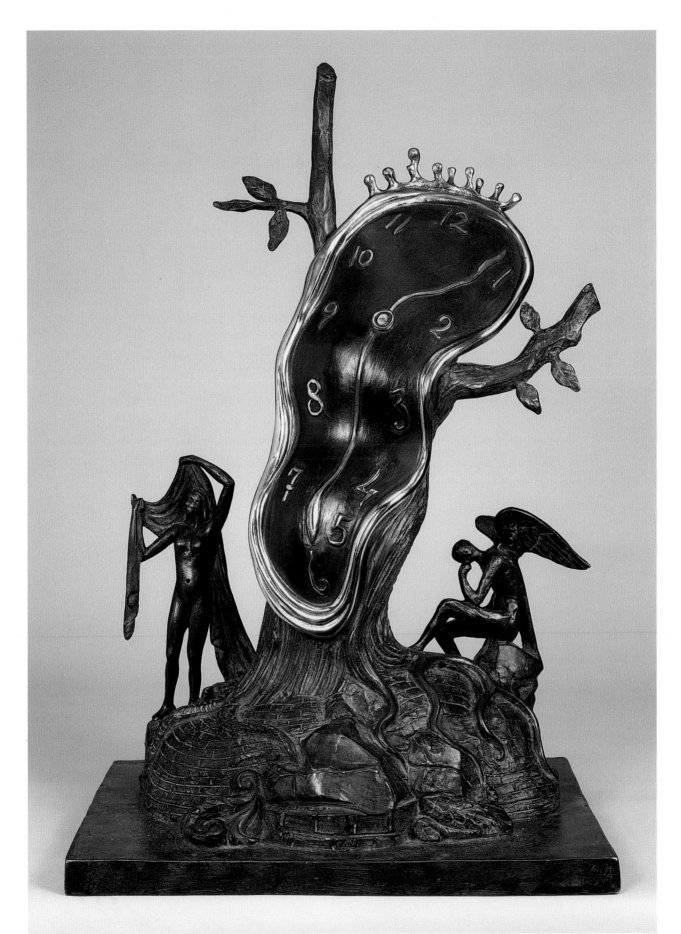

Profile du Temps (1984)

Courtesy of Christie's Images

DALÍ'S most famous and persistent image, the "soft watch," was first seen in his 1931 painting *The Persistence of Memory*. One of the soft watches hangs limply from the branch of a dead tree; this particular image has been used for *Profile du Temps*. Made from bronze, the *Profile du Temps* was cast and conceived in 1984. A green and brown patina has been applied to parts of the bronze to afford it the illusion of age and solidity as a contrast to the "soft" appearance of the watch. The patina also gives the metal on the tree more of an appearance of wood.

Dalí placed his soft watches against hard objects, such as rocks or trees, to emphasize their malleable state. Here the watch seems to be dissolving it has become so soft, the bottom melts into huge drops that look as if they will soon fall. The brass on the watch has been polished so that the shine will help the metal gain the appearance of liquid.

Dalí used the "soft watch" as an image through which he could explore the idea of time. The watches' softness implies disintegration, recalling the transitory nature of mankind.

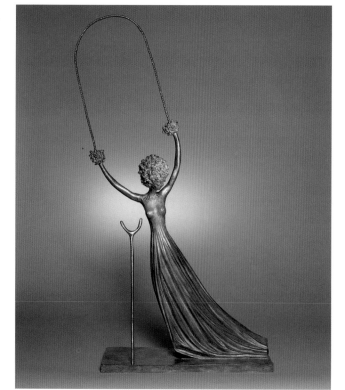

Alice in Wonderland (1984)
Courtesy of Christie's Images. (See p. 244)

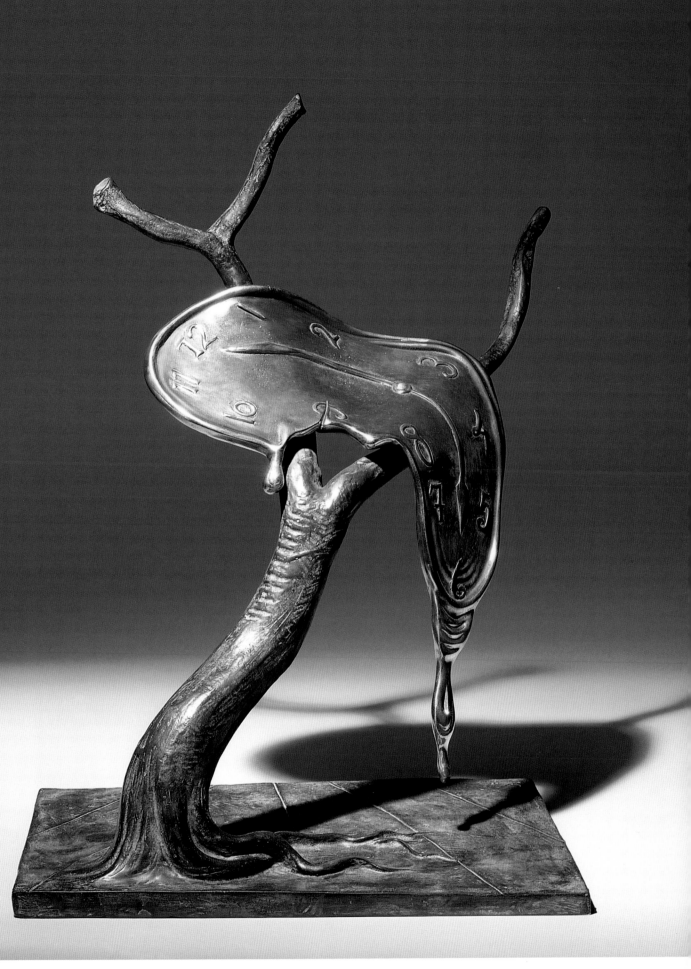

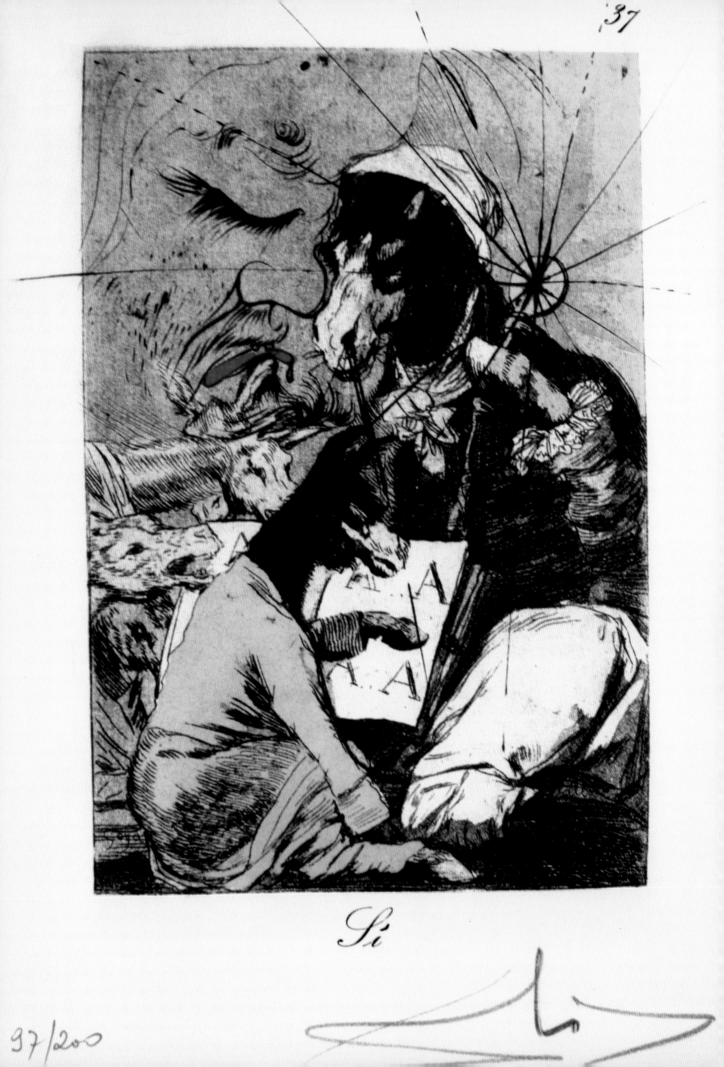

INTERPRETATION OF GOYA'S "LOS CAPRICHOS"
(undated)
Courtesy of AiSA

GOYA was a Spanish artist of the eighteenth century. He had initially painted in the style of Velásquez, a painter who Dalí also admired, but after an illness which left him deaf, Goya began to use more personal and social themes in his works. *Los Caprichos* (1798) was a series of etchings. They were banned in Spain because of their anti-clerical stance, but they were popular elsewhere.

Following his illness, Goya's work was dominated by a palette of gray, brown, and black, emphasized by red. Dalí has mimicked this palette for his interpretation, as well as the cartoon-like quality that some of Goya's work had. Whilst firmly in the style of Goya, there are still the Dalínian touches to the drawing. The shape of the man's head on the left, with its eyes shut, long lashes, and a frown on the forehead, is reminiscent of the huge heads seen in paintings such as *The Enigma of Desire* (1929).

The donkeys in this drawing are characterized as human; they write letters and wear clothes—a visual metaphor for the foolishness of mankind.

The Enigma of Desire (1929)
Courtesy of Christie's Images. (See p. 52)

Six Designs of Playing Cards, The Joker (undated)

Courtesy of Christie's Images

*T*HE *Joker* is Dalí's rendition of the traditional subject of the joker, from within the constrained field of playing cards.
Although Dalí has kept most aspects of the standard portrayal of the joker, he has added some of his Surrealistic trademarks to the drawing. Dalí would often include a repetitive Surrealist image, such as the crutch, in his commissioned works; their inclusion performed a visual reference to him, ensuring that the viewer understood this to be a work by Dalí. One of these repeated images is the figure of a medieval jester, or joker. They can often be seen in the background, such as in the 1949 painting, *Rome*.

The colors in the drawing are restricted to the bold, mainly primary colors that are usually seen in playing cards. The joker is standing in an impossible position, performing a handstand with his legs bending over his head, twisting back the wrong way. Out of his chest, a drawer appears with a crutch balanced inside it. The crutch supports the elongated skull, an image that Dalí included in a series of paintings. It is an image that obviously refers to mortality but becomes strangely sexual because of its elongated, phallic, appearance.

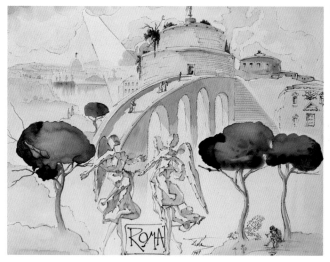

Rome (1949)
Courtesy of Christie's Images. (See p. 178)

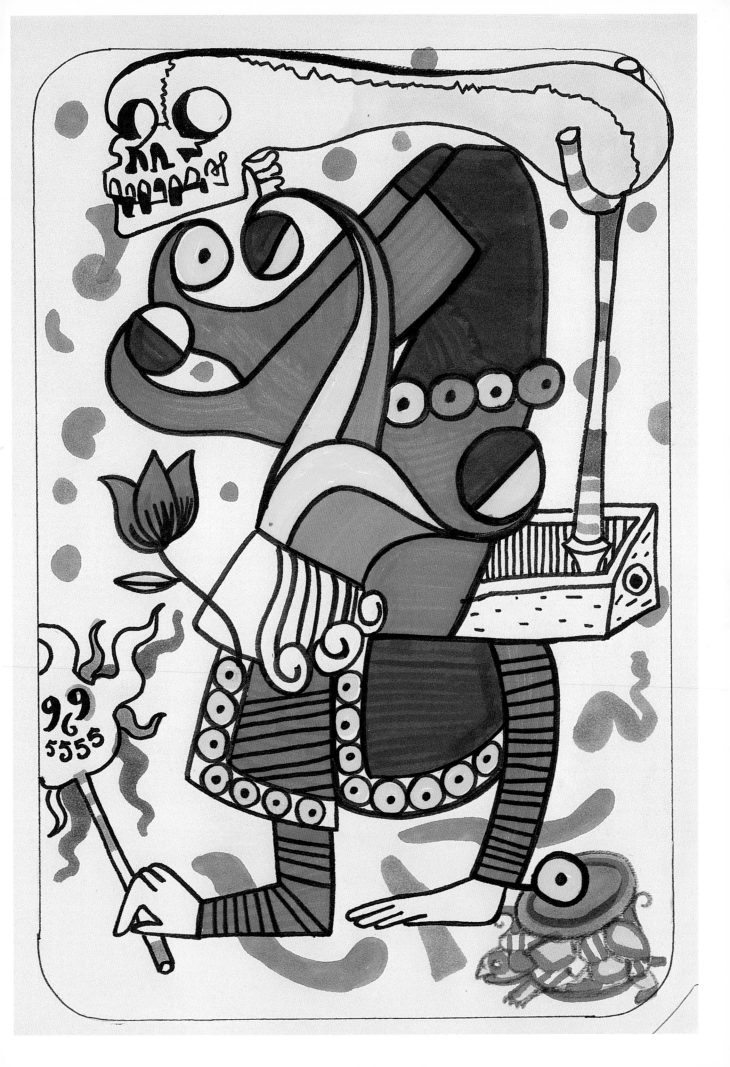

AUTHOR BIOGRAPHIES AND ACKNOWLEDGMENTS

For Nimar.

Kirsten Bradbury was born in 1969. Her childhood was spent living in New Zealand and the West Country of England; as an adult she moved to London. She undertook an arts degree at the University of Surrey and has been fascinated by the works of Salvador Dalí since her first visit to an exhibition of his works. She currently combines her writing career with working in the music industry.

For Dodie.

Jonathan Wood was educated at York University and the Courtauld Institute of Art in London. He is presently writing a book about twentieth-century sculpture in France.

While every endeavor has been made to ensure the accuracy of the reproduction of the images in this book, we would be grateful to receive any comments or suggestions for inclusion in future reprints.

With thanks to Image Select and Christie's Images for assistance with sourcing the pictures for this series of books. Grateful thanks also to Frances Banfield, Lucinda Hawksley, and Sasha Heseltine.

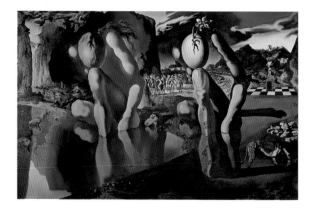